Put any picture you want on any state book cover. Makes a great gift. Go to www.america24-7.com/customcover

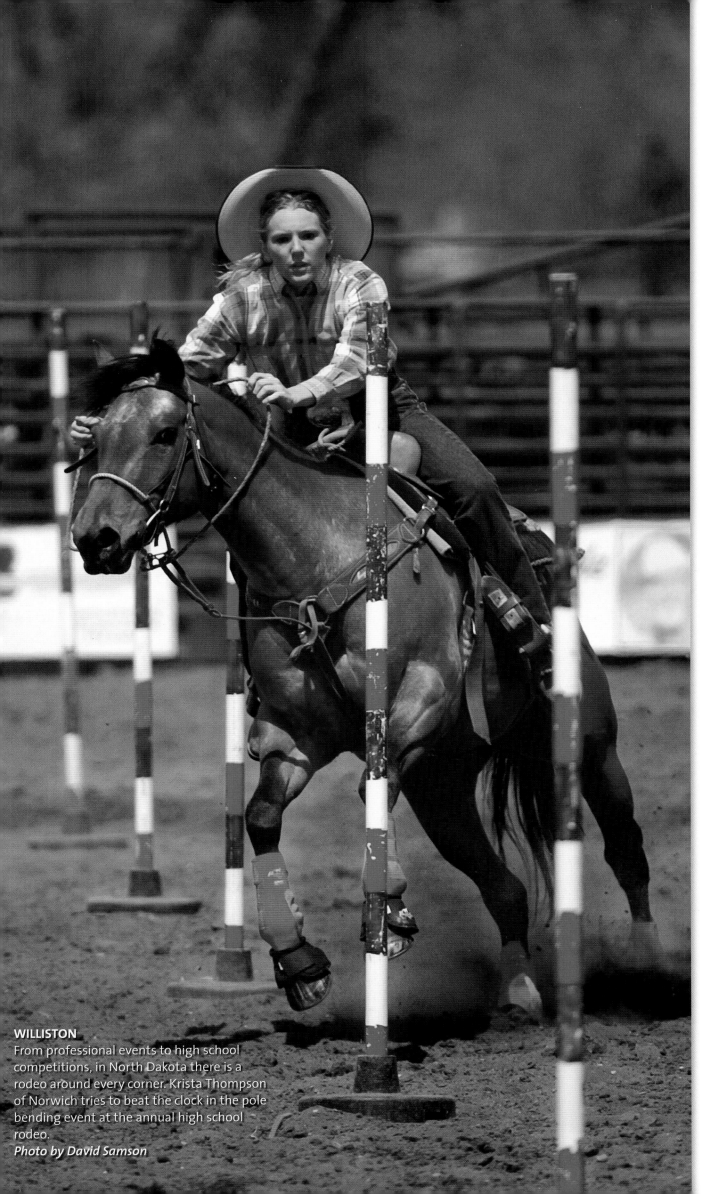

WILLISTON
From professional events to high school competitions, in North Dakota there is a rodeo around every corner. Krista Thompson of Norwich tries to beat the clock in the pole bending event at the annual high school rodeo.
Photo by David Samson

North Dakota 24/7 is the sequel to *The New York Times* bestseller *America 24/7* shot by tens of thousands of digital photographers across America over the course of a single week. We would like to thank the following sponsors, the wonderful people of North Dakota, and the talented photojournalists who made this book possible.

LONDON, NEW YORK, MUNICH, MELBOURNE, and DELHI

Created by Rick Smolan and David Elliot Cohen

24/7 Media, LLC
PO Box 1189
Sausalito, CA 94966-1189
www.america24-7.com

First Edition, 2004
04 05 06 07 08 10 9 8 7 6 5 4 3 2 1

Published in the United States by
DK Publishing, Inc.
375 Hudson Street
New York, NY 10014

DK Publishing, Inc. offers special discounts for bulk purchases for sales promo-
tions or premiums. Specific, large-quantity needs can be met with special
editions, personalized covers, excerpts of existing guides, and corporate
imprints. For more information, contact:

Special Markets Department
DK Publishing, Inc.
375 Hudson Street
New York, NY 10014
Fax: 212-689-5254

Cataloging-in-Publication data is available
from the Library of Congress
ISBN 0-7566-0075-8

Printed in the UK by Butler & Tanner Limited

First printing, October 2004

CASSELTON

In 1872, the first train pulled into the Dakota
Territory at Fargo, and railroads continue to
define the state's destiny. Just east of down-
town Casselton, this length of Burlington
Northern Santa Fe's 32,500-mile nationwide
network handles more than 400 freight
trains each week.
Photo by Sandee Gerbers

NORTH DAKOTA 24/7

24 Hours. 7 Days.
Extraordinary Images of
One Week in North Dakota.

Created by Rick Smolan and David Elliot Cohen

DK Publishing

About the America 24/7 Project

A hundred years hence, historians may pose questions such as: What was America like at the beginning of the third millennium? How did life change after 9/11 and the ensuing war on terrorism? How was America affected by its corporate scandals and the high-tech boom and bust? Could Americans still express themselves freely?

To address these questions, we created *America 24/7*, the largest collaborative photography event in history. We invited Americans to tell their stories with digital pictures. We asked them to shoot a visual memoir of their lives, families, and communities.

During one week in May 2003, more than 25,000 professionals and amateurs shot more than a million pictures. These images, sent to us via the Internet, compose a panoramic yet highly intimate view of Americans in celebration and sadness; in action and contemplation; at work, home, and school. The best of these photographs, more than 6,000, are collected in 51 volumes that make up the *America 24/7* series: the landmark national volume *America 24/7*, published to critical acclaim in 2003, and the 50 state books published in 2004.

Our decision to make *America 24/7* an all-digital project was prompted by the fact that in 2003 digital camera sales overtook film camera sales. This techno-logical evolution allowed us to extend the project to a huge pool of photographers. We were thrilled by the response to our challenge and moved by the insight offered into American life. Sometimes, the amateurs outshot the pros—even the Pulitzer Prize winners.

The exuberant democracy of images visible throughout these books is a revela-tion. The message that emerges is that now, more than ever, America is a supersized idea. A dreamspace, where individuals and families from around the world are free to govern themselves, worship, read, and speak as they wish. Within its wide margins, the polyglot American nation manages to encompass an inexplicably complex yet workable whole. The pictures in this book are dedicated to that idea.

—*Rick Smolan and David Elliot Cohen*

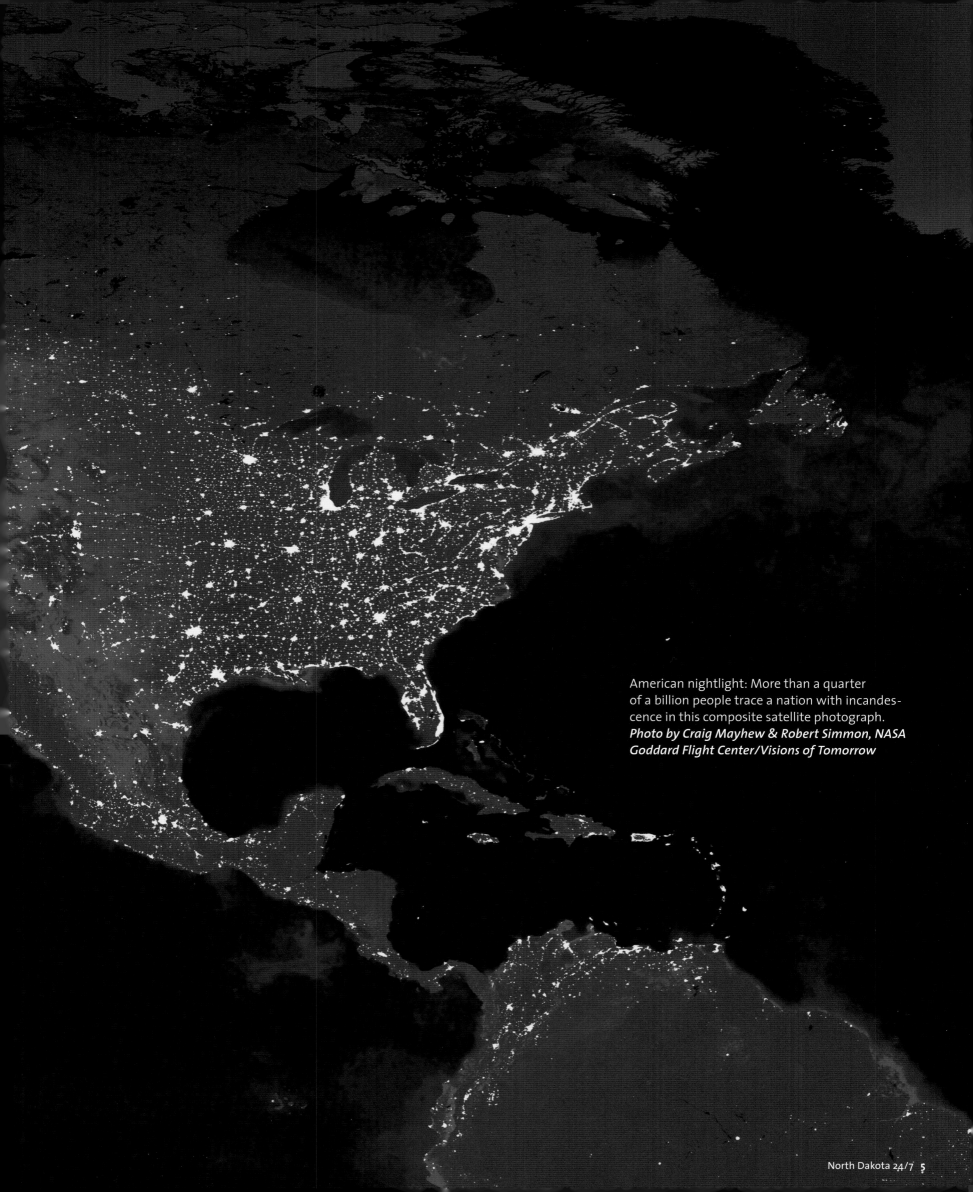

American nightlight: More than a quarter of a billion people trace a nation with incandescence in this composite satellite photograph.
Photo by Craig Mayhew & Robert Simmon, NASA Goddard Flight Center/Visions of Tomorrow

One Big Small Town

By Janell Cole

In western North Dakota you can hike to the top of the Killdeer Mountains and look down the Medicine Hole, a shaft that legend says was the escape route of the Sioux Indians when they fled from General Sully in 1864. Turn to the east and the south and there, 700 feet below, the Great Plains stretch out as far as you can see. In the distant west and north are the rugged, multicolored Little Missouri Badlands, where Theodore Roosevelt ranched and set himself on a course to the White House.

Visitors who think they know what to expect in North Dakota—"nothing but miles and miles of miles and miles"—are sometimes surprised when they see the variety. They expected 71,000 square miles of frozen flatness. Oh, yes, we do have the flattest of the flat on our eastern border in the Red River Valley. It's an amazing phenomenon, where the glacial Lake Agassiz deposited pancake-level black dirt that's ranked among the most fertile and prosperous cropland in the world.

North Dakota is really just one big small town. With 634,000 residents, it takes only a few minutes of casual conversation with a new acquaintance to find that you have someone or something in common. You went to church camp with his brother. Or a coworker at your third job out of college was the senator's cousin. You're more likely than most Americans to have the chance to chat up your local legislator or bump into the governor or congressional representative at the local coffee shop or garden club. Or with a little effort, you can BE a legislator.

We delight in these connections to each other, yet take them for granted as part of our understanding and affection for this place, its landscape, its quirks of character, its people.

SLOPE COUNTY
To celebrate the ranching heritage of the southwestern part of the state, local welder Derrick Lyson created a metal bucking bronco and rider on a hill outside Marmarth.

Our appreciation, evident in the everyday images of this volume, makes our challenge all the more personal and painful: This small town of a state struggles to stem the emptying out of the countryside. Young college graduates realize they'll strain to pay off their loans and start a family on an average salary of $26,000, so they're off to Minneapolis or Chicago or Denver. Little town schools close and consolidate with neighboring rivals, then consolidate yet again a few years later, taking in ever-increasing territory and ever-shrinking numbers of kids on ever-longer bus rides.

Because we appreciate that which we have and that which we seek to preserve, NoDaks can be a proud and defensive lot, not always willing to brush off shallow insults from the humor columnists and the millions who saw the movie *Fargo* and think they learned all there is to know.

Back in February of 2004, a CBS news correspondent who's made a name for himself doing sensitive feature stories on everyday people, came to report on the state's Democratic caucuses. He, like so many before him, returned our hospitality with the kind of snide, condescending remarks (e.g., "North Dakota's Hall of Fame is a punch line waiting to happen.") we've come to loathe.

What was so telling afterward was this: Many of those who told me they were most offended by the CBS report were not lifelong North Dakotans but rather newcomers who have chosen to settle and stay. That's the best vindication of all.

Thirty years ago, Janell Cole *made a conscious decision to stay. Living in Bismarck, Cole is the Capitol correspondent for* The Forum of Fargo-Moorhead.

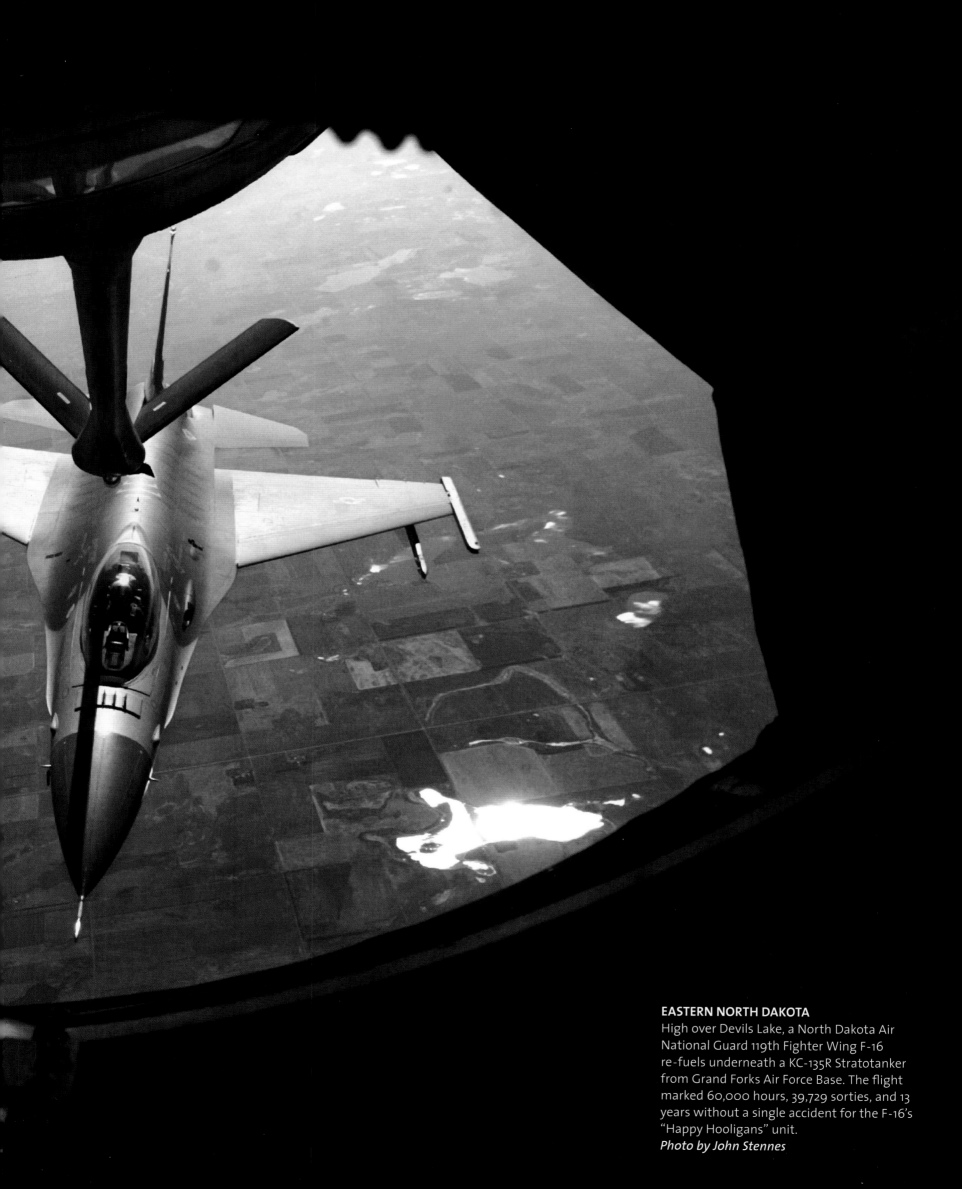

EASTERN NORTH DAKOTA
High over Devils Lake, a North Dakota Air National Guard 119th Fighter Wing F-16 re-fuels underneath a KC-135R Stratotanker from Grand Forks Air Force Base. The flight marked 60,000 hours, 39,729 sorties, and 13 years without a single accident for the F-16's "Happy Hooligans" unit.
Photo by John Stennes

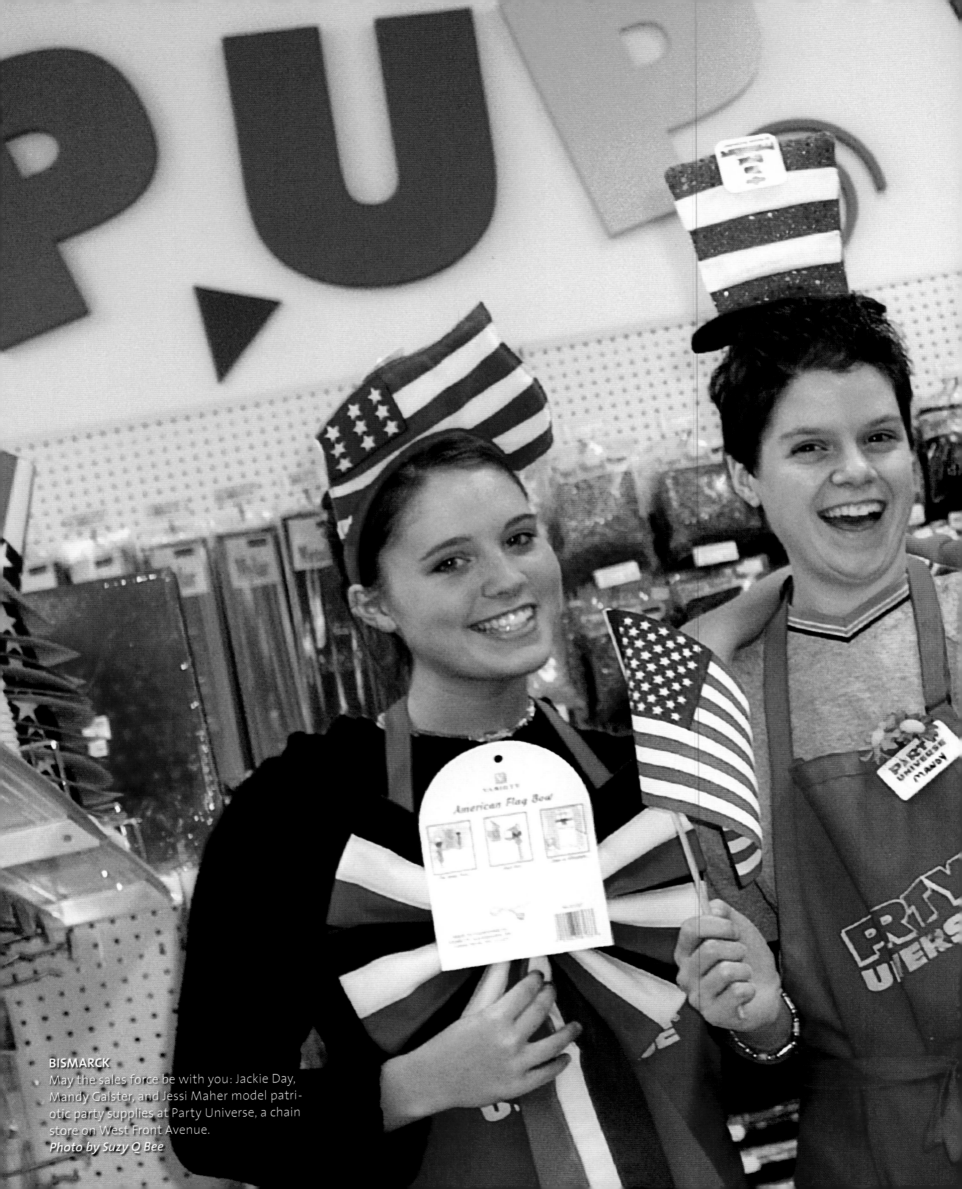

BISMARCK
May the sales force be with you: Jackie Day, Mandy Galster, and Jessi Maher model patriotic party supplies at Party Universe, a chain store on West Front Avenue.
Photo by Suzy Q Bee

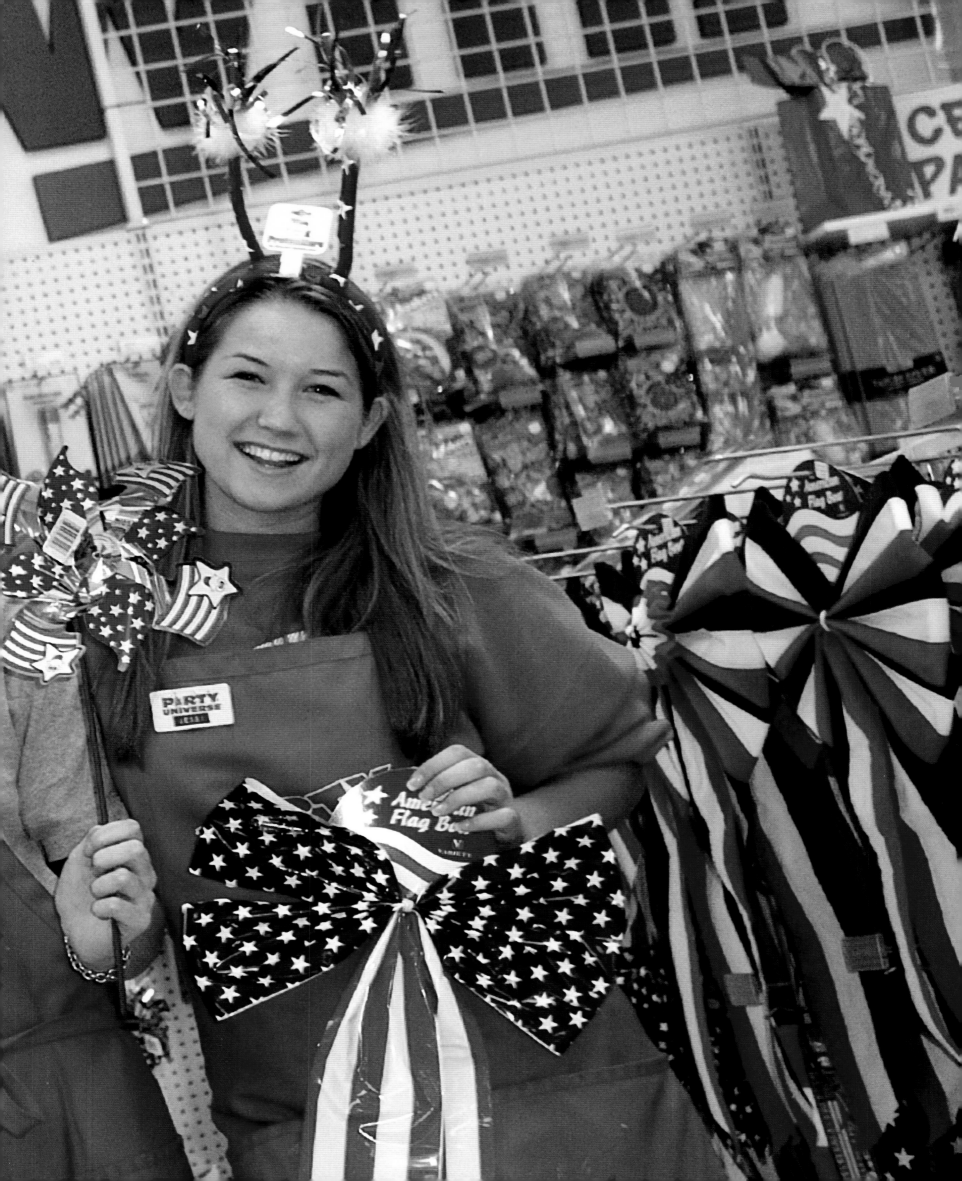

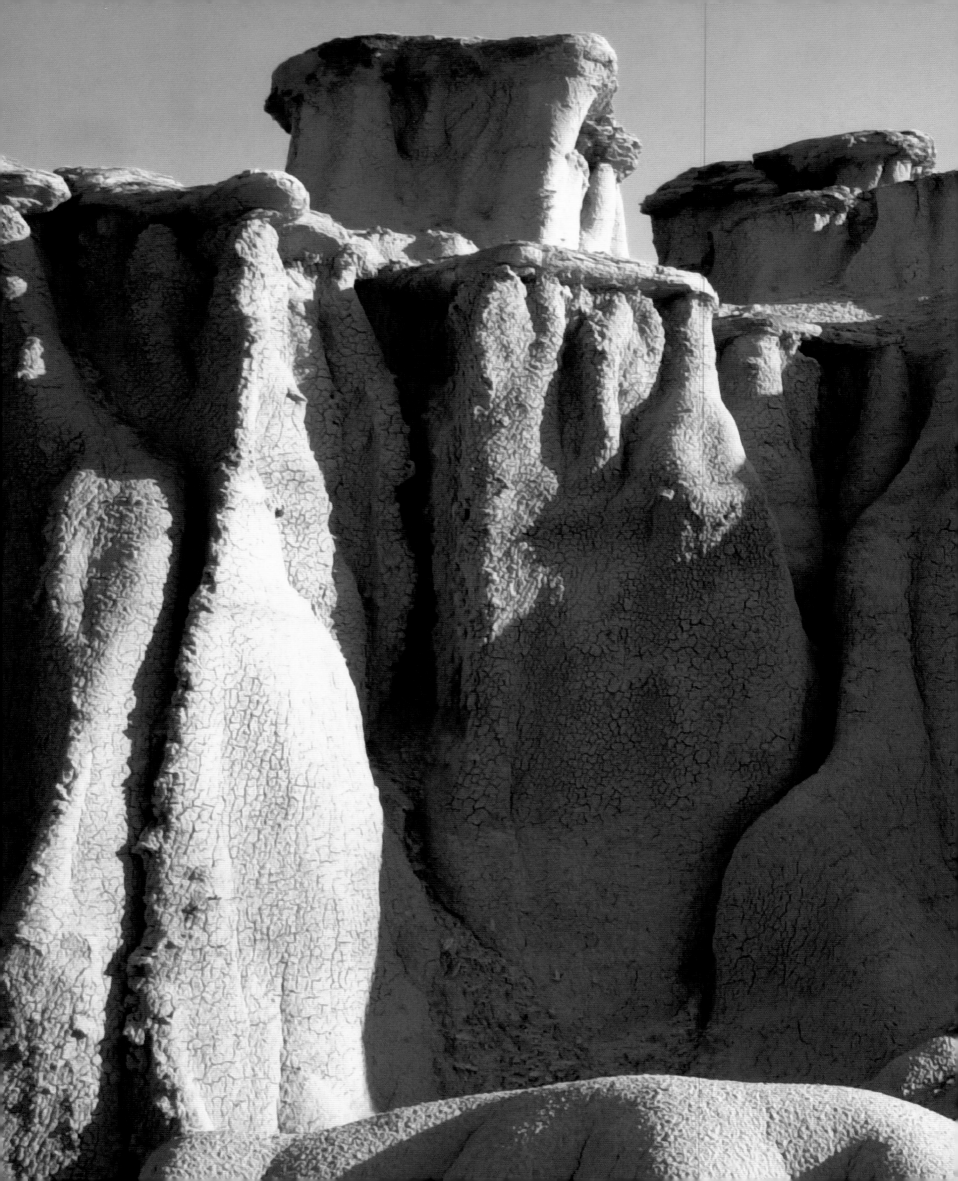

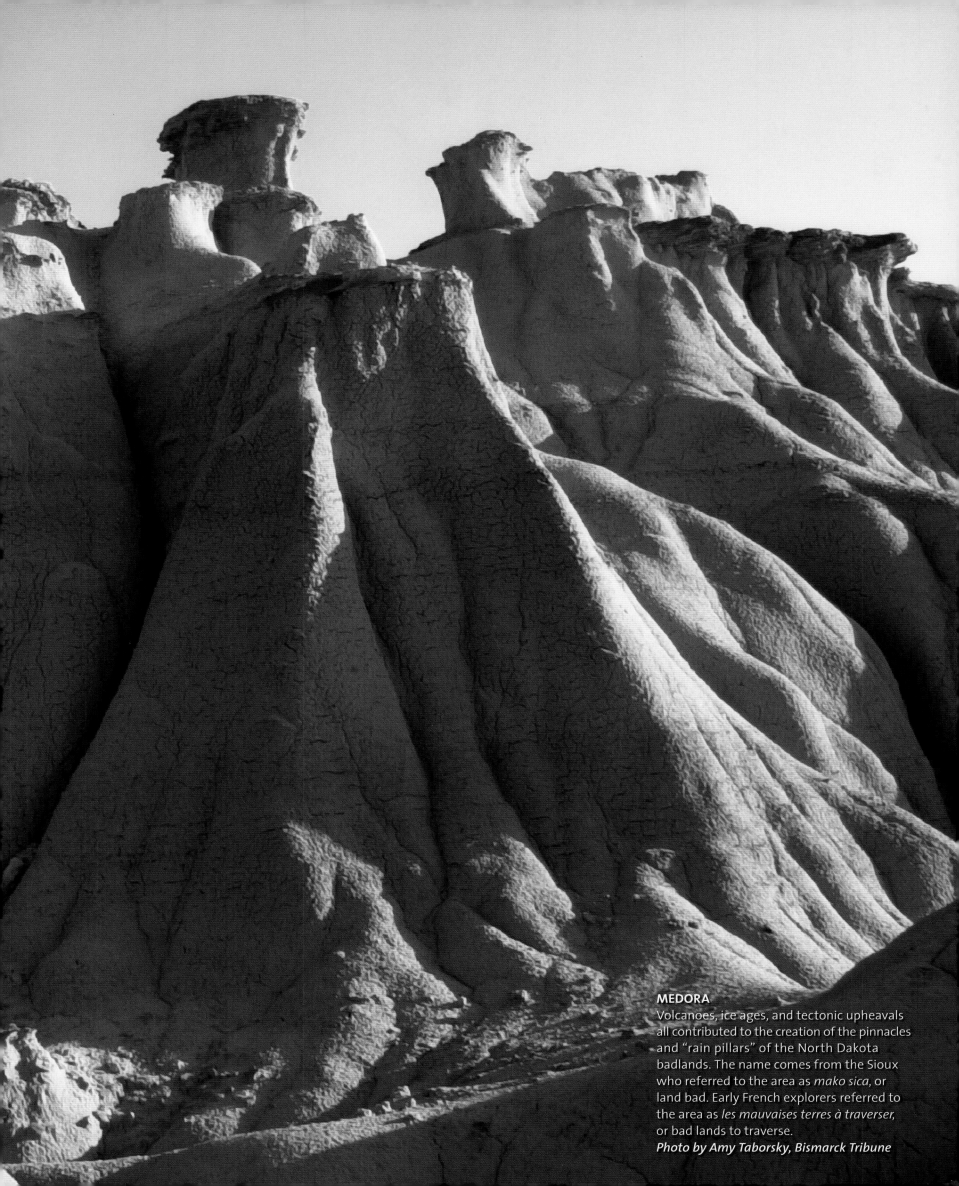

MEDORA

Volcanoes, ice ages, and tectonic upheavals all contributed to the creation of the pinnacles and "rain pillars" of the North Dakota badlands. The name comes from the Sioux who referred to the area as *mako sica*, or land bad. Early French explorers referred to the area as *les mauvaises terres à traverser*, or bad lands to traverse.

Photo by Amy Taborsky, Bismarck Tribune

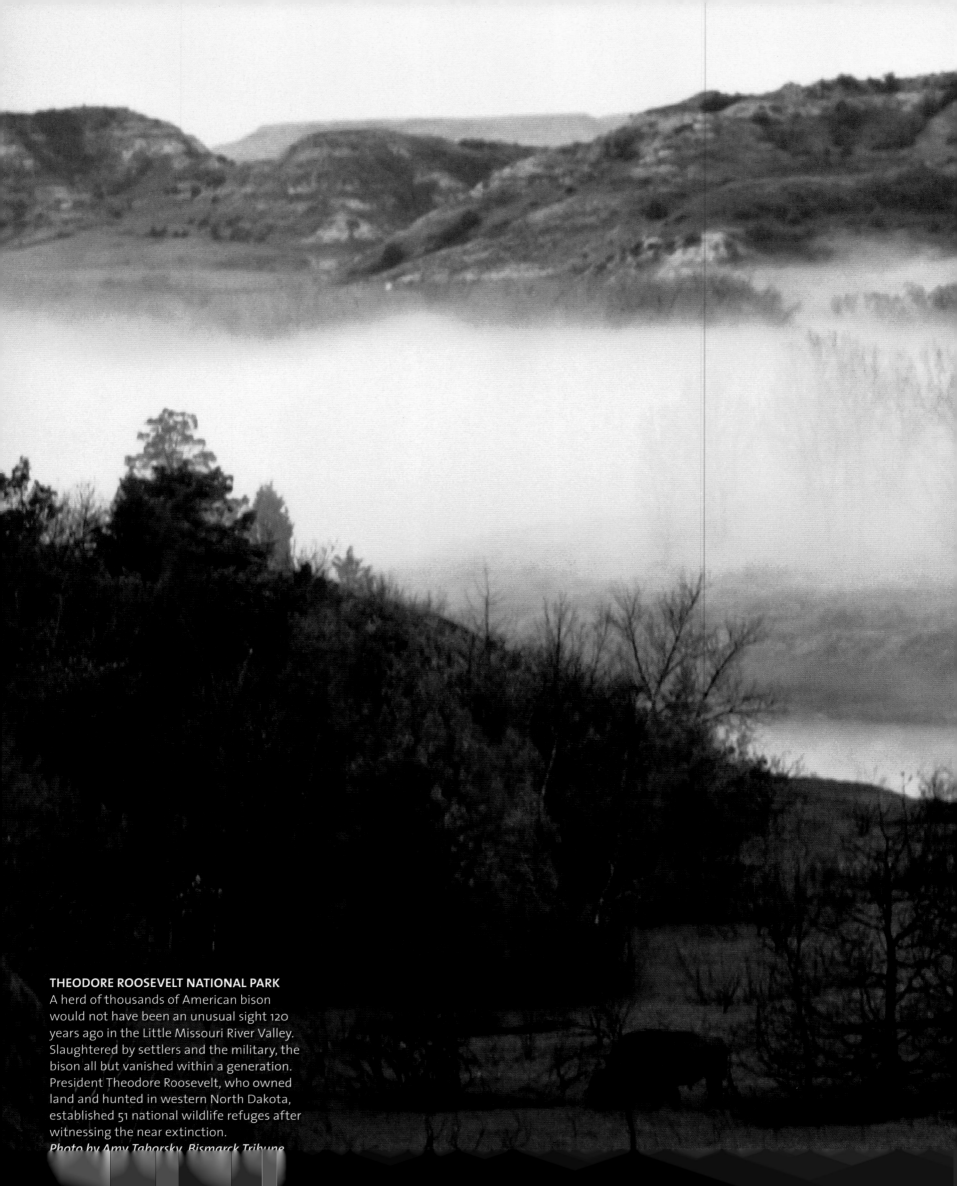

THEODORE ROOSEVELT NATIONAL PARK
A herd of thousands of American bison
would not have been an unusual sight 120
years ago in the Little Missouri River Valley.
Slaughtered by settlers and the military, the
bison all but vanished within a generation.
President Theodore Roosevelt, who owned
land and hunted in western North Dakota,
established 51 national wildlife refuges after
witnessing the near extinction.
Photo by Amy Taborsky, Bismarck Tribune

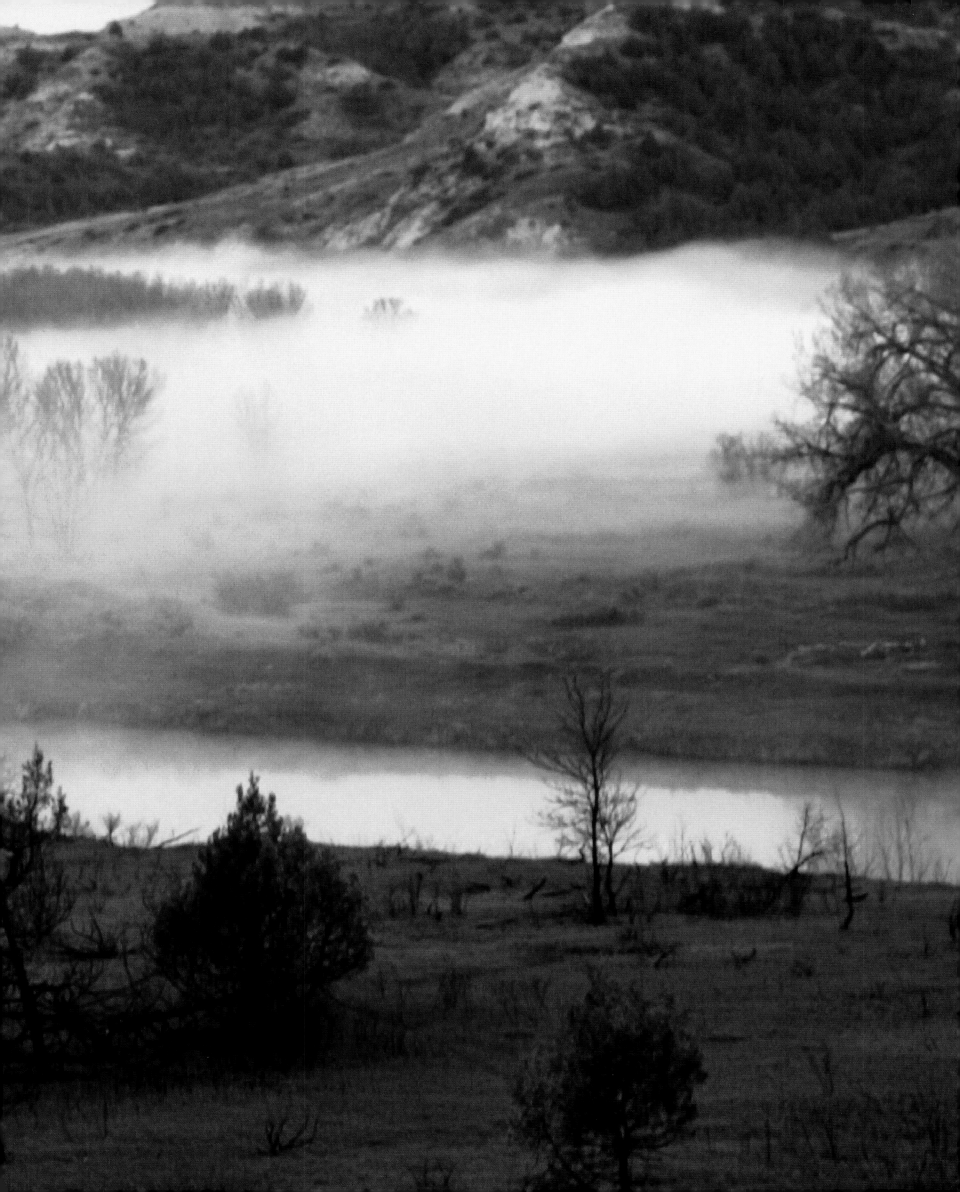

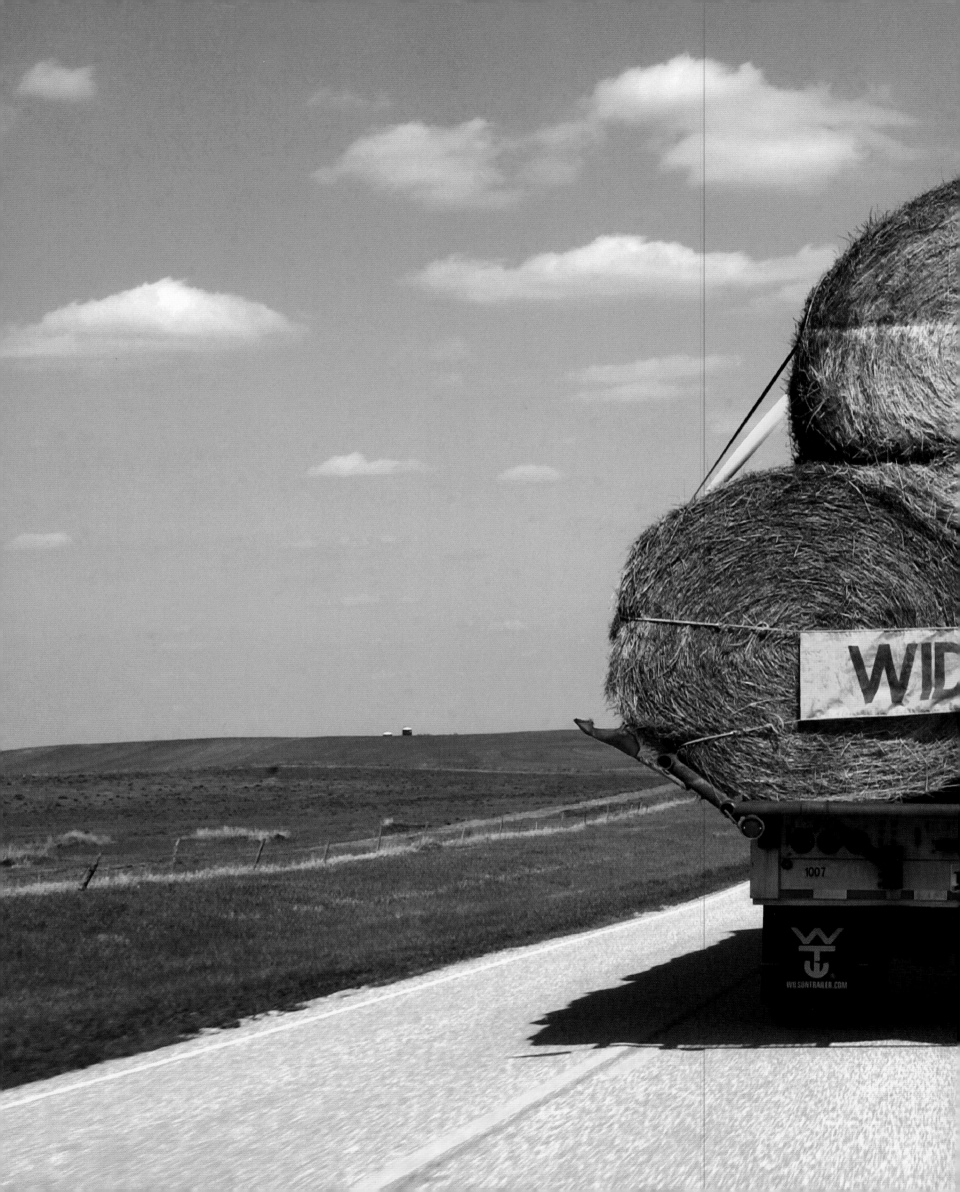

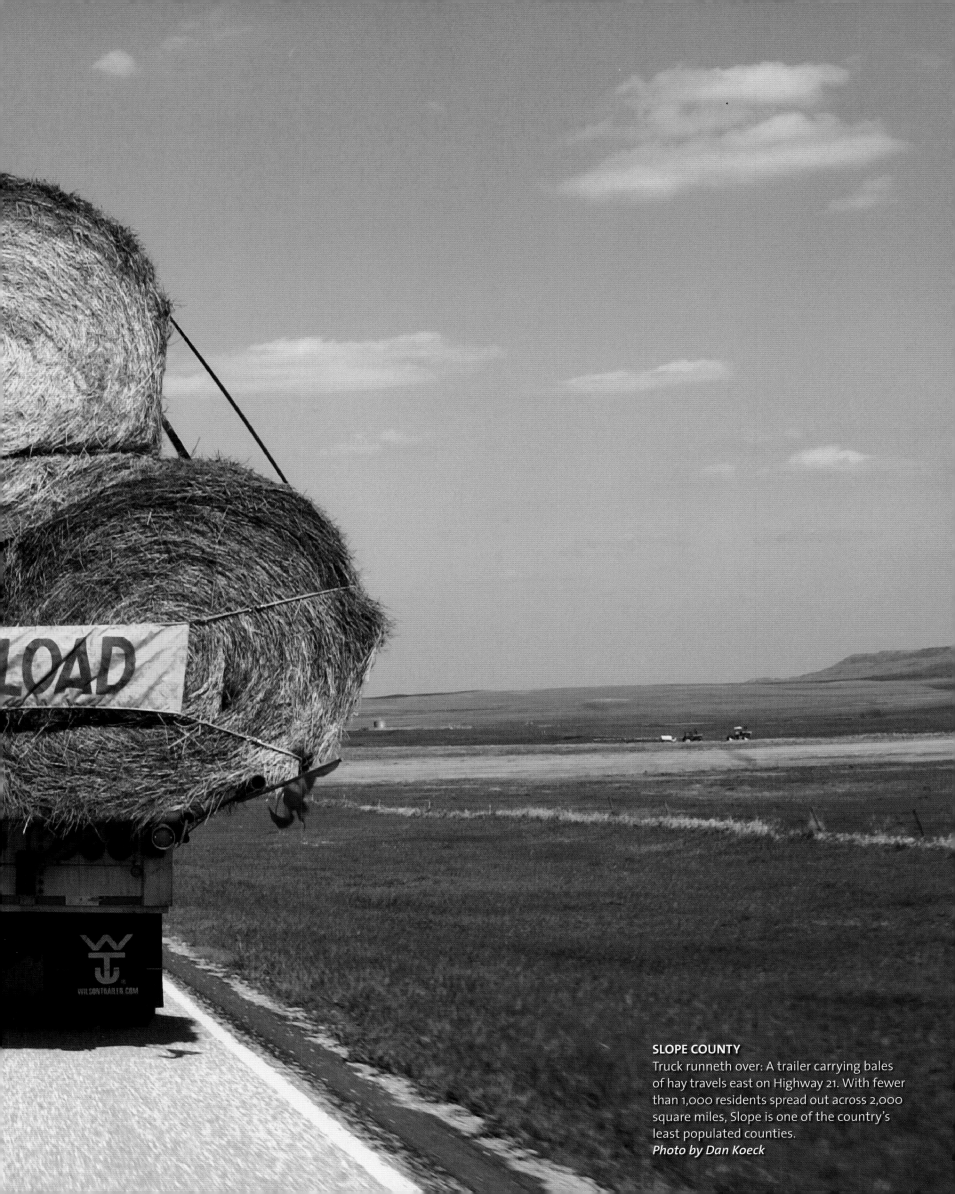

SLOPE COUNTY
Truck runneth over: A trailer carrying bales of hay travels east on Highway 21. With fewer than 1,000 residents spread out across 2,000 square miles, Slope is one of the country's least populated counties.
Photo by Dan Koeck

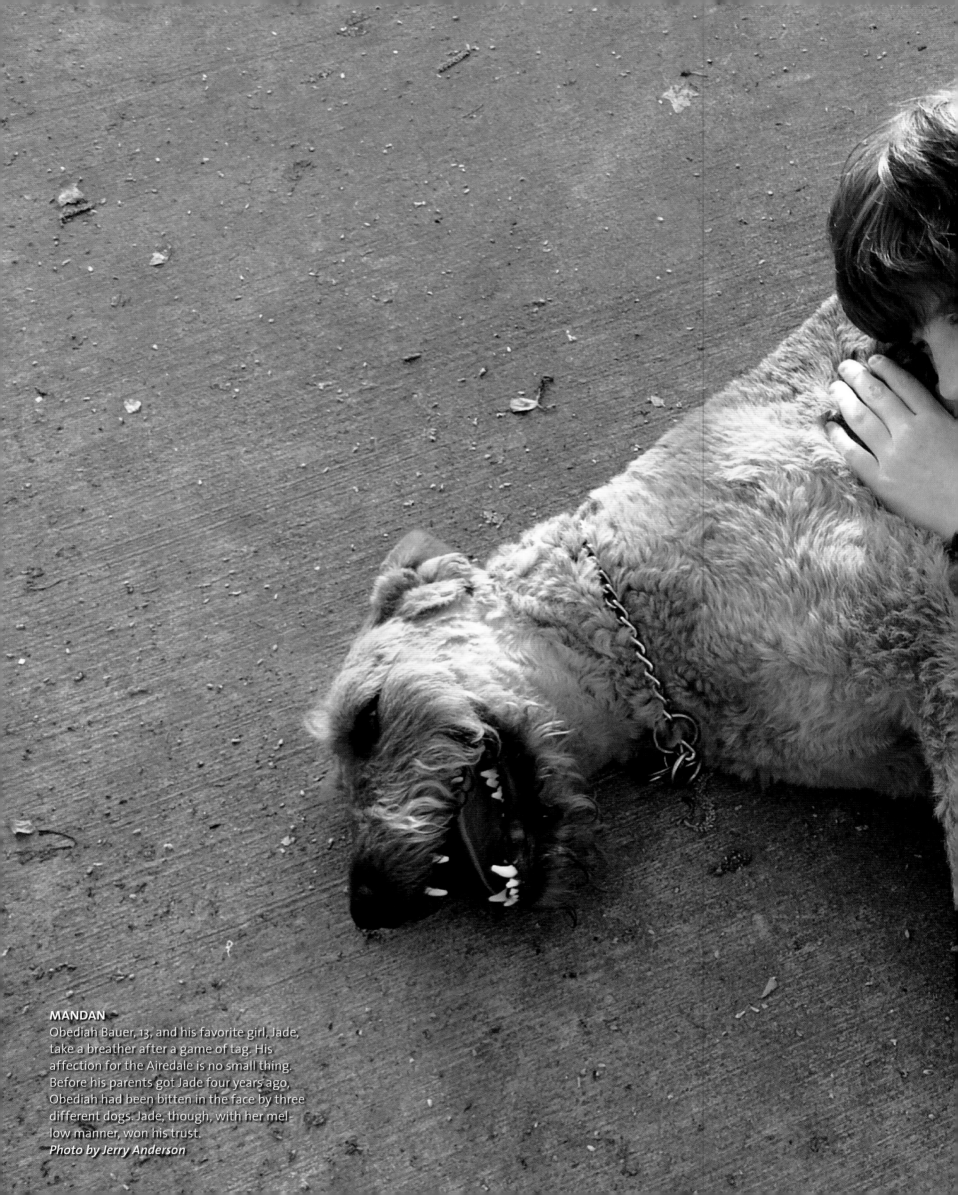

MANDAN
Obediah Bauer, 13, and his favorite girl, Jade, take a breather after a game of tag. His affection for the Airedale is no small thing. Before his parents got Jade four years ago, Obediah had been bitten in the face by three different dogs. Jade, though, with her mellow manner, won his trust.
Photo by Jerry Anderson

FARGO

Mindy Grant de Herrera knows the magic formula. To get her daughters to sit still, she just turns on *Sesame Street*. This gives her enough time to braid 4-year-old Isabetta's hair and to move 2-year-old Miro into the lineup for morning grooming.

Photos by Ludvik Herrera

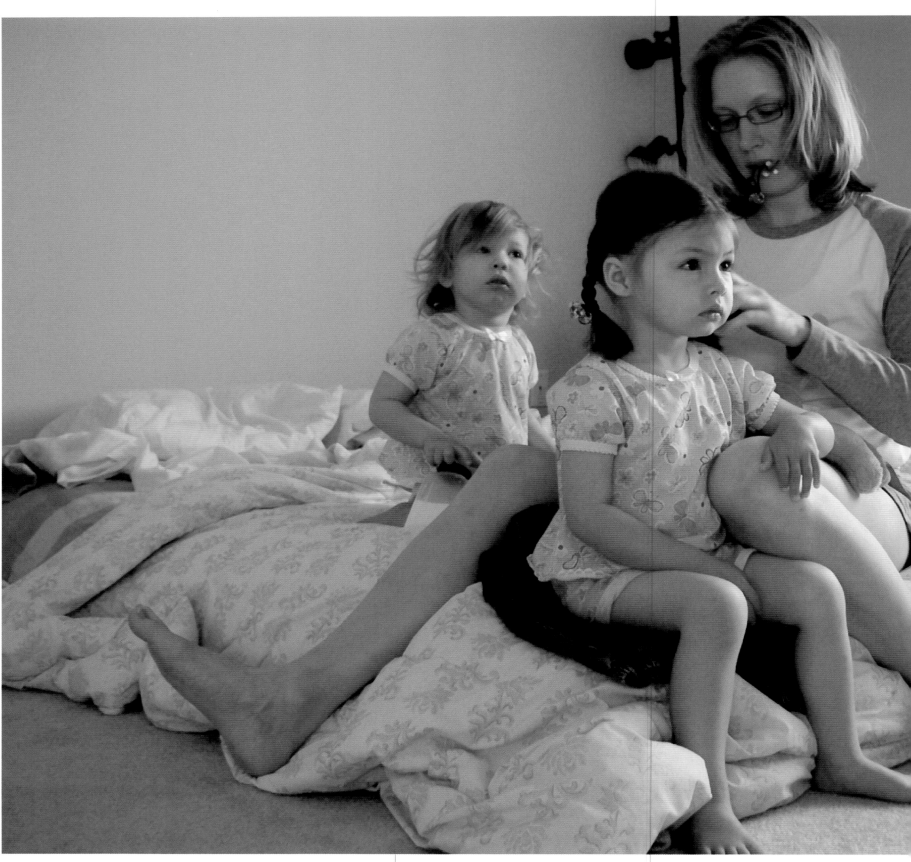

FARGO

One of Isabetta's favorite games is "mud monster," made easier by the softness of the May ground after three days of rain. She entertains herself while her mom plants day lilies along the back edge of their property.

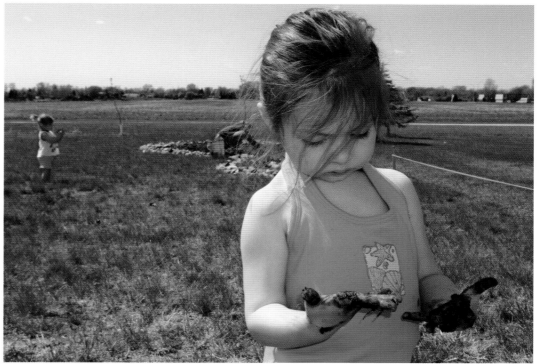

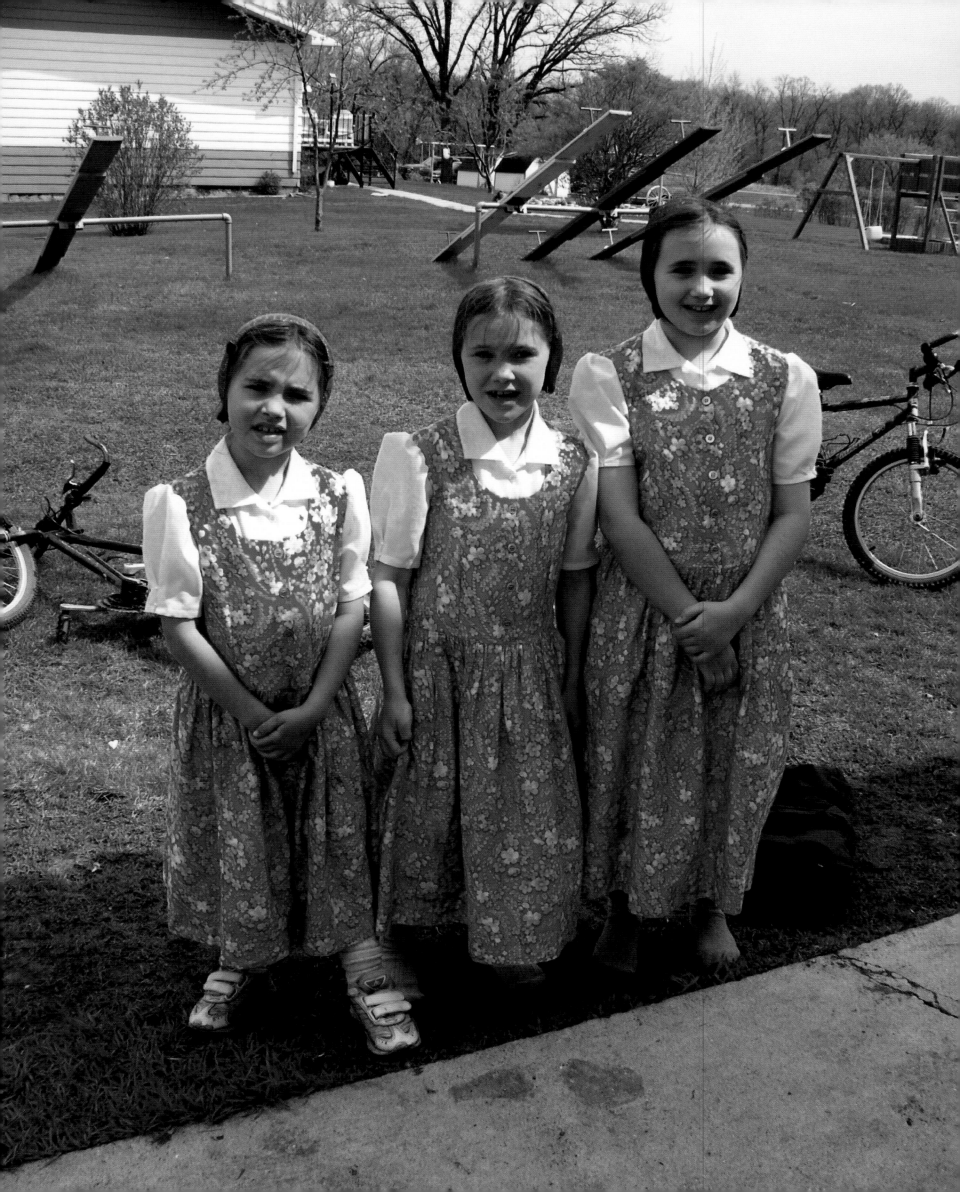

FORDVILLE

Abigail, Maria, and Lois Waldner's dresses were made by their mother. The family is part of the Forest River Community in northeastern North Dakota, which was established in 1949. The Hutterite families live communally like the Amish but use modern conveniences.

Photo by Jackie Lorentz

AMIDON

Big-city girls Hannah Hanson of Bismarck and Jesse Burgum of Fargo spend a weekend each summer at Logging Camp Ranch, where they get a taste of the Old West. The working guest ranch offers horseback riding and bison hunting.

Photo by Jason Lindsey,
JasonLindsey.com

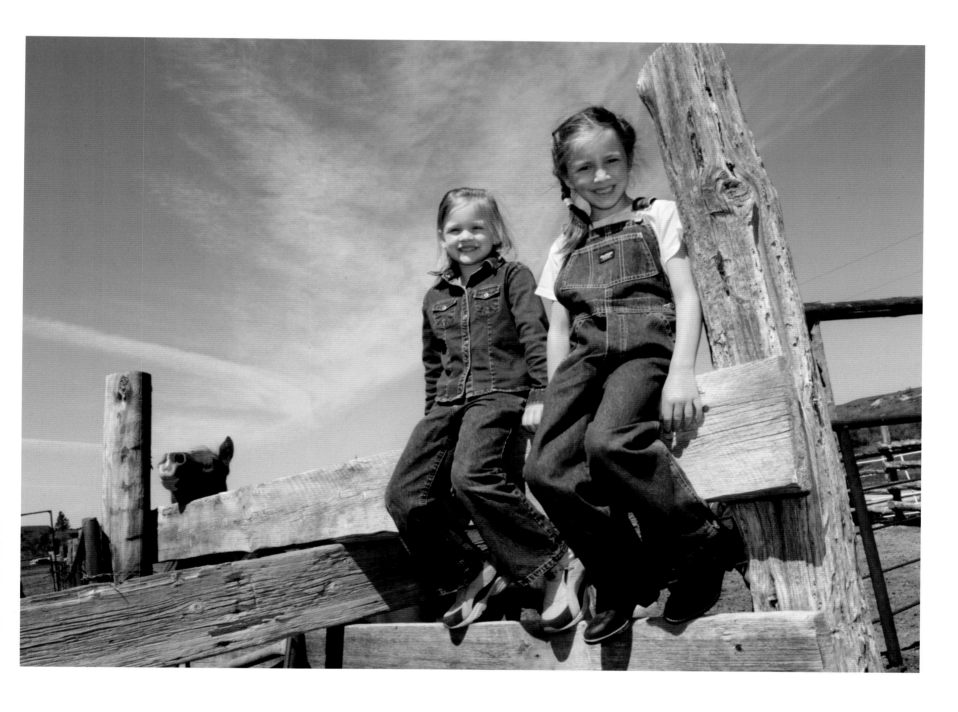

MANDAN
At bedtime, Chandra Beehler flips on her book light to read Helen Keller's autobiography. She picked up the little-light habit from mom Susan, who credits all the book reading to the long winters and solitude of North Dakota.
Photos by Suzy Q Bee

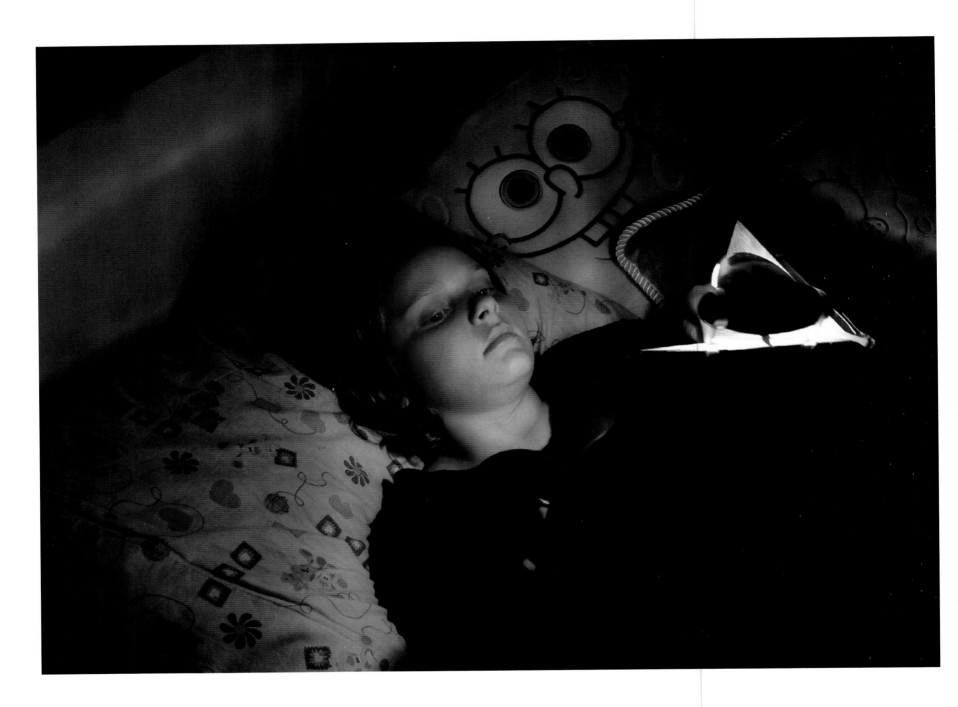

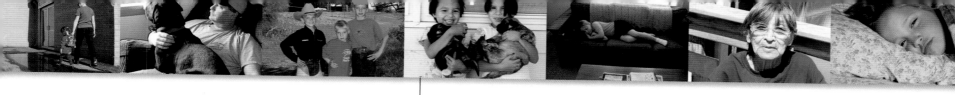

STANDING ROCK INDIAN RESERVATION
Cheydene and Cheylynn Lester cuddle puppies at their home on the reservation. The sweet smiles belie what life is like for most of the 8,000 residents—unemployment is 70 percent and per capita income is $3,400.

GRAND FORKS
The doctor recommended three eggs for John and Stacy Friend's in vitro fertilization process. The couple wanted a child in the worst way, so they asked for four eggs to increase their chances. Boy, did it ever. In May of 1998, Bailey, Brady, Courtney, and Nicholas made their grand entrance. And how is life with quadruplets? "Busy," says John.
Photo by Jackie Lorentz

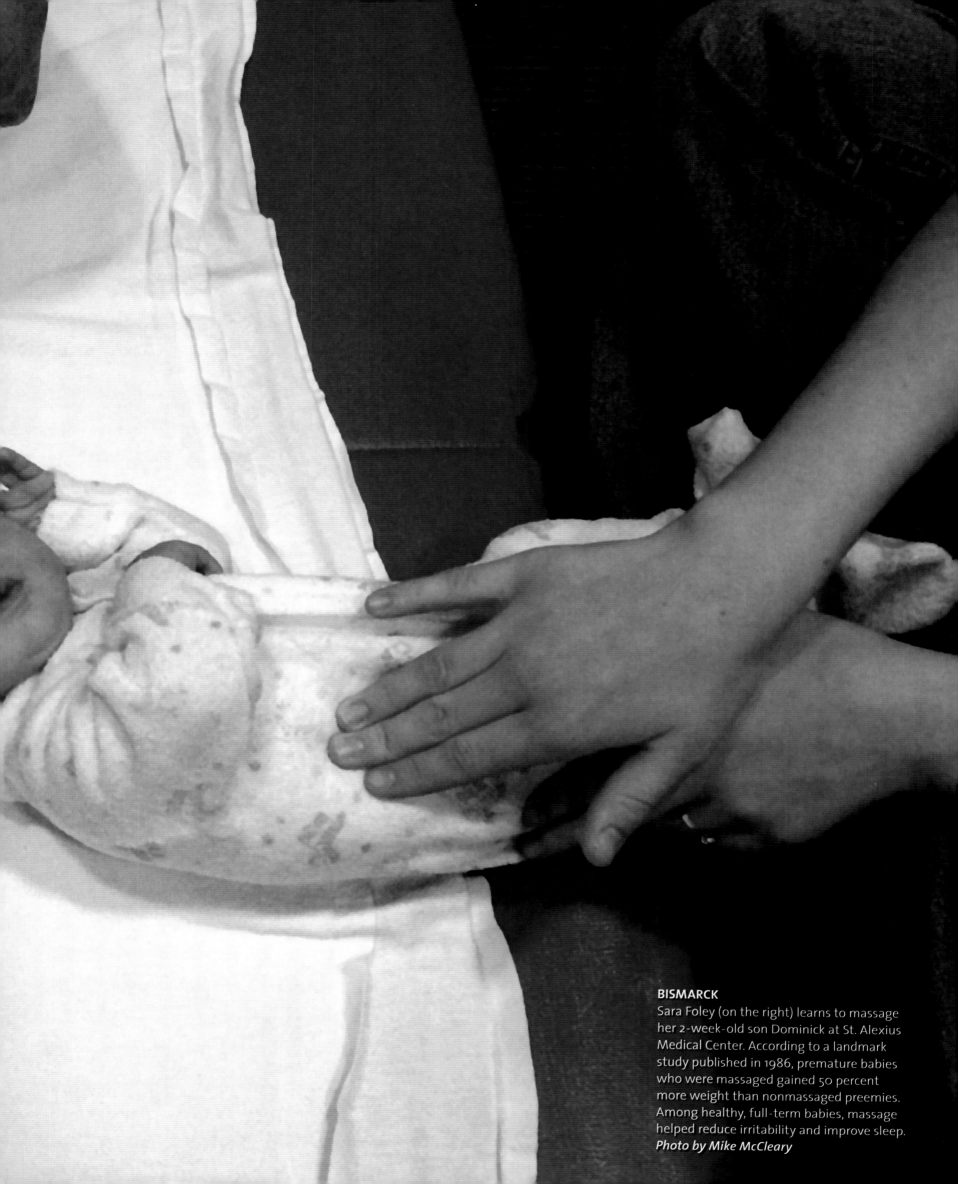

BISMARCK
Sara Foley (on the right) learns to massage her 2-week-old son Dominick at St. Alexius Medical Center. According to a landmark study published in 1986, premature babies who were massaged gained 50 percent more weight than nonmassaged preemies. Among healthy, full-term babies, massage helped reduce irritability and improve sleep.
Photo by Mike McCleary

FOUR BEARS VILLAGE

Lydia Sage-Chase holds a portrait of her Mandan ancestors, Mattie Grinnell, Katy Nagel, Moves Slowly, Scattered Corn, and Alice Bluestone. Her great-grandmother was the first female Corn Priest of the tribe, and now the role has passed down to Sage-Chase, who blesses seeds, asking the gods to protect her people's crops from frost and flood.

Photos by Jason Lindsey, JasonLindsey.com

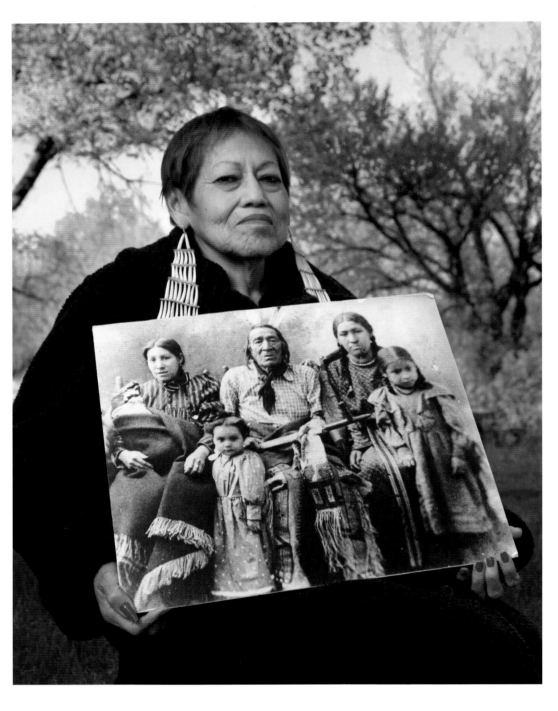

Take good care of the land, your family and your life.

FORT BERTHOLD INDIAN RESERVATION

Amy Mossett, a Mandan Indian and director of tourism for the Three Affiliated Tribes at the Fort Berthold Indian Reservation feels a deep connection to Indian guide Sacagawea. In 1804 when Lewis and Clark wintered in North Dakota on their way west, they met Sacagawea, who was living with Mossett's ancestors. It was there that she joined the celebrated expedition.

GRASSY BUTTE

The wound on Jim Johnston's finger is nothing compared to what might have happened had he overstayed his welcome as a professional rodeo cowboy. "There aren't too many people over 42 doing it," says the 69-year-old cattle rancher. "I retired before I got hurt."
Photos by Dan Koeck

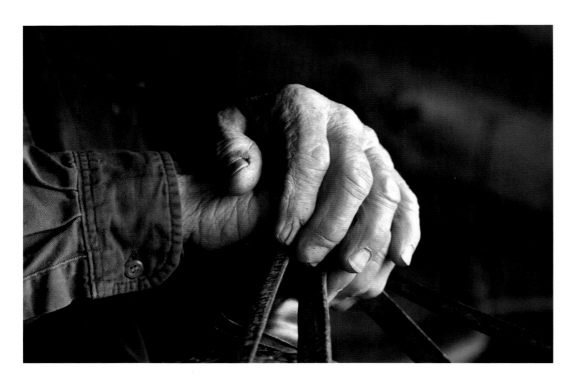

GRASSY BUTTE

Johnston was once one of the country's best rodeo cowboys. And the saddle behind him attests to it. His children had it stamped with the emblems of the 16 national and state championships he won during his 18-year career as a bull and bareback rider and team roper.

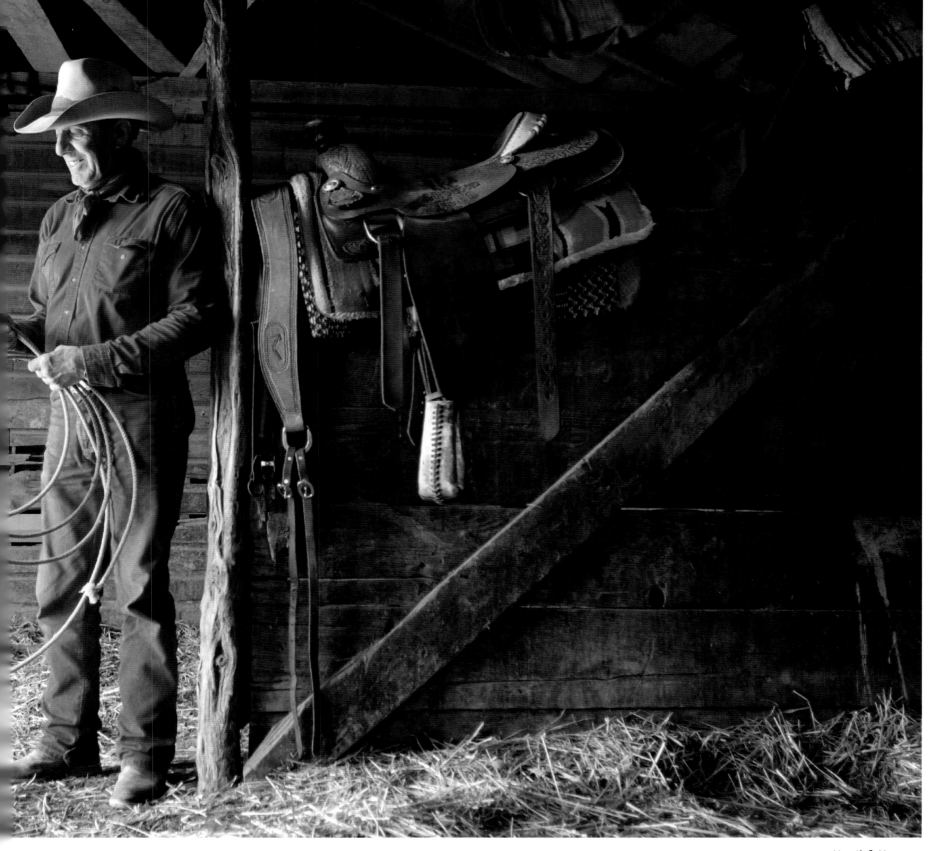

GRAND FORKS

On the grounds of the historic Myra Museum, 90-year-old Martha Hoghaug tiptoes to the tulips. It's Syttende Mai, or May 17, Norway's Constitution Day, so Hoghaug wears her grandmother's handmade, 111-year-old *bunad*, the traditional Norwegian woman's outfit reserved for special occasions.

Photo by Eric Hylden, Grand Forks Herald

FARGO

Helen Johnson, 89, clasps her hands in delight after sneaking a taste of *lefse*. To honor Fargo's Norwegian heritage (one-third of the area's residents are from Norway), the Bethany Homes retirement community prepares *lefse*, luteisk, and *rommegrot* for Syttende Mai.

Photo by Sandee Gerbers

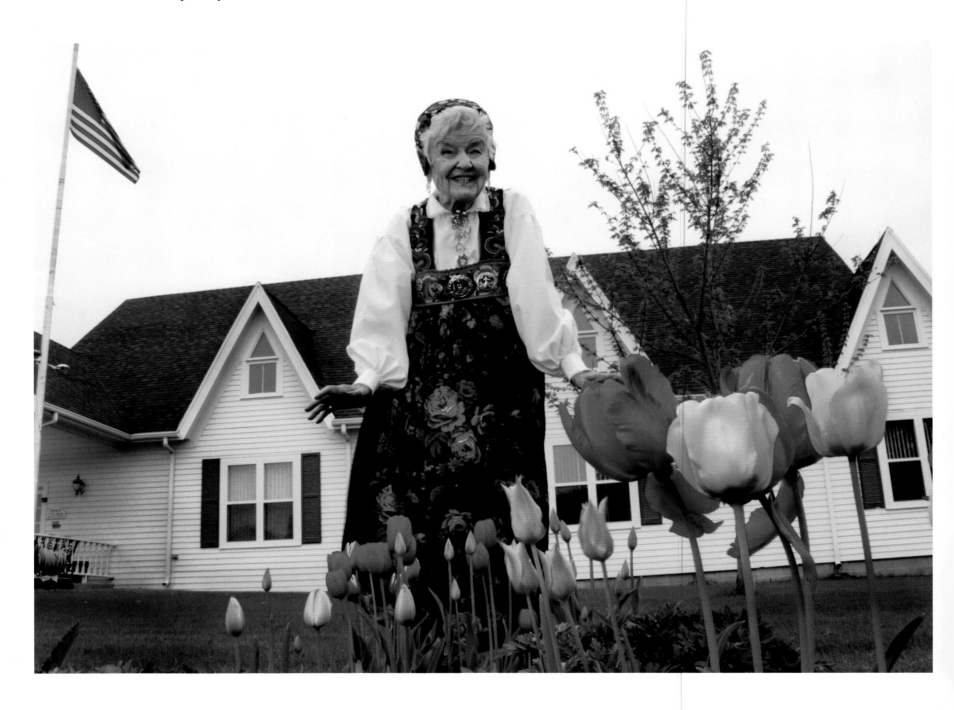

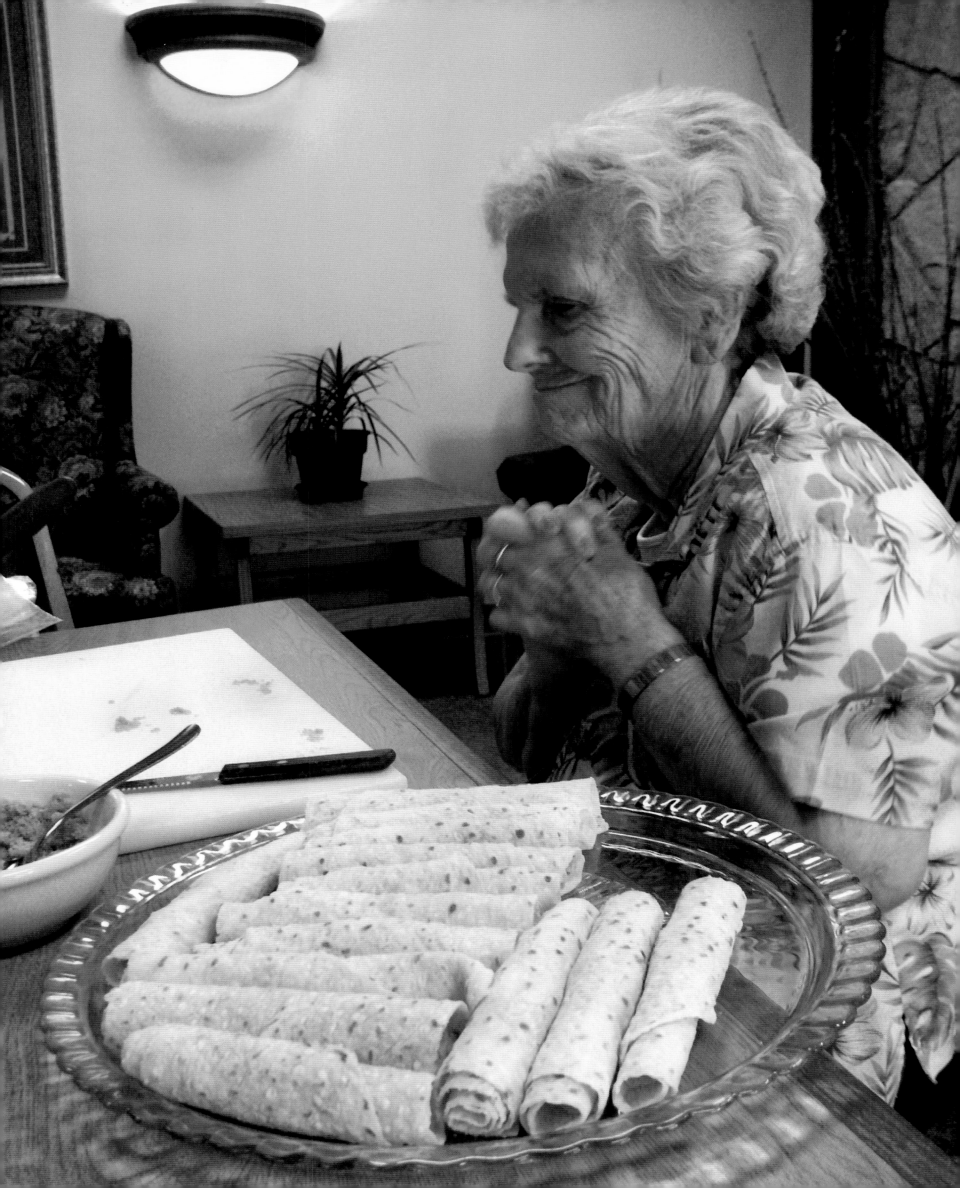

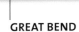

GREAT BEND

After 30 years in suburban Southern California, Minnesota farm girl Denise Eastin stepped onto the 32-acre farm she and her husband John found for sale on the Internet and knew this was where they would retire. "I smelled that mix of hay and manure and fresh air, and I knew I was home," she says.
Photo by Dave Arntson

MARMARTH

When she's not raising goats or adopting burros from the Bureau of Land Management, Patti Perry runs the city of Marmarth (pop. 135). She serves on the city council and is Slope County's economic development director. She's also the Marmarth police commissioner—even though the nearest police officer works for the town of Bowman, 28 miles away.

Photo by Dan Koeck

GREAT BEND

With a tool in hand, Aaron Deike awaits instructions to help repair the wheel bearings on his father Harlan's all-terrain vehicle. Harlan, a third-generation farmer, raises cattle, wheat, and soybeans on his 1,500-acre ranch in the Red River Valley.

Photo by Dave Arntson

MARMARTH

Animals are Josie Mastel's life. She rode her horse Blaze to capture Montana's 2003 Fallon County Princess crown. She has also raised and sold steers, rabbits, pigs, and lambs in 4-H county events. "The money goes for feed and her college fund," says her mom Hope. "And for some fun."
Photo by Dan Koeck

BISMARCK

Rain or snow, sleet or hail, Bruce Furness fills his bird feeder without fail. At 98, the former mailman has been retired for as many years as he worked. A Mandan native who moved to Bismarck in 1934, Furness is the oldest surviving member of his family. His son is the mayor of Fargo and his large extended family is spread throughout America.
Photo by Tom Stromme

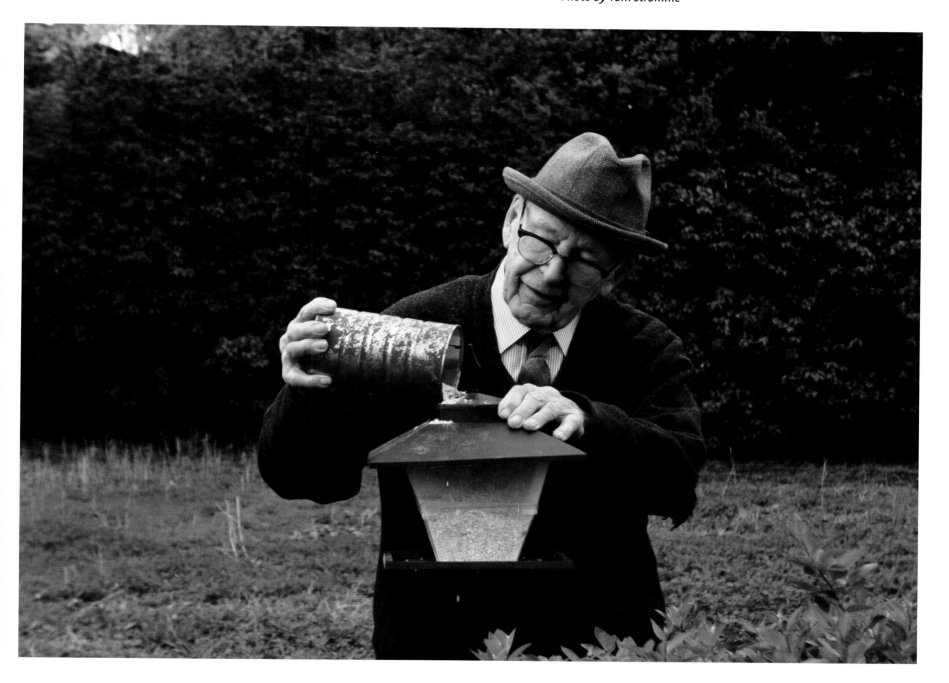

MANDAN
The town of Mandan is famous for its crab apple trees, which rain pink petals all over town every spring.
Photo by Suzy Q Bee

BISMARCK

Richard and Judy Weinberger began decorating their house with American flags and yellow ribbons immediately following 9/11. By the time they were done, they had about 100 flags on their North 16th Street home. Other displays of Old Glory from that time have been put away, but the Weinbergers intend to keep theirs. "We will not forget what happened," says Richard.

Photo by Darren Gibbins

FARGO

Nothing says spring like freshly cut grass. And there's plenty of it along this stretch of 7th Street North in Fargo.

Photo by Ed Vizenor, Wisdom Productions

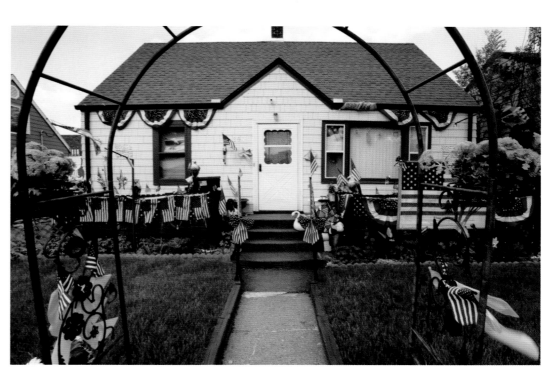

The year 2003 marked a turning point in the history of photography: It was the first year that digital cameras outsold film cameras. To celebrate this unprecedented sea change, the *America 24/7* project invited amateur photographers—along with students and professionals—to shoot and, via the Internet, submit digital images. Think of it as audience participation. Their visions of community are interspersed with the professional frames throughout this book. On the following four pages, however, we present a gallery produced exclusively by amateur photographers.

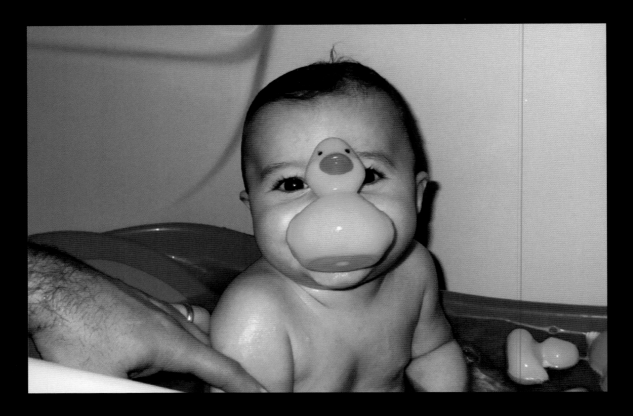

FARGO Eleven-month-old Mason Wheelock bites into his favorite bath toy and quacks his parents up.
Photo by Tammy Wheelock

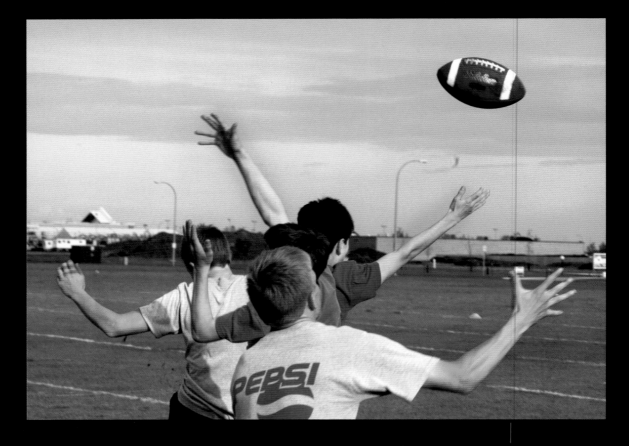

WEST FARGO Rob Gibson, Tanner Farkas, Chris Urlaub, and Dustin Pfeifel come up empty-handed during a Football Passing League practice at West Fargo High School. ***Photo by Anna Frissell***

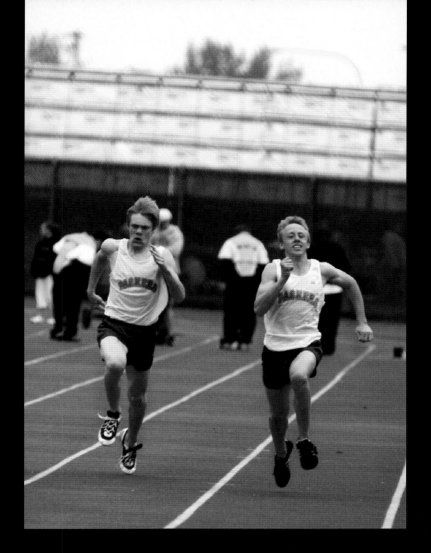

GRAND FORKS Josh Jones and Rob Gibson compete in the 100-meter dash at the Eastern Dakota Conference Track Meet at the University of North Dakota's Memorial Stadium. *Photo by Anna Frissell*

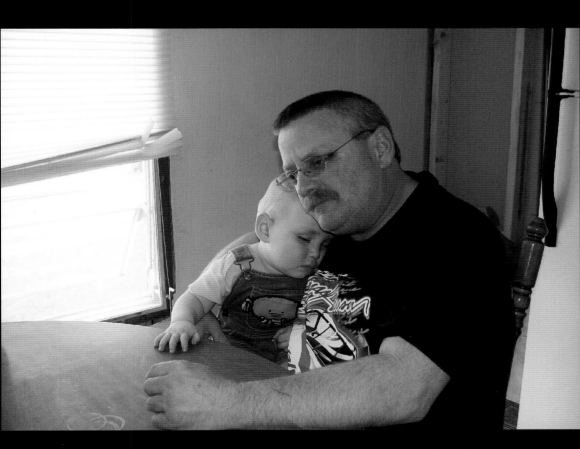

BISMARCK Ryan Zacher isn't the only one tuckered out after a full day in the sun. Grandpa Jeff Ehli is ready to nod off himself. *Photo by Meredith Ehli*

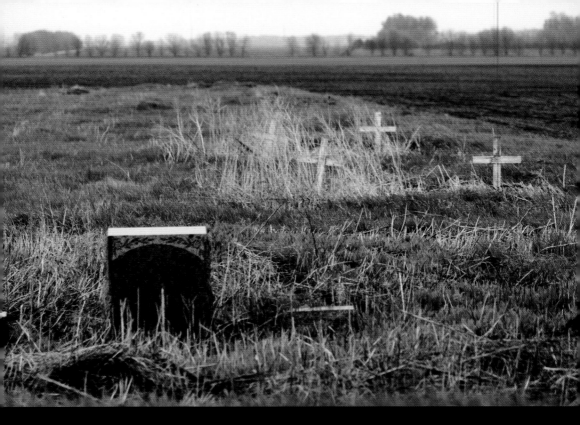

CASS COUNTY On Highway 81 north of Fargo, an old roadside cemetery stakes its claims to the earth.
Photo by Anna Frissell

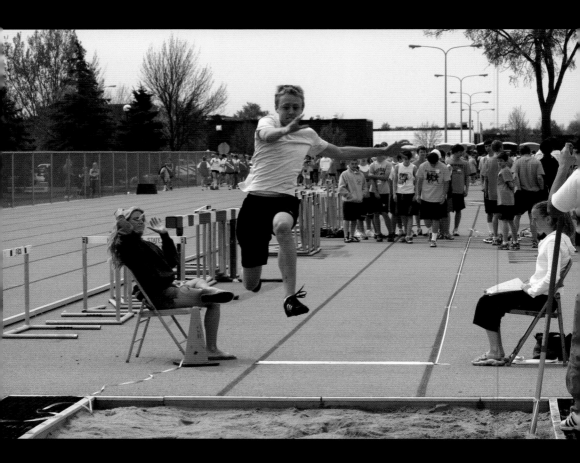

FARGO Airborne long jumper Rob Gibson comes in for a landing during the All-City Track Meet for junior high

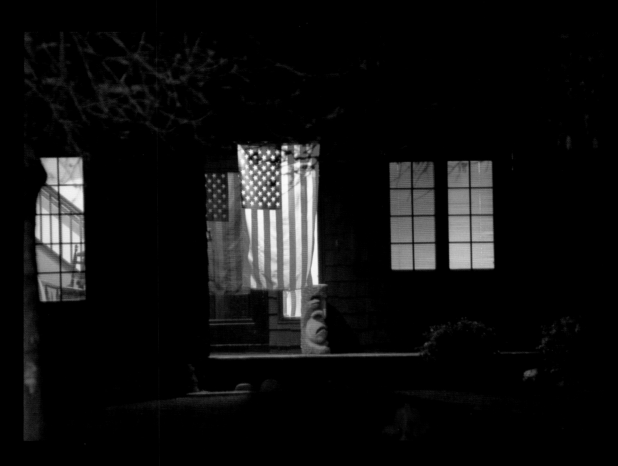

WEST FARGO A home on Cottonwood Court just before the family turns in for the evening.
Photo by Anna Frissell

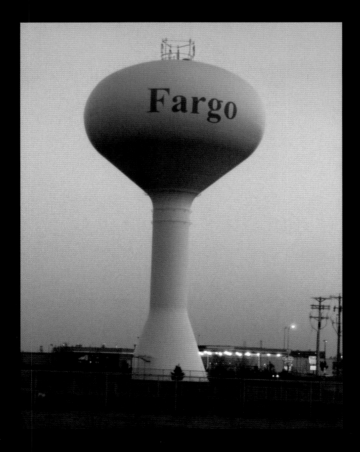

FARGO Of Fargo's nine water towers, this onion dome serving the West Acres shopping center is the only one bearing the city's name. *Photo by Mason Mannie*

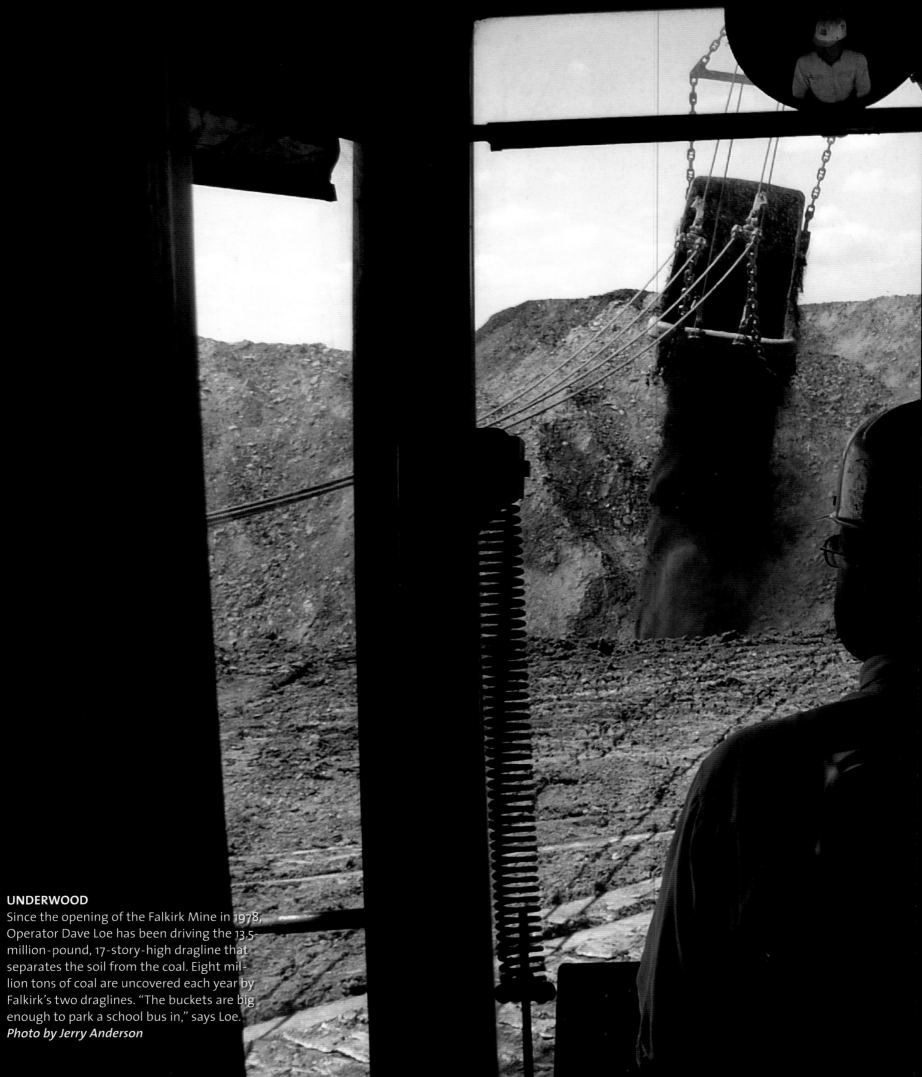

UNDERWOOD
Since the opening of the Falkirk Mine in 1978, Operator Dave Loe has been driving the 13.5-million-pound, 17-story-high dragline that separates the soil from the coal. Eight million tons of coal are uncovered each year by Falkirk's two draglines. "The buckets are big enough to park a school bus in," says Loe.
Photo by Jerry Anderson

Hard At Work

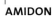

AMIDON
Cowboys Dorm Henders and Gordon Gerbig survey the cattle rounded up for branding at the Logging Camp Ranch. The 100-year-old ranch accepts guests, many of whom ride and hunt on the remote, 12,000-acre stretch of badlands.
Photos by Jason Lindsey, JasonLindsey.com

AMIDON

Ted Hanson, whose father Robert owns Logging Camp Ranch, trains Boone Bars Bear, a 9-month-old quarter horse. Hanson lives in Bismarck but returns to Amidon every May to help with branding and other ranch tasks.

AMIDON

John Hanson repairs a barbed wire fence on his father's ranch, where he lives during the week. His wife and children, 40 miles away in Bowman (the nearest town with a school), join him on the weekends.

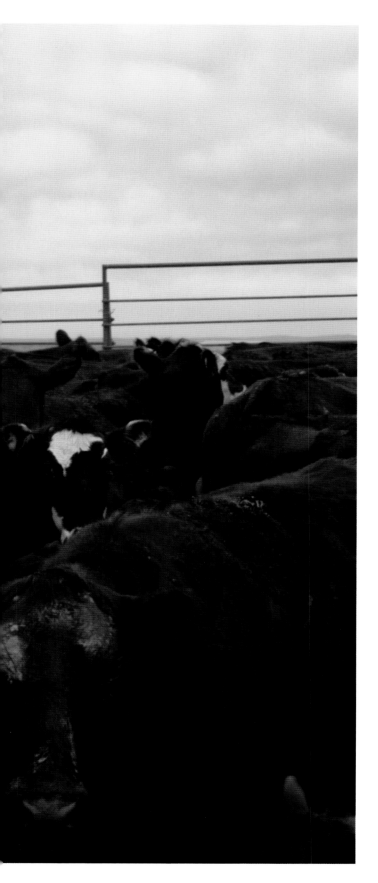

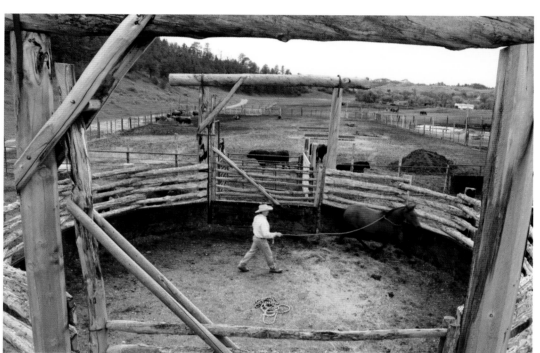

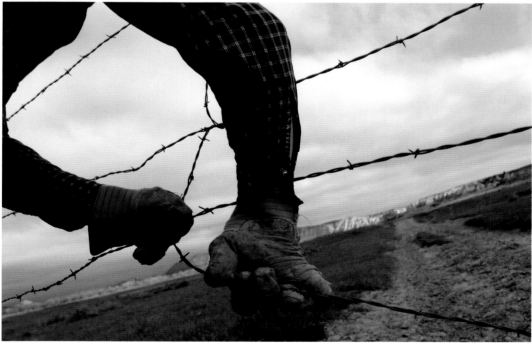

AMIDON

Dorm Henders and Doug Burgum rope calves for branding and vaccinations. Logging Camp Ranch neighbors come from as far as 30 miles away to help the Hanson family with this annual undertaking.

Photos by Jason Lindsey, JasonLindsey.com

AMIDON

The 7-S brand gets imprinted into a calf's hindquarters. The ranch's brand refers to its seven tenets: shared values, strategy, staff, structure, skills, style, and systems.

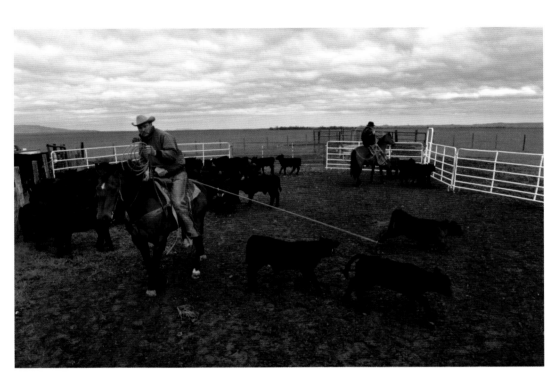

AMIDON
Miles Gerbig and Matt Burke hold a calf still as John Hanson brands it. Logging Camp Ranch cowboys can brand 100 head of cattle in half a day.

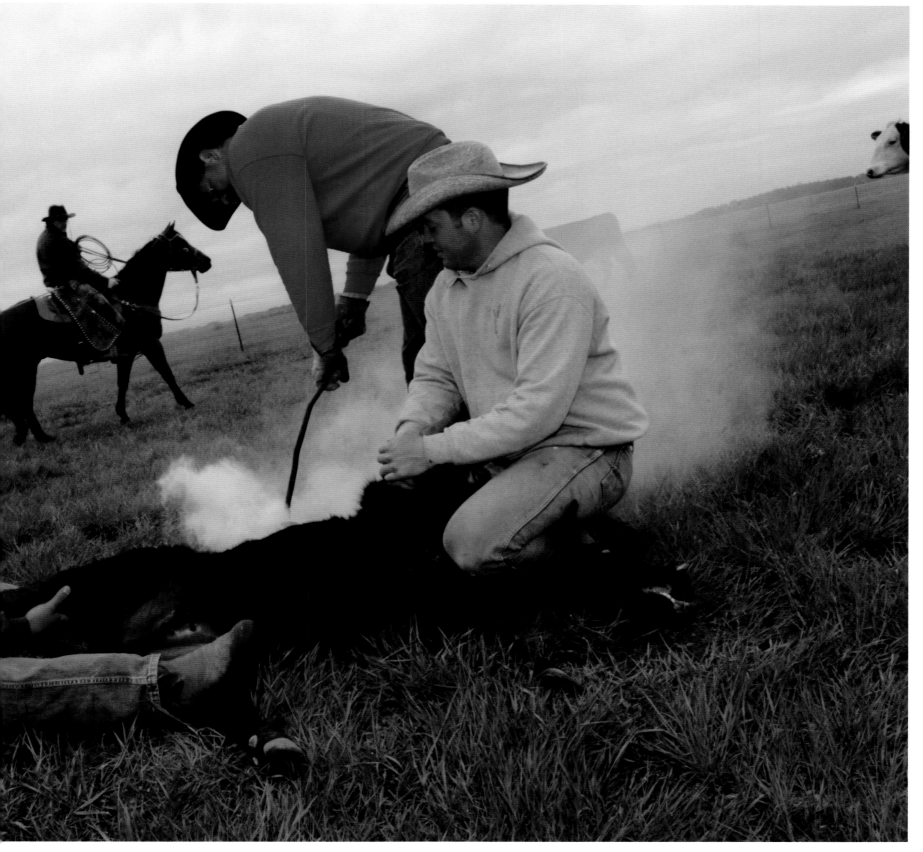

MANDAN

The Kist Livestock Auction opened in 1956 and is now run by the second and third generations of the Kist family. The big day here is Wednesday, when beef cattle are sold. In 2003, the auction house moved 130,000 beef cattle, most of them destined for feedlots. On the last Saturday of every month, Kist sells dairy cattle and horses.
Photos by Mike McCleary

MANDAN

The cattle inside this hauling trailer, especially those on the upper level, are not too keen on leaving their mobile home. To move them down the ramp and into the auction holding pens, the driver tries to spook them. If that doesn't work, he'll use the paddle.

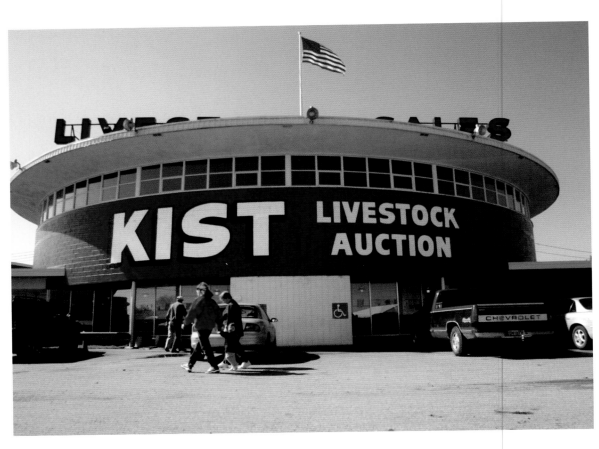

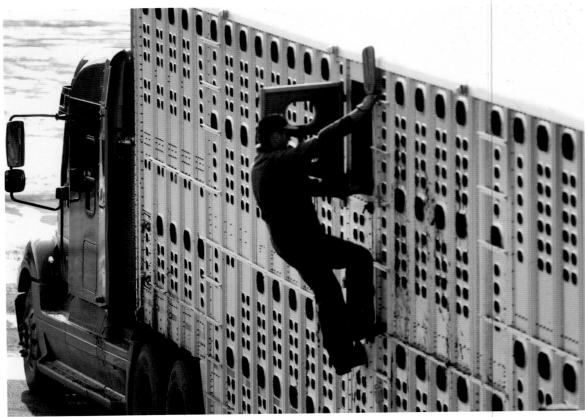

MANDAN

Donna Aggieri and Pat Nickel, penners at the Kist Livestock Auction, watch while a bull is sold. Once the sale is final, they will open the swing gate and move the bull to an outdoor pen. The two are among 50 workers on hand on sale day. The advice above their heads is offered by company owner Fred Kist.

MANDAN

The ring handler discusses the merits of a Holstein with potential buyers. At auctions, some cows are sold individually; others are sold in "load lots" totaling 50,000 pounds—the weight typically carried by one semitrailer. Ranchers' brands have been burned into the wooden auctioneer booth.

FARGO

This Wurlitzer organ was an integral part of the Fargo Theatre's early years, providing sound effects for silent films and accompanying musical revues. Talking pictures forced it into retirement in 1948. Then local restorer Lance Johnson (at the boards) brought it back to life in 1974. He performs regularly on his labor of love.

Photo by Meg Luther Lindholm

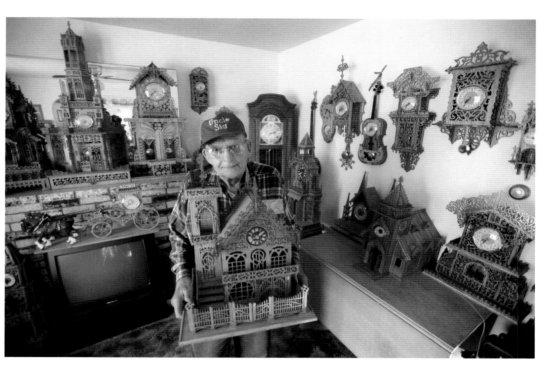

GRAFTON

When he's not hosting his old-time music show on KXPO or giving tours of Jugville, USA, a miniature town he built, Sig Jagielski, 93, keeps busy assembling clocks. To date, he's constructed 75 of these elaborate timepieces, many of which he donates to community raffles.

Photo by Chuck Kimmerle

LINTON

"I've saved a lot of soles over the years," quips 90-year-old Joe Martin. A third-generation shoe repairman, Martin sold the Main Street shop to his son several years ago and now whiles away the day visiting with old friends who stop by to chat.

Photo by C.J. Kurszewski

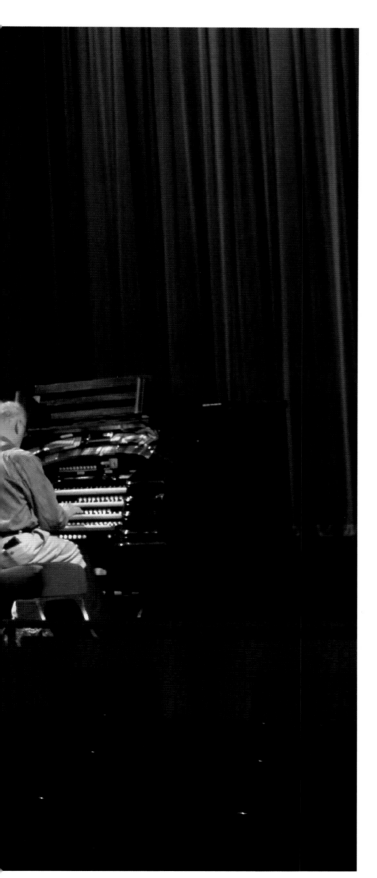

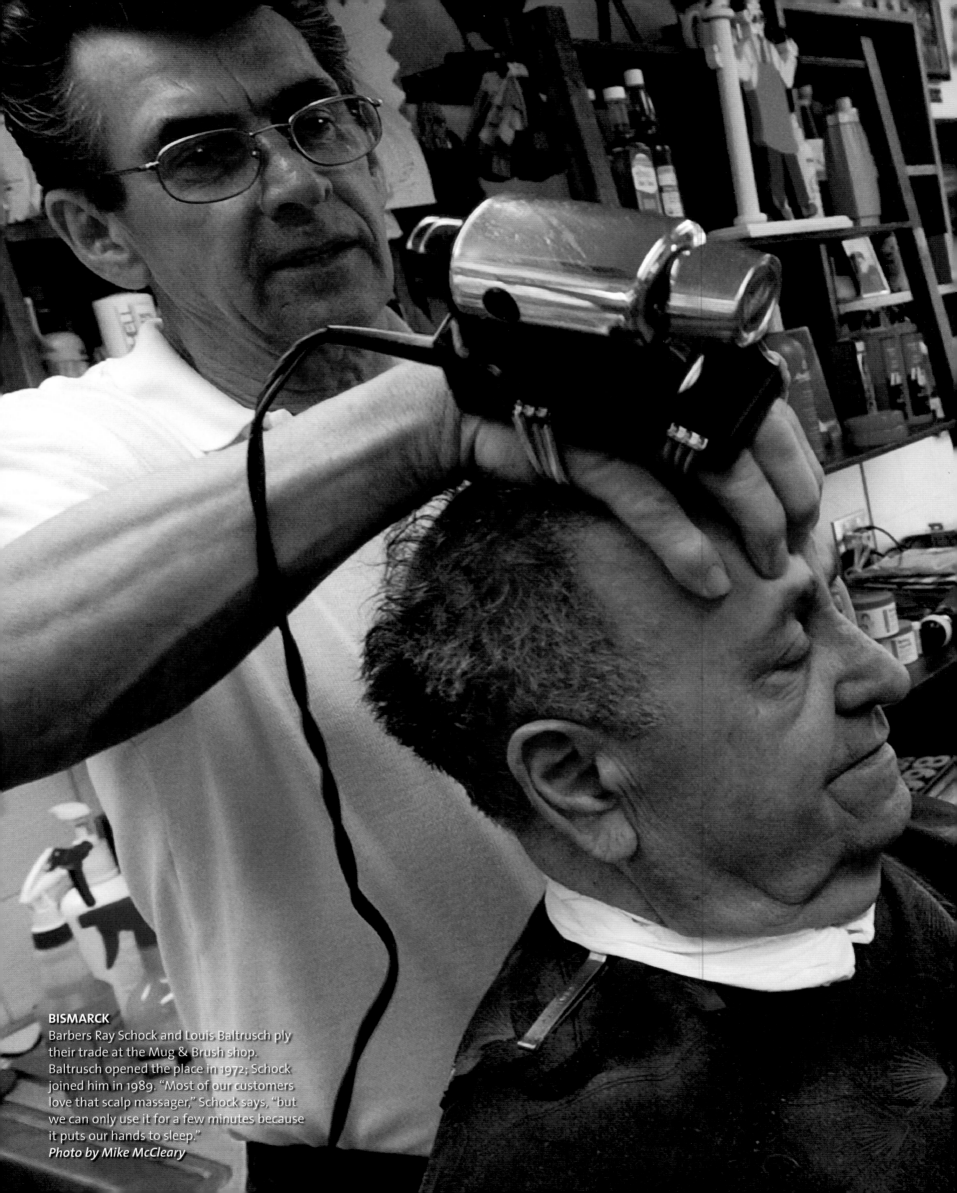

BISMARCK
Barbers Ray Schock and Louis Baltrusch ply their trade at the Mug & Brush shop. Baltrusch opened the place in 1972; Schock joined him in 1989. "Most of our customers love that scalp massager," Schock says, "but we can only use it for a few minutes because it puts our hands to sleep."
Photo by Mike McCleary

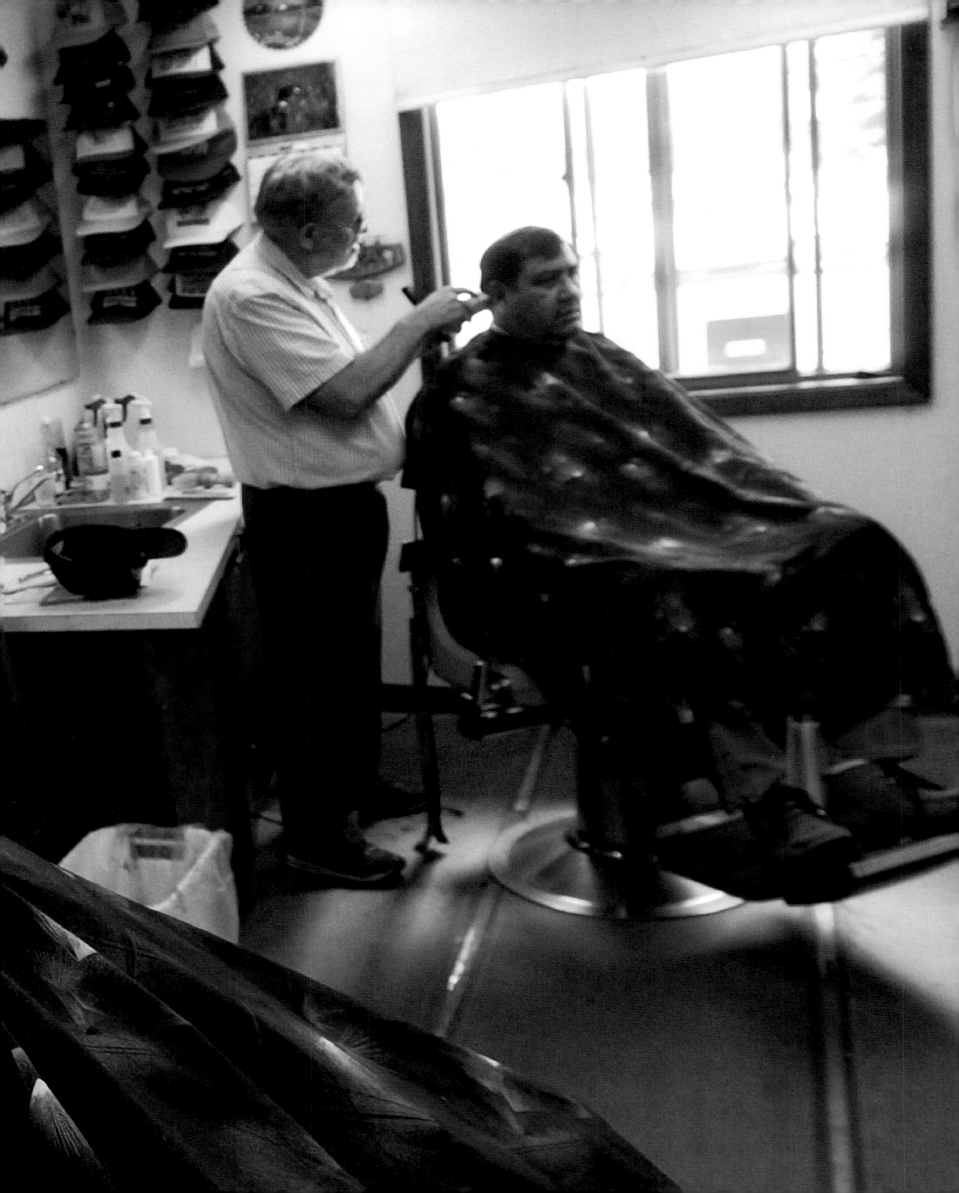

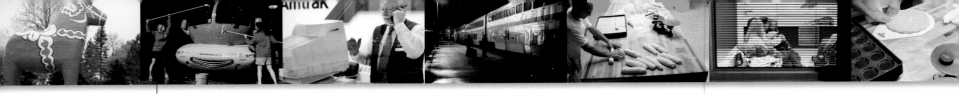

GRAND FORKS
Each year, Oscar Meyer, based in Madison, Wisconsin, hires a dozen college graduates like Betsy Cramer and Robyn Frank to promote its products across the country in the Wienermobile, aka the "Wienie Lamborghini."
Photos by Eric Hylden, Grand Forks Herald

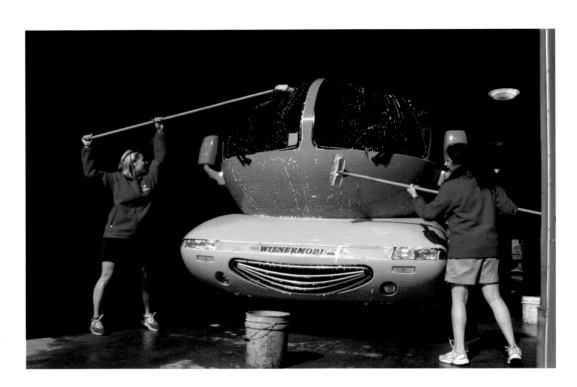

GRAND FORKS

Hold the mustard. The "hotdoggers" are readying the Wienermobile to visit Roosevelt Elementary in Minot, winner of the statewide Oscar Meyer Schoolhouse Jam Talent Contest. The school, which sent in a tape of the kids singing the Oscar Meyer wiener jingle, will receive a check for $10,000.

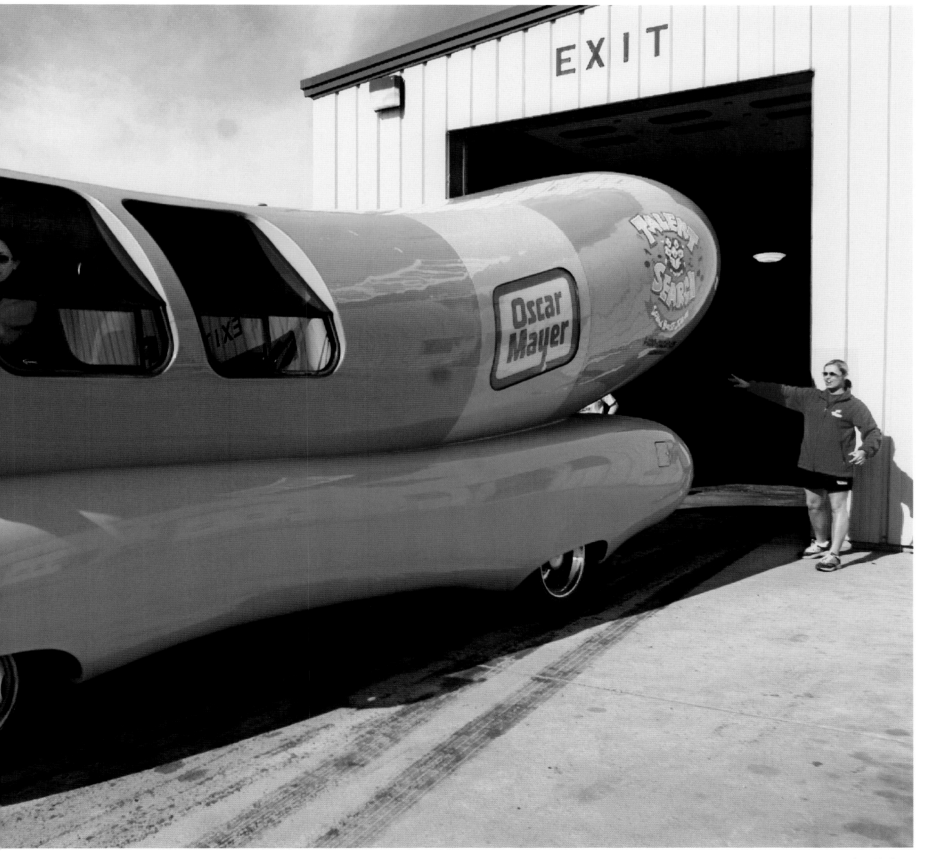

WILLISTON

As day turns into night, trucks line up for the showing of *Anger Management* at the Lake Park drive-in. First opened in 1949, it is the last outdoor movie theater in North Dakota.
Photo by David Samson

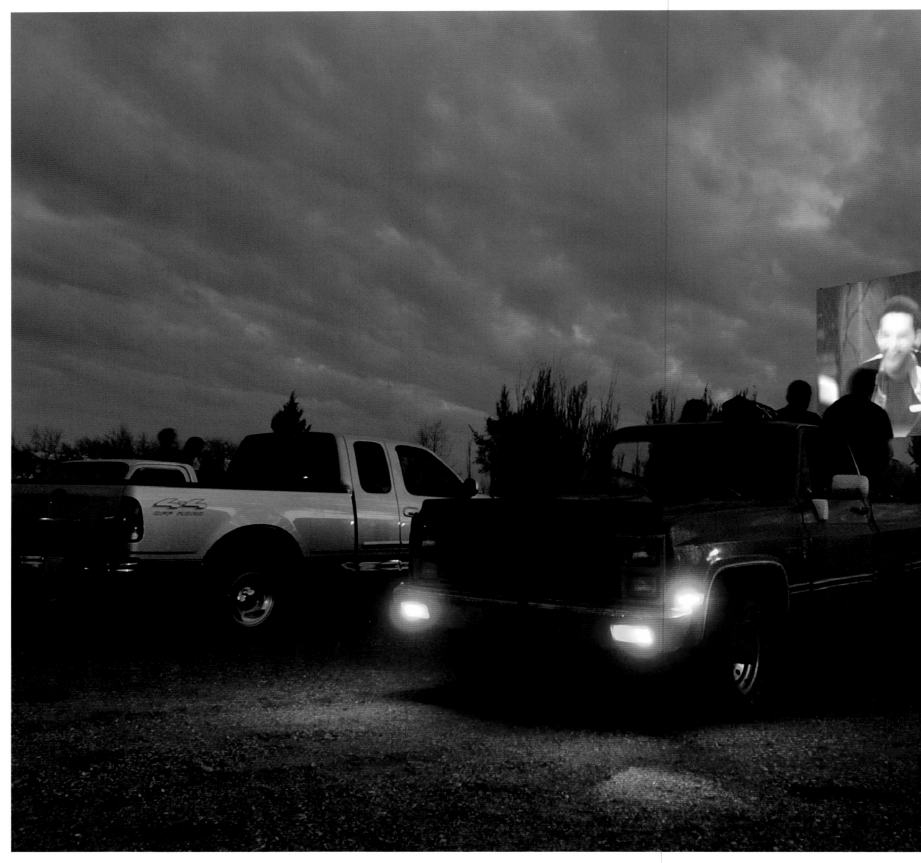

PARK RIVER

With community support, the Park River Public School District rescued the vintage Lyric Theater from demolition. Students volunteer their time running the movie house—labor that the district eventually plans to convert to academic credit. Seventh-grader Kevin Ellingson cleans up after the last show.

Photo by Eric Hylden, Grand Forks Herald

WILLISTON

In her four years as an employee of Lake Park drive-in, Amber Johnson has done it all—sold tickets, worked the concession stand, loaded the 35mm film projector, and cleaned the grounds. She started while a student in high school and continued through community college, but she plans to leave soon to attend Medcenter One College of Nursing in Bismarck.

Photo by David Samson

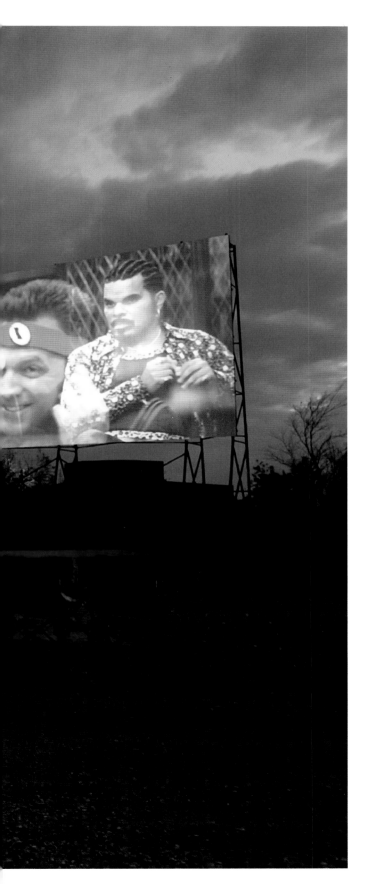

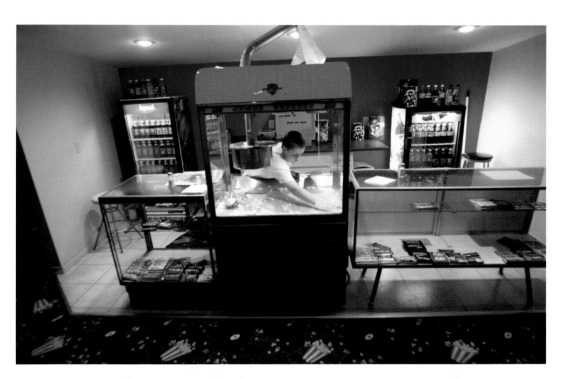

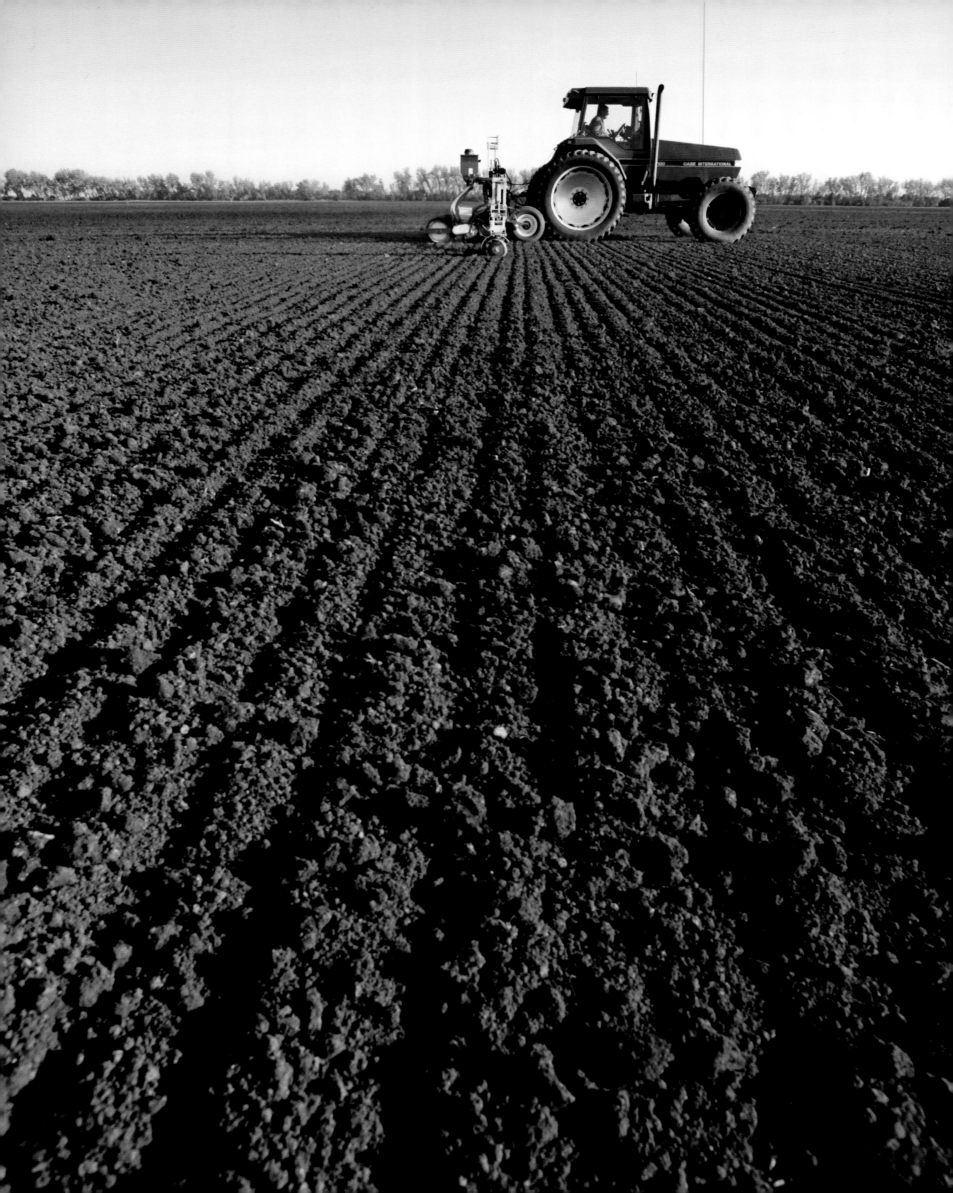

GRAND FORKS

Sugar beet farmer Steve Mathiason uses his tractor planter to sow 6 million seeds in his 150-acre field during the spring planting season. Mathiason owns two other fields in the township of Brenna, which was named after his great-grandparents, Norwegian immigrants who homesteaded the land in 1860.

Photo by Chuck Kimmerle

GRAND FORKS

Mathiason, who has been farming for 25 years, checks the depth and spacing of his sugar beet seeds. He's hoping for a better season than last year's, when 90 percent of his crops were destroyed by flooding.

Photo by Chuck Kimmerle

NEKOMA

Prairie pyramid: This 77-foot-tall, missile-tracking radar facility is a monumental remnant of the Cold War. Such installations were a boon to local businesses, but farmers like Larry Petri and his family kept on planting and harvesting grain crops. Good thing: The facility was shut down by Congress in 1976, six months after it was activated.

Photo by Bill Alkofer

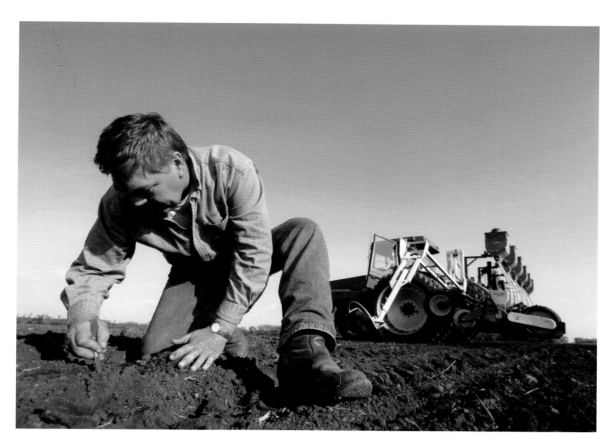

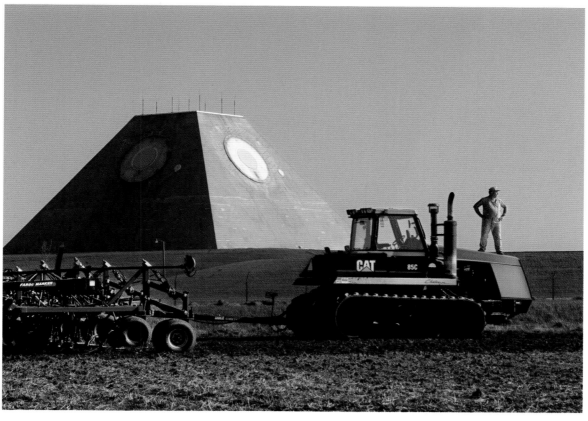

EMMONS COUNTY
Every spring the Noel family's 200 dairy and beef cows drop calves. Riding out to check on new arrivals, Albert Noel leaves his truck idling while he ear-tags the calves to keep track of their lineage.
Photo by C.J. Kurszewski

MANDAN

With 275 dairy Holsteins to care for, Walter Keidel, 72, gets up early. After a lifetime of feeding and milking his cattle, Keidel says he's looking forward to turning the operation over to his sons and moving into town in the fall. The Keidel dairy farm has been producing milk since 1900.

Photo by Amy Taborsky, Bismarck Tribune

HORACE

Brad Forness trims the back hoof of filly Henna as her owner Stacey Fosse looks on. After graduating from Oklahoma Farrier's College in 1997, Forness worked construction during the day and shoed horses at night. In 2000, he decided to go full-time. Forness likes getting to know his neighbors and says he's always learning something new about horses.

Photo by David Samson

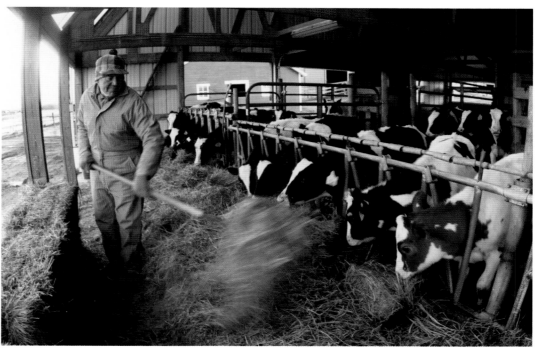

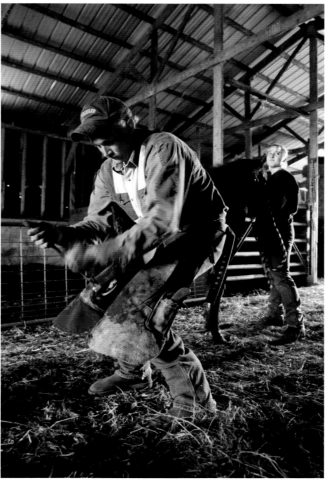

FARGO

Amy Johnson, owner of the vintage furniture store Created Treasures, paints a European village scene on a suitcase she purchased at a rummage sale. Johnson opened the shop in 2000 with her artist mom, Sheila Johnson. In addition to displaying their own works, the two also sell consignment pieces by local artists.
Photo by Meg Luther Lindholm

INKSTER

Nathan Stahl and Lana Maendel spread seed potatoes into a cutting machine at the Forest River Community warehouse. Once cut, the pieces will be planted and the resulting potatoes sold. The Forest River Community, made up of Hutterite families who live communally, has a contract with the giant frozen potato producer Simplot.
Photo by Jackie Lorentz

CARRINGTON

Statice, yarrow, and bells of Ireland surround Ann Hoffert in her drying shed. The former nurse practitioner opened her business, Pipestem Creek, in 1989 so she could work with wildlife and stay home with her four daughters. She sells wreaths and birdhouses made from flowers, grains, and grasses grown on her property.
Photo by Sandee Gerbers

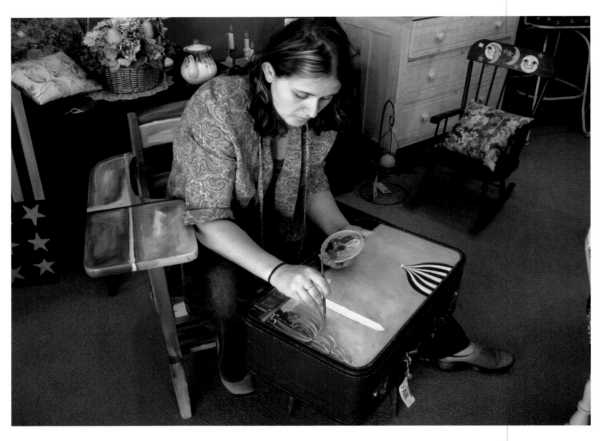

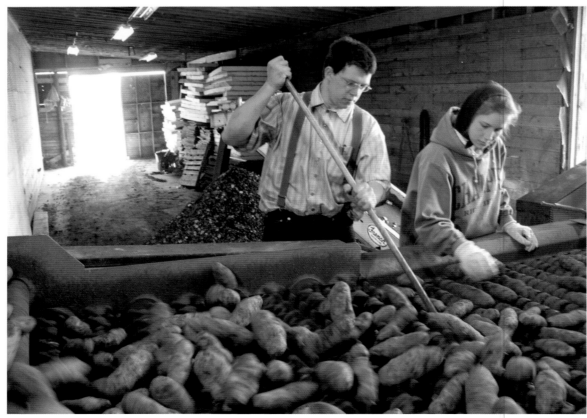

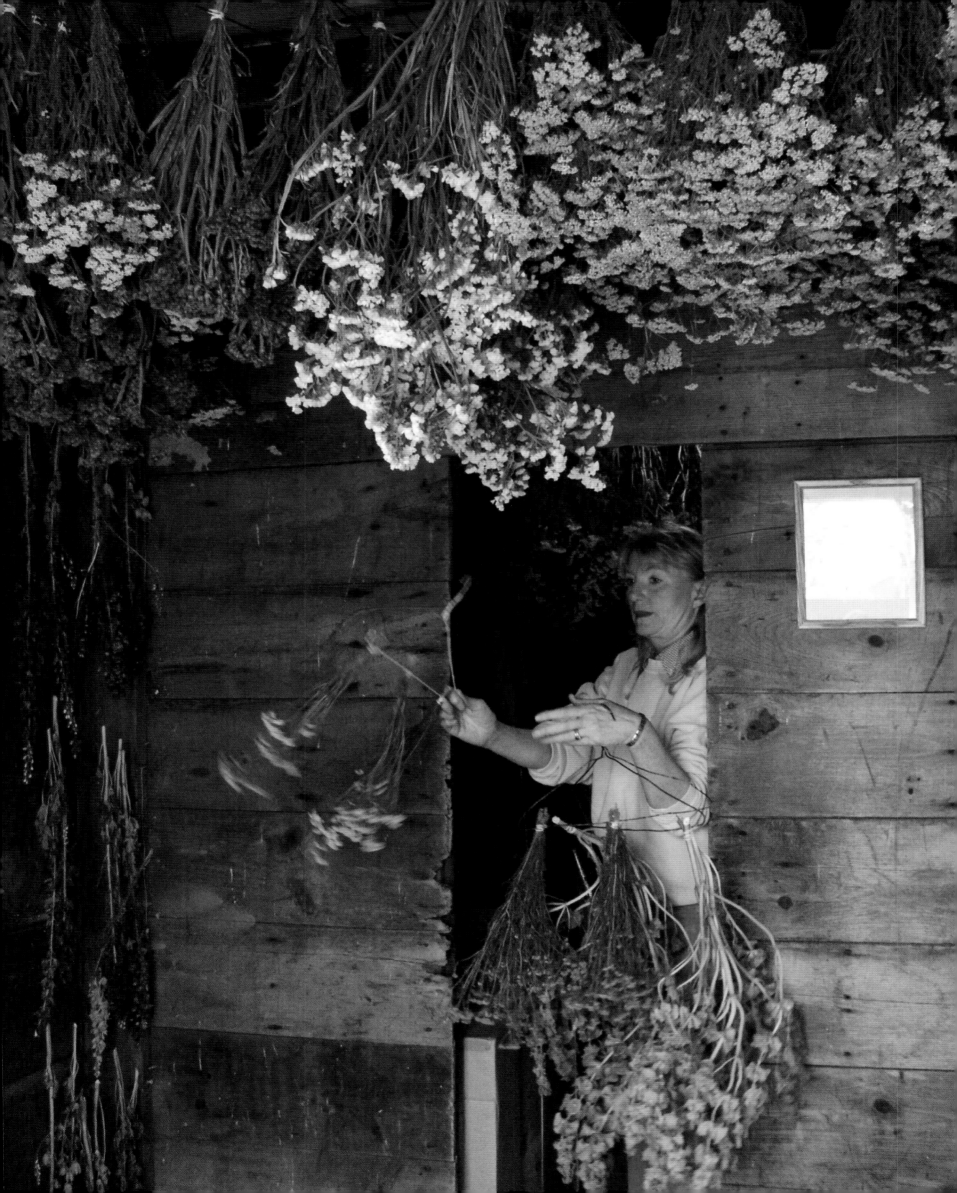

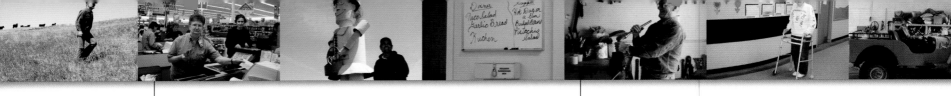

MANDAN

Widowed in 1969 with two young boys to raise, Rose Beehler couldn't quit her job as a checker at Barlow's—and wouldn't have dreamed of it anyway. For 40 years now she's been a favorite at the store and in town. Customers often bypass other checkers for her, and in 2002, the local ladies' auxiliary named her Woman of the Year.
Photo by Suzy Q Bee

KEENE

Ever since he can remember, Ray Gilstad worked on his dad's farm, which he purchased from him 37 years ago. As if growing wheat, raising cattle, and doing his own repairs weren't enough, he also operated heavy equipment in the oil fields for Amerada Hess for nearly 30 years. "It kept me out of trouble most of the time," Gilstad explains.
Photo by Dan Koeck

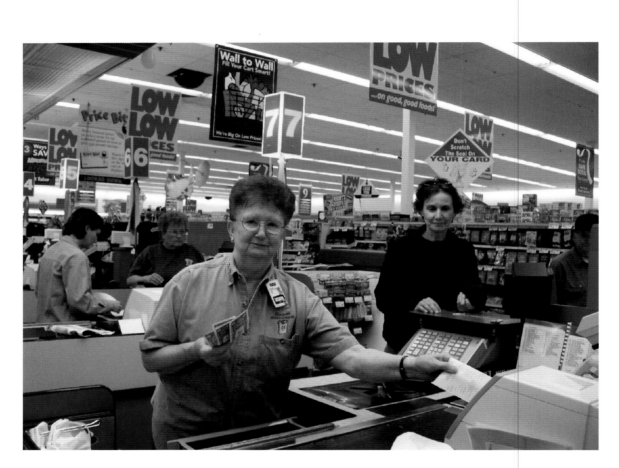

Dietary aide Susan Carpenter prepares to set the dining room tables at the Bismarck Baptist Home. Getting to know everyone's food requirements has opened the door to wonderful personal relationships, says Carpenter, who's also a certified nursing assistant.
Photo by Suzy Q Bee

Gary Greff, a former school teacher and principal, taught himself welding so he could create landmark metal sculptures to spice up the plains. He hopes his fantastical objets d'art will draw tourists to his part of the state and help stimulate the economy. Six Greff creations are already up. The artist uses a cutting torch to hew number seven.
Photo by Sandee Gerbers

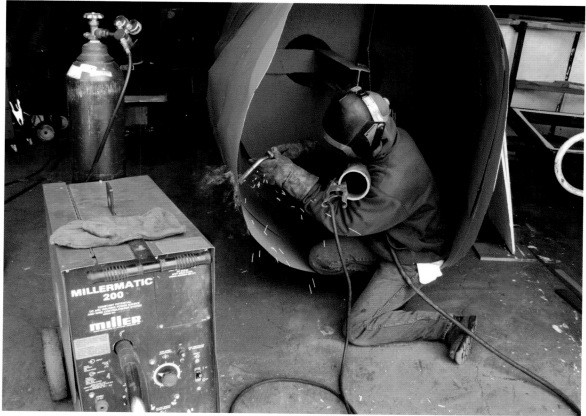

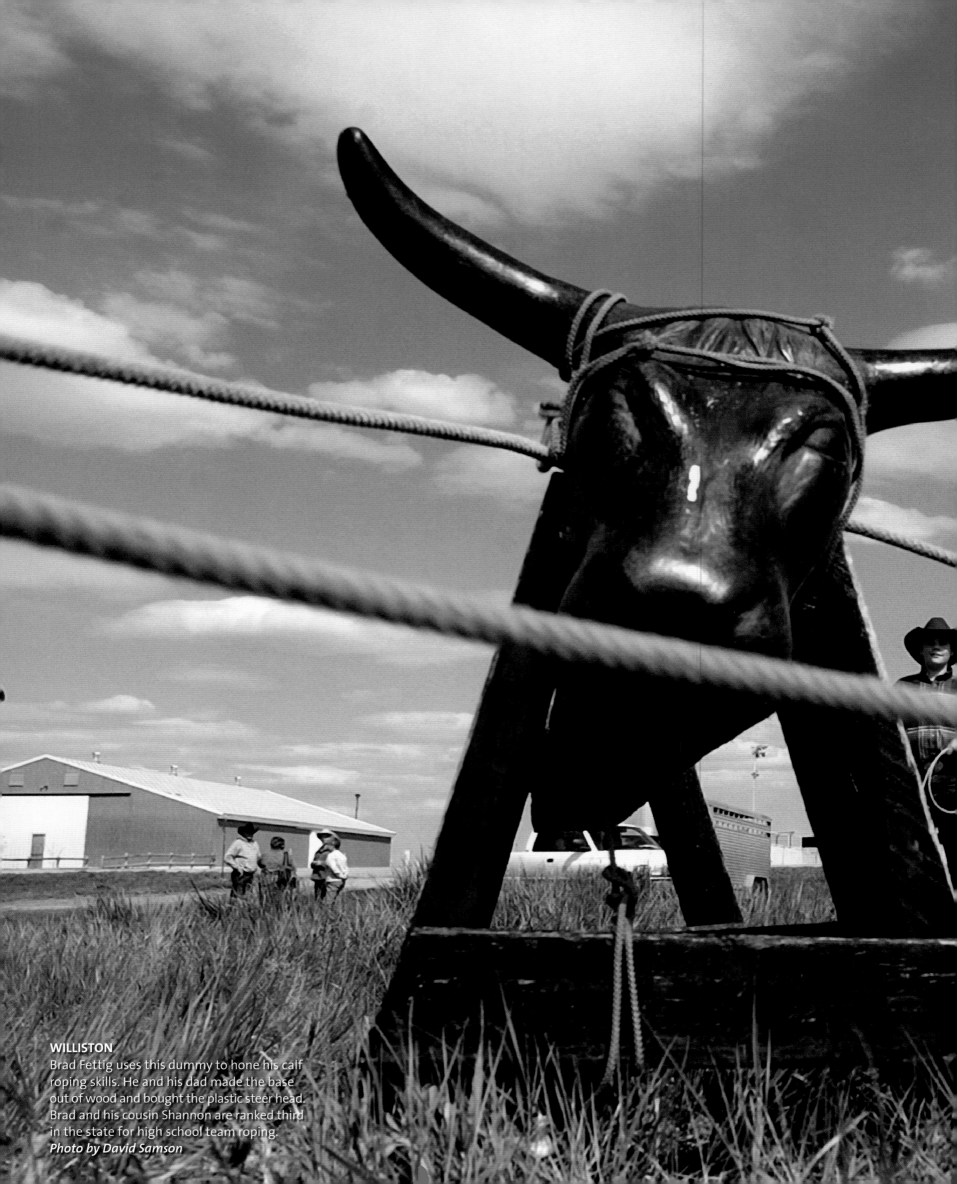

WILLISTON
Brad Fettig uses this dummy to hone his calf roping skills. He and his dad made the base out of wood and bought the plastic steer head. Brad and his cousin Shannon are ranked third in the state for high school team roping.
Photo by David Samson

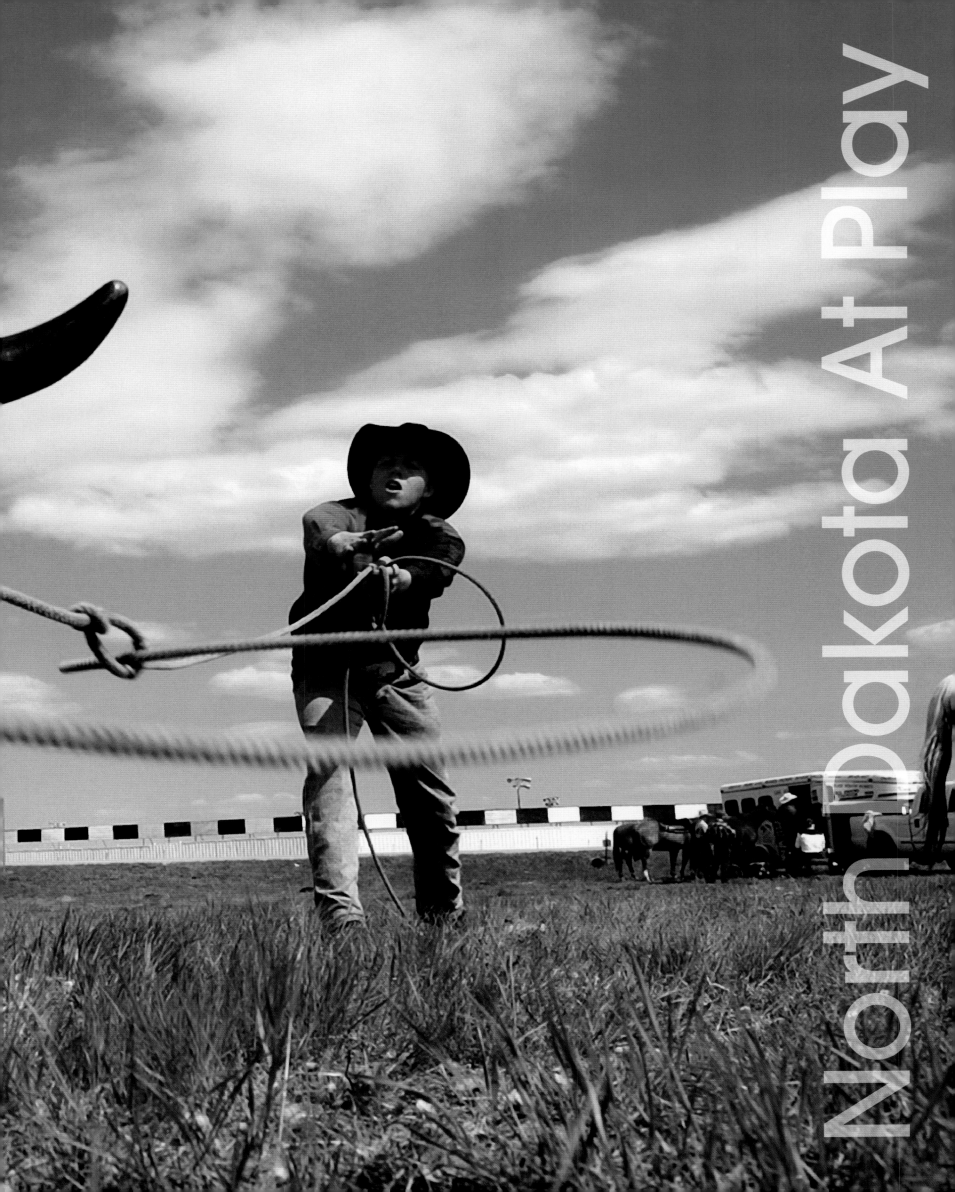

North Dakota At Play

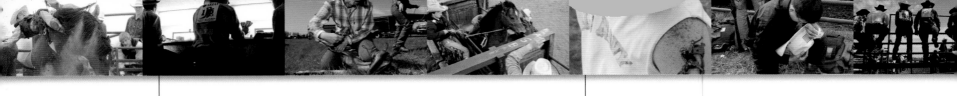

WILLISTON
Team roping duo Cameron Hodgkiss
and Casey Moran join Jeremiah LaDue
for a bite to eat during the high school
rodeo.
Photos by David Samson

WILLISTON
Chance Sauers, 17, wears his passion on
his arm. He pulled the legendary bull
Johnny Skidmarks for his rodeo ride;
Johnny got the better of him in about
four seconds.

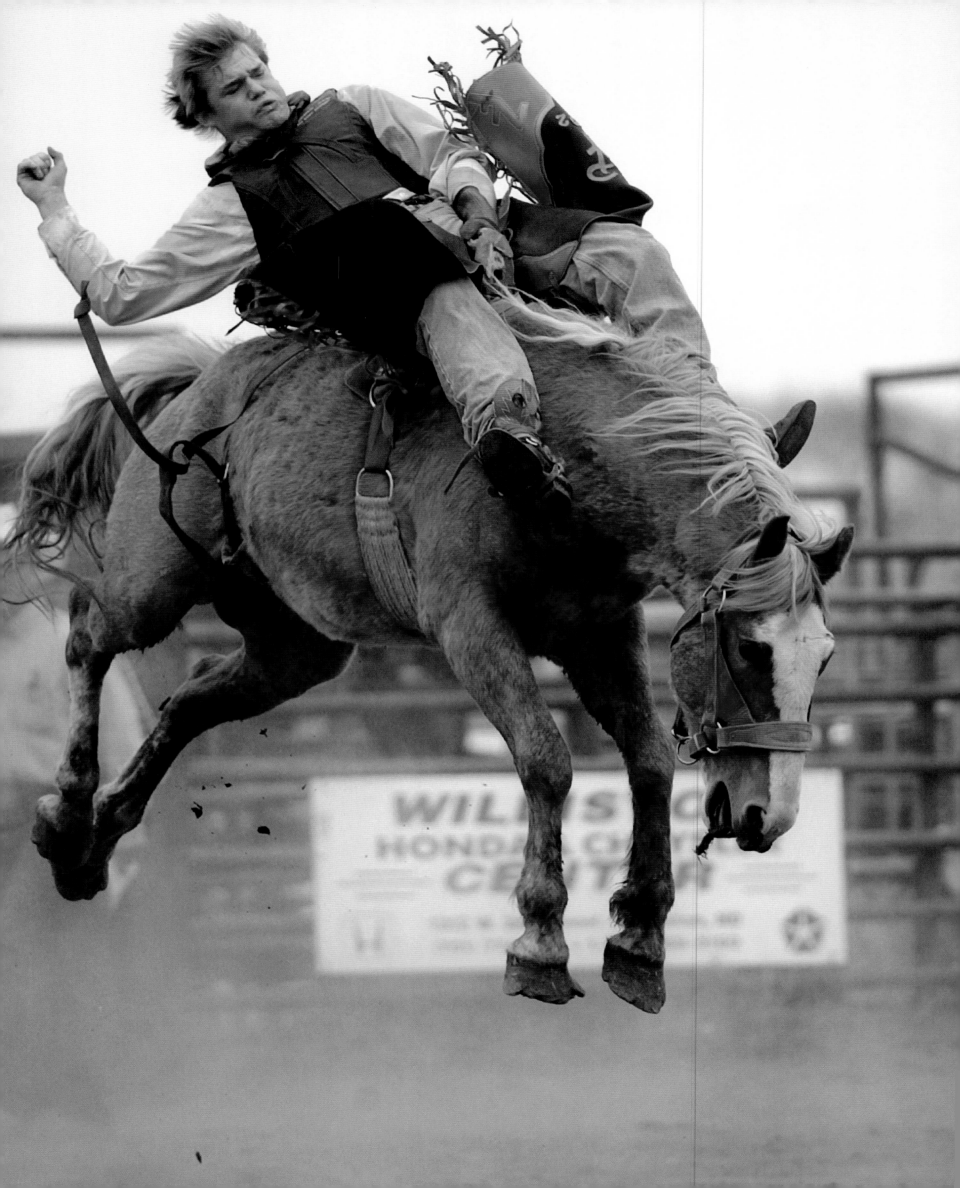

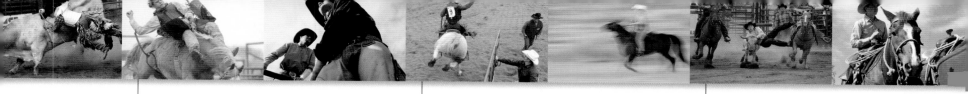

WILLISTON

Zane Forster, 17, holds on for the required eight seconds to win the bareback riding event. The following month, he placed first at the state high school championship.

Photos by David Samson

WILLISTON

Holding on as his mount bucks out of the chute, Casey "Rooster" Jacobson of Bowman gets a good start in the saddle bronc competition. Even so, the horse won the eight-second battle.

WILLISTON

Steer wrestler Anton Helfrich slides out of the saddle, hooks his right arm under the horn, grabs the left horn with his other hand, and flips the steer to the ground. Even with a torn ACL and a knee brace, he placed second.

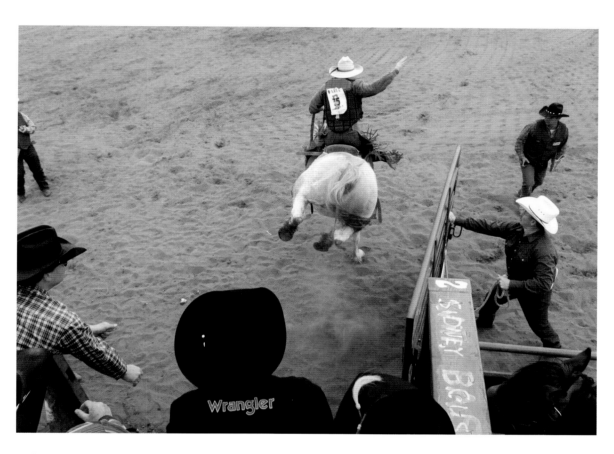

WILLISTON

At goat tying events, competitors race to the middle of the ring, dismount, flip the goat (that's tethered to a stake), then tie three of its legs. The best time wins. Brandi Guttormson and her pal Shaldon Moran-Gjermundson practiced goat tying on Brandi's pet. Neither girl won at the rodeo, but Shaldon did place third in breakaway roping.
Photos by David Samson

WILLISTON

Kalsey Wenger, 14, tries to lasso a calf during the breakaway roping event at the high school rodeo. Wenger's gelding, Hammer, got as close as he could, but the lariat missed its mark.

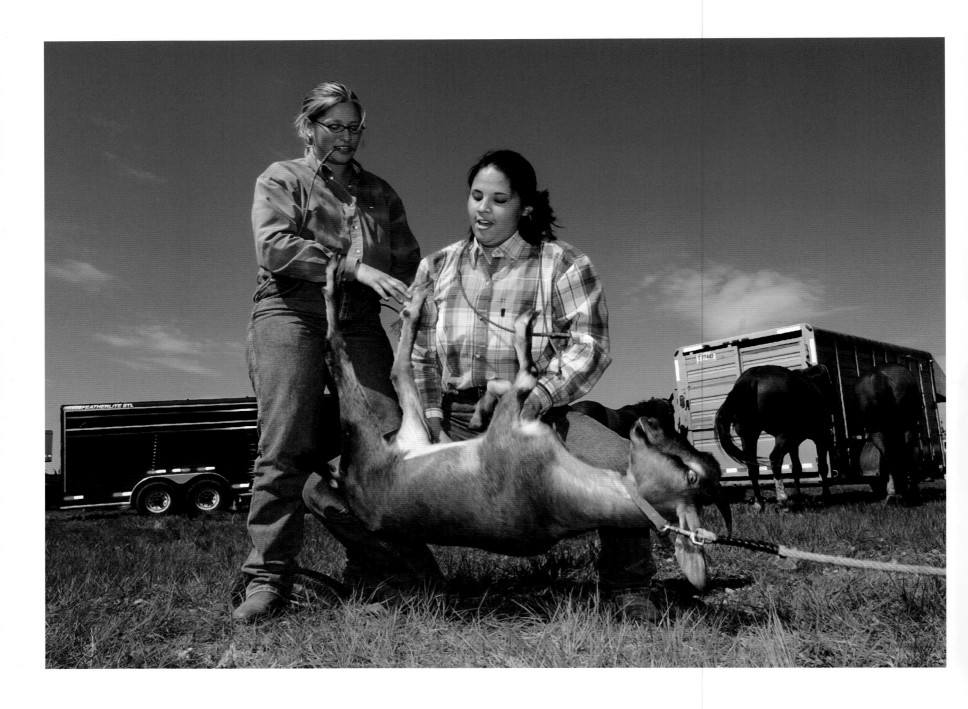

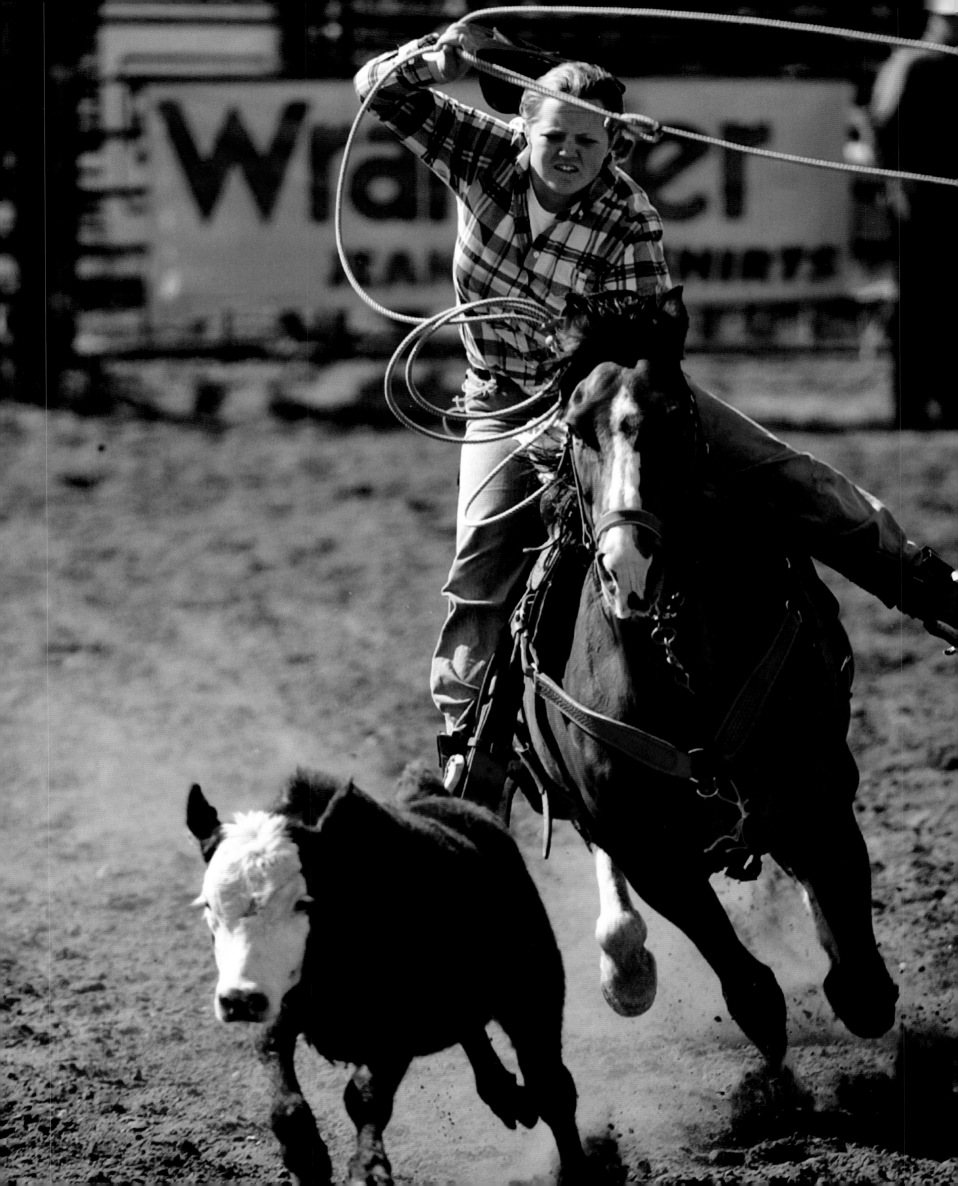

FARGO
Brad Gray, Director of Religious Education at St. Mary's Cathedral, gets in a quick trampoline jump before heading to work. More than 4 million bounce-inducing contraptions are in use across the country, according to the International Trampoline Industry Association.
Photo by Ed Vizenor, Wisdom Productions

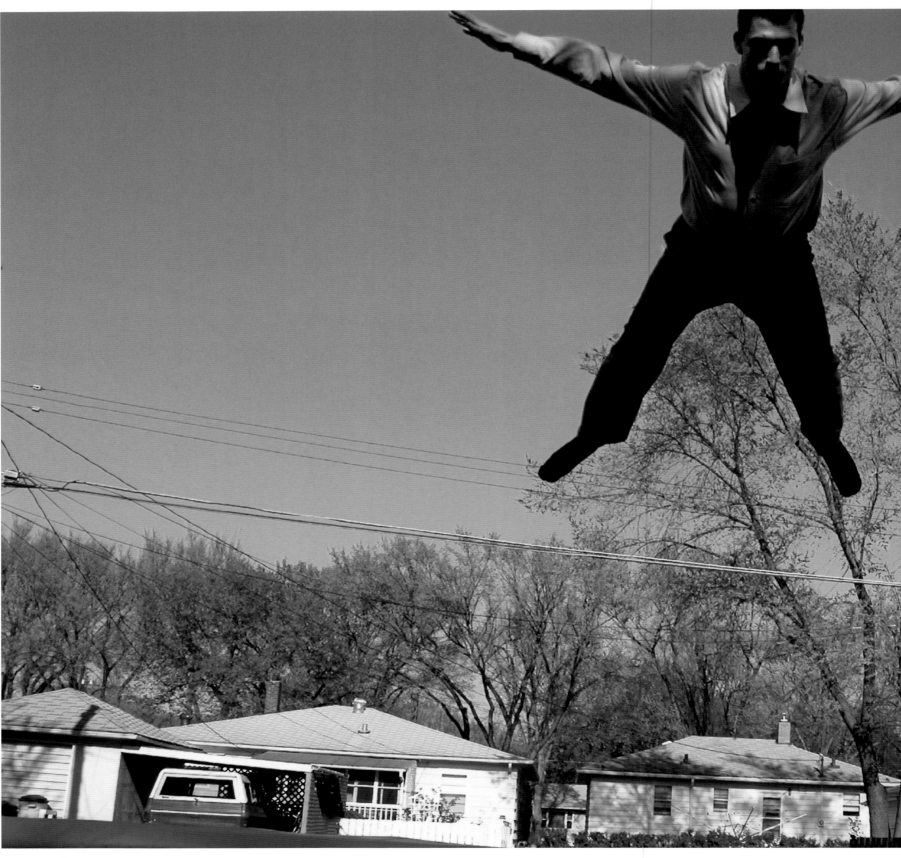

FARGO

Looking a bit unsure about his next move, 3-year-old Alex Gruver straddles the "Space Walk" at Lindenwood Park. Though the Gruvers live in Moorhead, Minnesota, his mom takes Alex across the Red River to this playground because of the unique equipment and nice scenery.
Photo by Sandee Gerbers

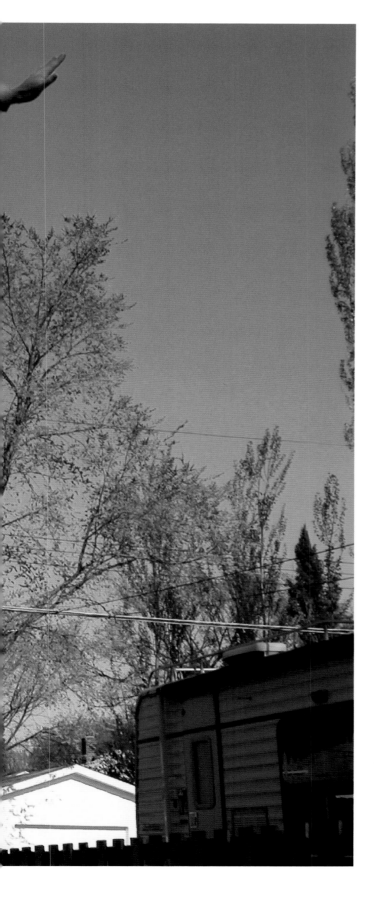

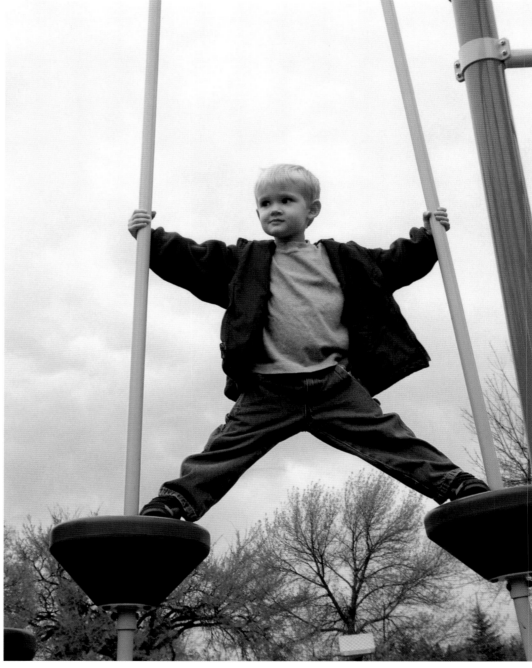

BISMARCK

Signe Snortland and Patricia Jessen, friends for 45 years, have much in common, including careers in archaeological and historical research and membership in a string quartet. The Bismarck natives part ways, though, over Scrabble at Barnes & Noble. "We get extremely creative with our words," says Snortland. "And then we can never agree on who's won."

Photo by Tom Stromme

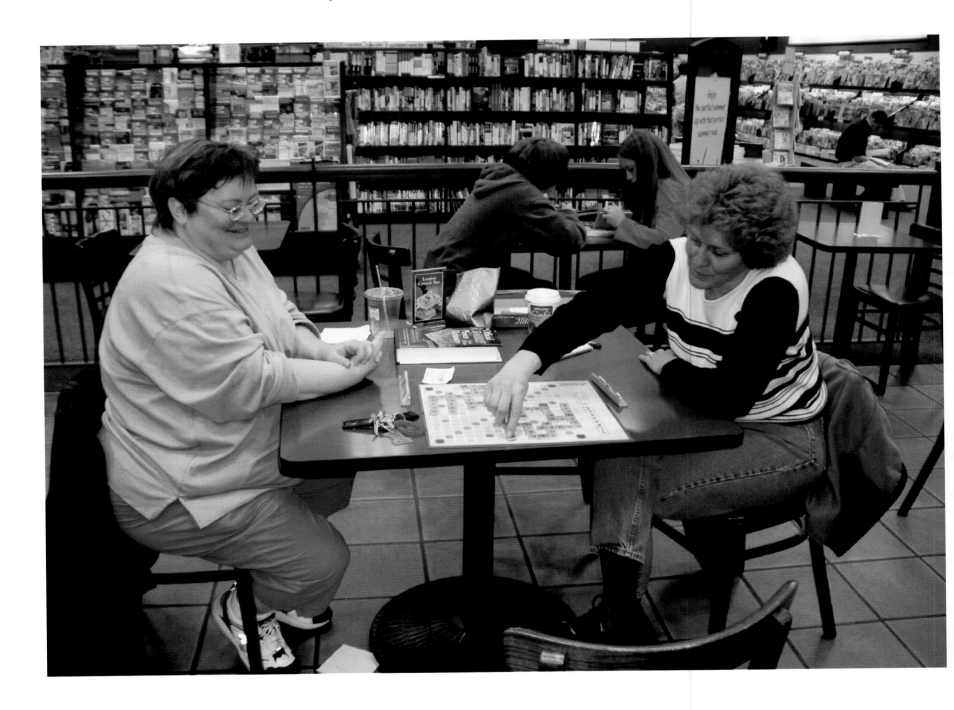

FARGO

Ron Peterson (center), is president of the Fargo-Moorhead Hotwheelers, a Hot Wheels collecting club. He owns 16,000 of the toy cars introduced by Mattel in 1968. Every month Peterson meets with Rick Jorgensen (left), Raymond Rosdahl, and 20 other club members to trade and buy miniature Camaros and Mopars. Prices range from 50 cents to $300.

Photo by Meg Luther Lindholm

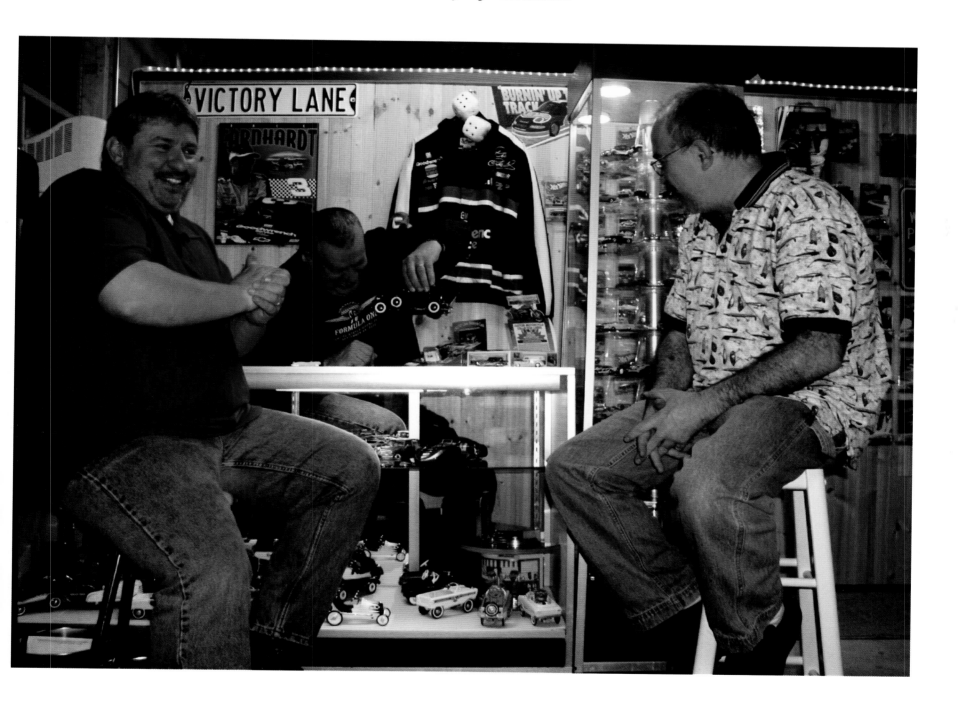

FARGO

No one, including this gentleman, bought the 1948 Chevrolet Fleetmaster Convertible at the Fargo-Moorhead Vintage Car Club Auction (the reserve price was $21,500)—and owner Dick Olsen was secretly happy. Olsen bought the rag-top in Virginia in 1952, sold it in 1956, and got it back twenty years later. Clearly, he has trouble letting go.

Photos by Colburn Hvidston III, The Forum, Fargo

FARGO

"It's the prettiest Jag ever," says Dick Olsen of his 1949 Jaguar Mark 5 Saloon, shown here posing in front of a private mansion known as the "Bishop's House" on South 8th Street. People often mistake the classic car for a Rolls Royce.

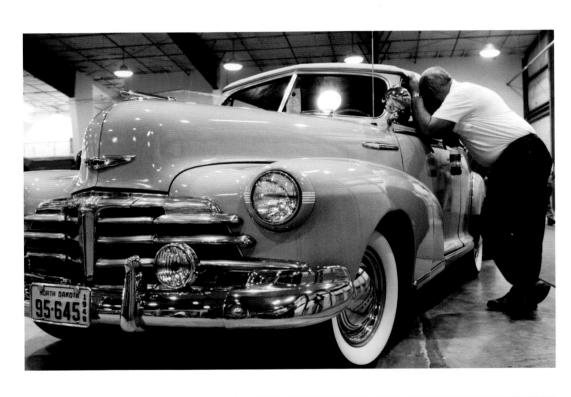

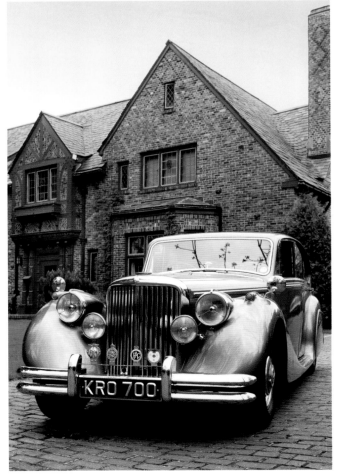

FARGO

Olsen bought this Jaguar in 1968 while he was
in England on a Fulbright Scholarship teaching
American and British history. The car cost him
$450 to ship home—$100 more than he paid for
it. Today, the vintage Jag is worth between
$15,000 and $20,000.

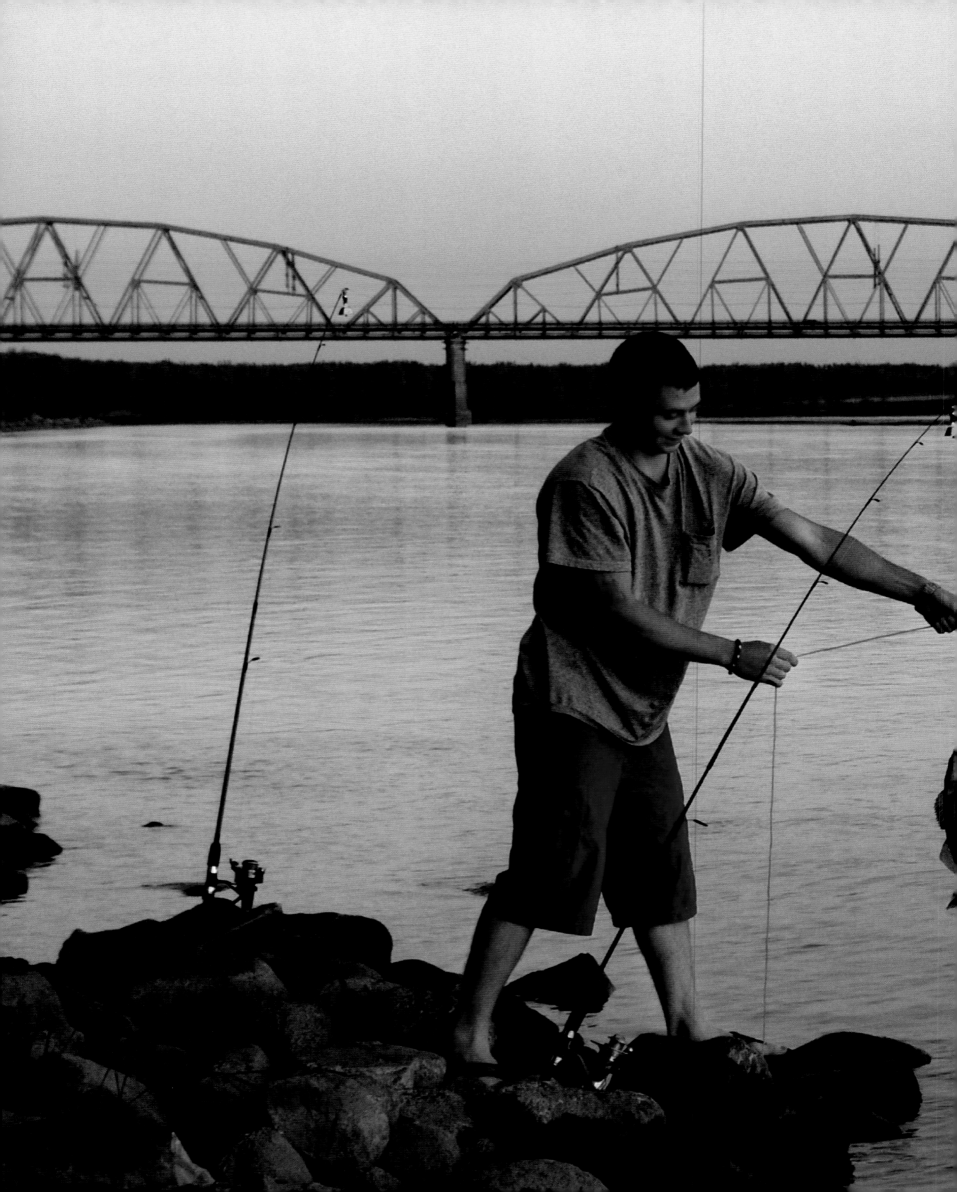

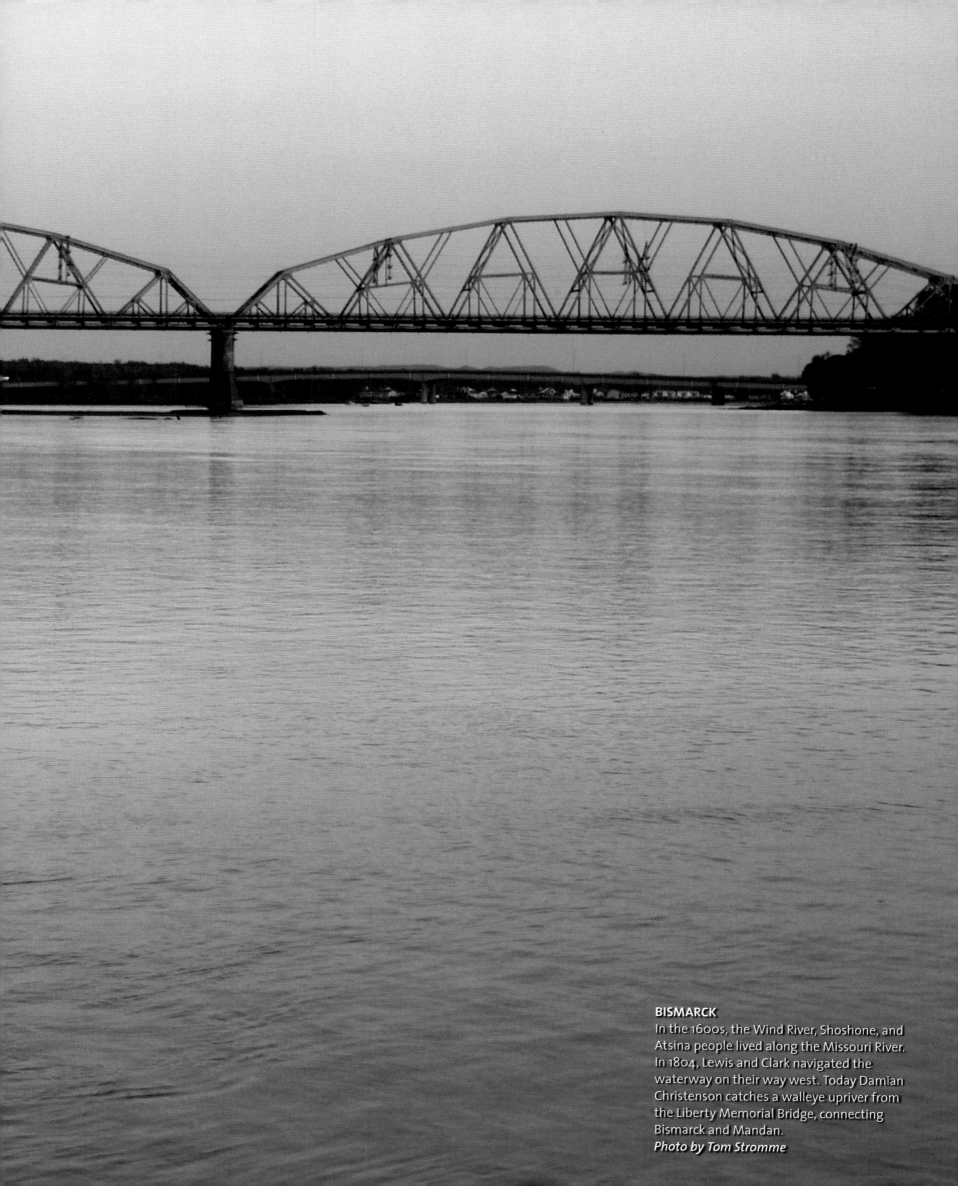

BISMARCK
In the 1600s, the Wind River, Shoshone, and Atsina people lived along the Missouri River. In 1804, Lewis and Clark navigated the waterway on their way west. Today Damian Christenson catches a walleye upriver from the Liberty Memorial Bridge, connecting Bismarck and Mandan.
Photo by Tom Stromme

FARGO

Mike Ausmus dons the mascot uniform for the Fargo-Moorhead RedHawks, an independent, minor-league baseball team. Ausmus, who is working on a pharmacology degree at North Dakota State University, relishes the anonymity of his "Hawkeye" disguise. "Very few people know it is me in the uniform," he explains. "That really frees me to perform."
Photos by David Samson

FARGO

The RedHawks lean on the Newman Field dugout rail during their first exhibition game of the season. These boys of summer edged out the Sioux Falls Canaries, 6–5. The team, founded in 1996, have made it to the Northern League playoffs every year but one.

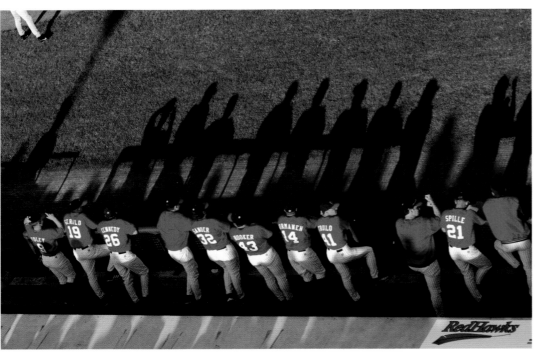

Pitcher Brian Barnett, formerly with the Anaheim
Angels franchise, winds up. Spring training and
eight exhibition games give RedHawk coaches
time to narrow the roster down to the requisite
22. Barnett was one of five players released be-
fore the official launch of the 2003 season.

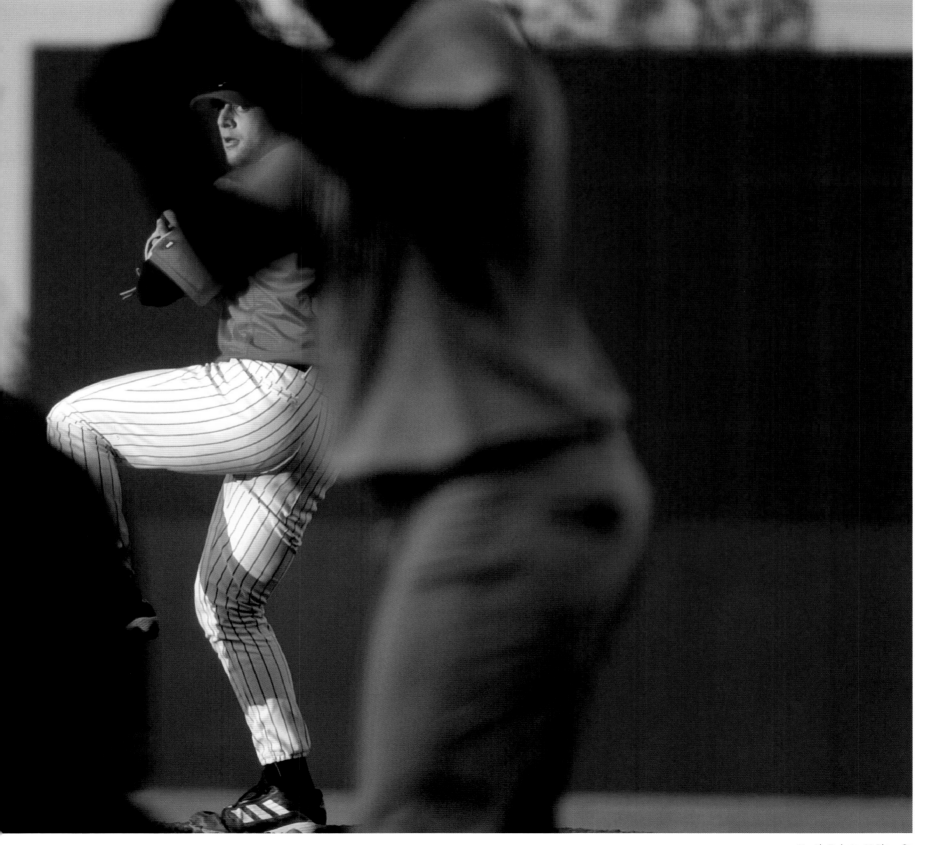

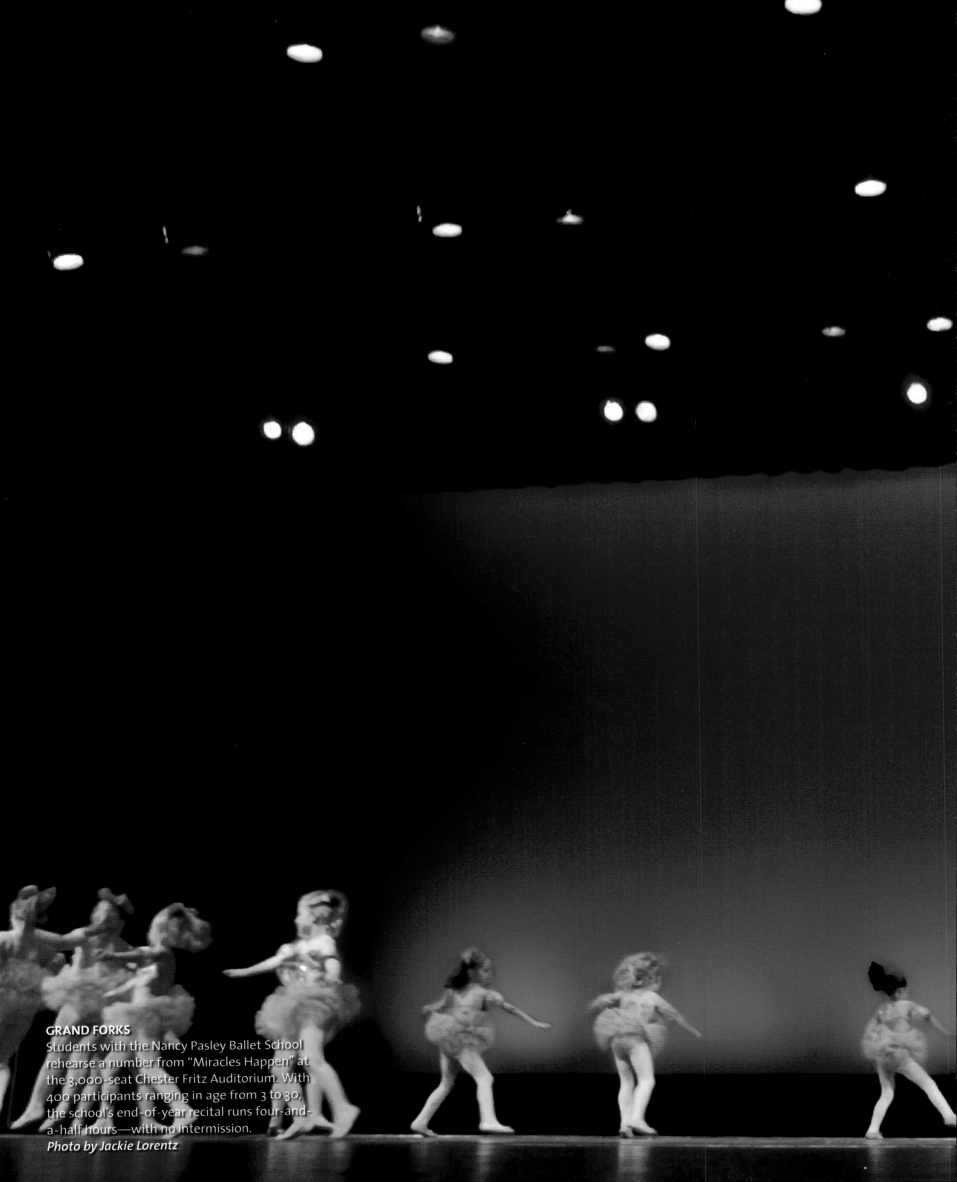

GRAND FORKS
Students with the Nancy Pasley Ballet School rehearse a number from "Miracles Happen" at the 3,000-seat Chester Fritz Auditorium. With 400 participants ranging in age from 3 to 30, the school's end-of-year recital runs four-and-a-half hours—with no intermission.
Photo by Jackie Lorentz

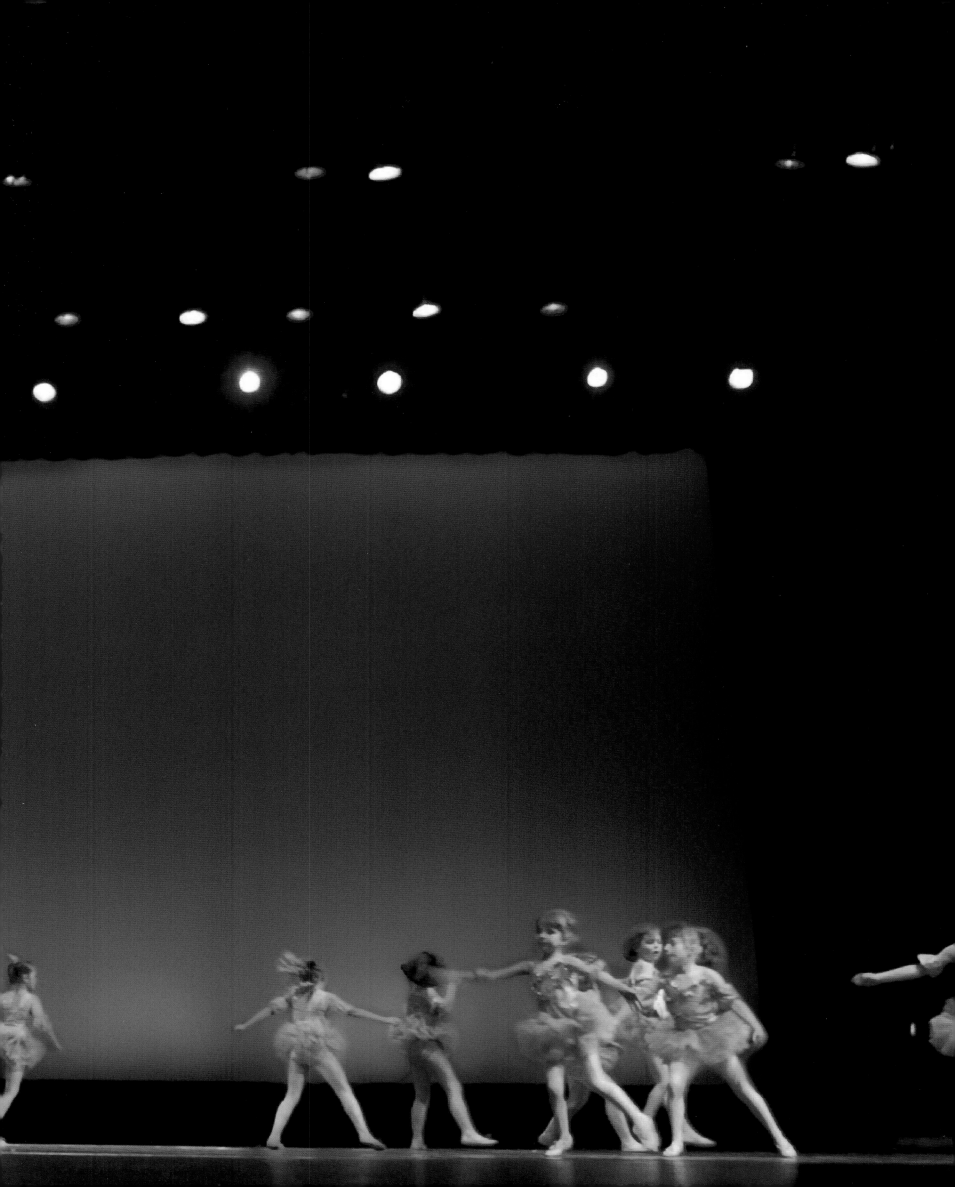

MARMARTH

After finishing a job, plumbers Ron Parfit and Mike Stinchfield (sitting down) shoot the breeze at the Pastime Club & Steakhouse on Main Street. While the bar is typical, the steakhouse is anything but. Menu items range from crab-stuffed mushrooms and escargot to prime rib and coconut-battered shrimp.
Photo by Dan Koeck

FARGO

A film major at Minnesota State University in Moorhead, Dustin Buchanan does a heel flip (also known as the ollie kick flip) over another skateboard near his home in Fargo. Buchanan pushes the envelope on stage, too, where he steps out as a member of the improv comedy group Line Benders.
Photo by Ludvik Herrera

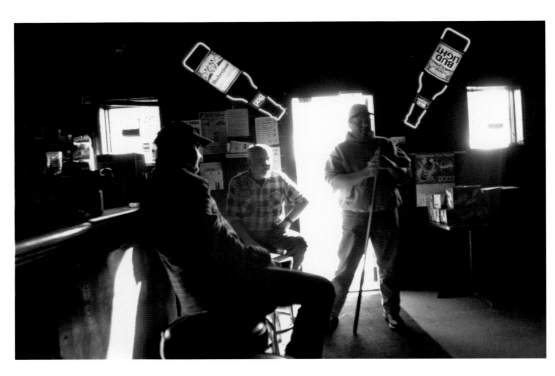

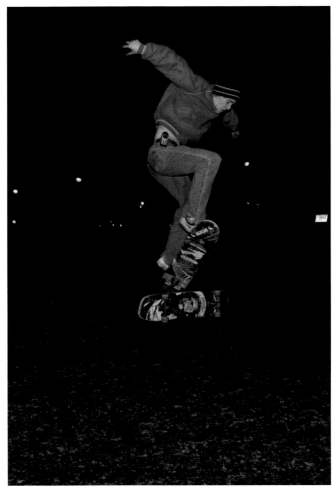

GRAND FORKS
Usually fans at River Cities Speedway flip for the
Friday night late-model stock car races. This time,
a car flips for them.
Photo by Eric Hylden, Grand Forks Herald

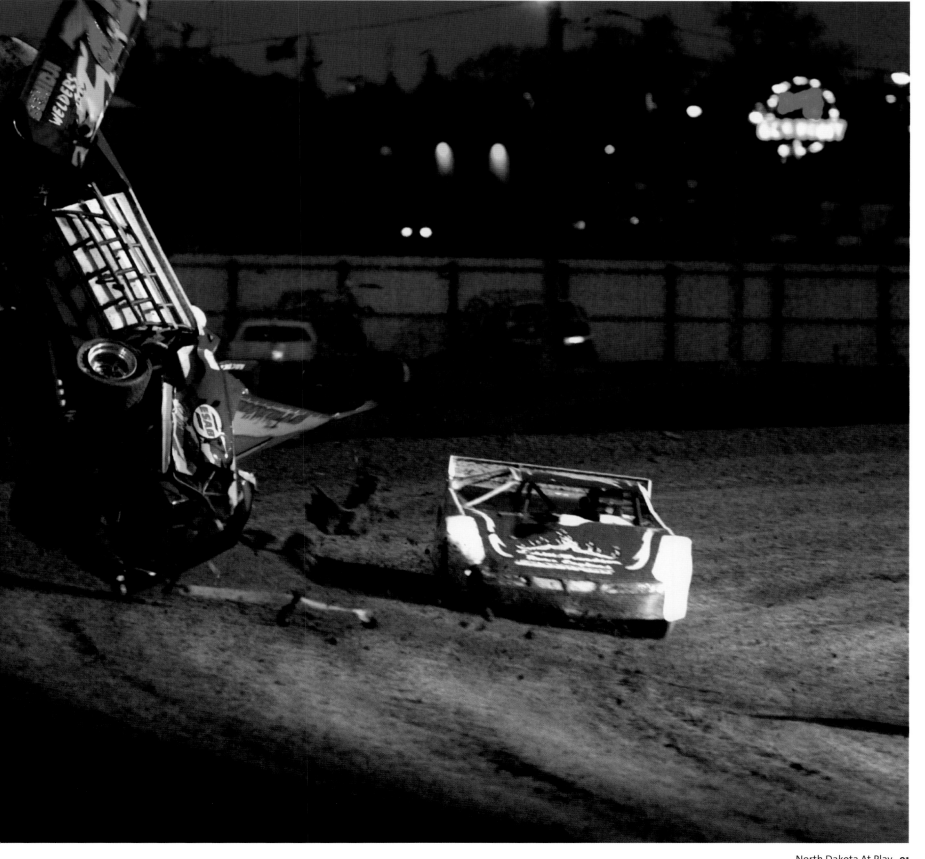

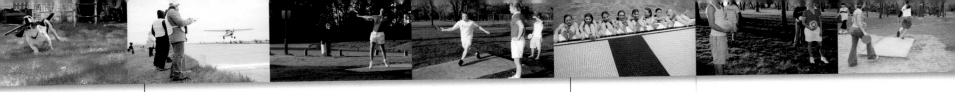

GRAND FORKS

For three days each spring, 400 collegiate flight students compete for the national Safety and Flight Evaluation Conference title. The novice pilots are judged on takeoffs, landings, message drops, and navigation at the Grand Forks International Airport.
Photo by Chuck Kimmerle

BISMARCK

Pooling around: The Bismarck Community Church's Life Club holds an end-of-school swim party at the YMCA.
Photo by Suzy Q Bee

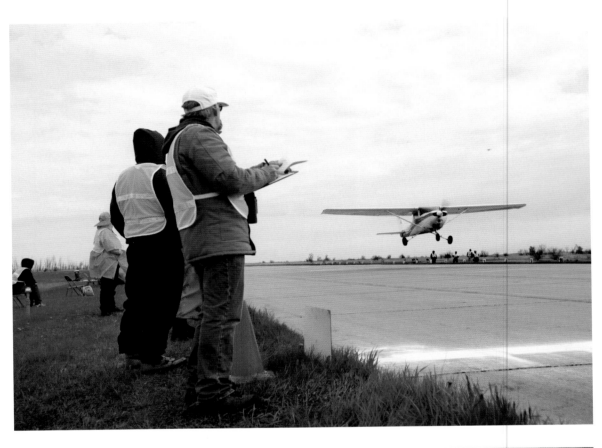

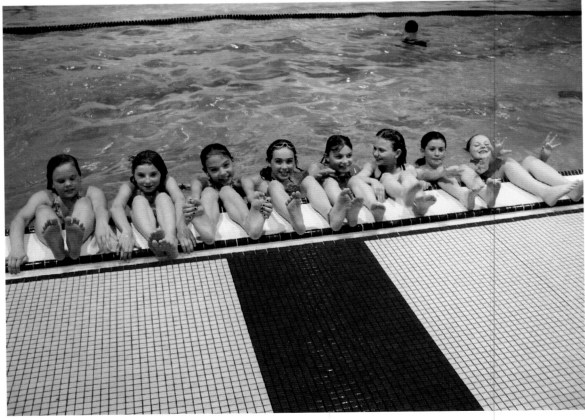

FARGO

Tom Sauvageau tees off at the disc golf course at Oak Grove Park, while Anthony Day lines up to take the next shot. Disc golf, or frolfing, started in Pasadena, California in 1975. Regular Frisbees can be used, though heavier, flatter discs are the standard. To score, a player must throw a disc into a 3-foot-high basket at each hole.

Photo by Ludvik Herrera

MEDORA

Powering up the last hill, Ross Glass takes the lead in the 21st annual Bison Challenge. The race, which spans 45-miles, makes two loops through Theodore Roosevelt National Park. Glass, a member of the High Plains Shifters cycling club and a B-52 crew chief at Minot Air Force base, finished seventh out of 17.

Photo by Sandee Gerbers

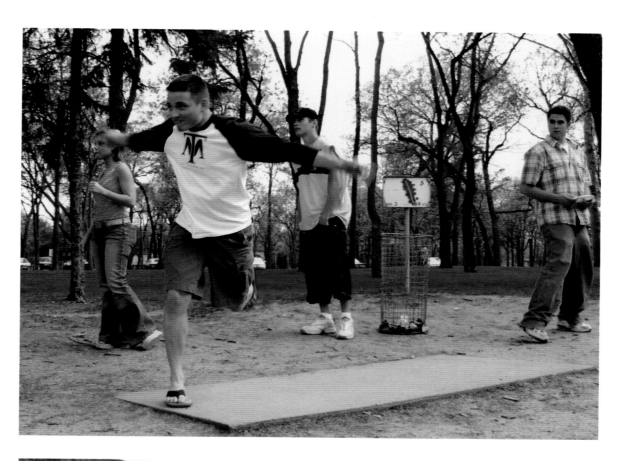

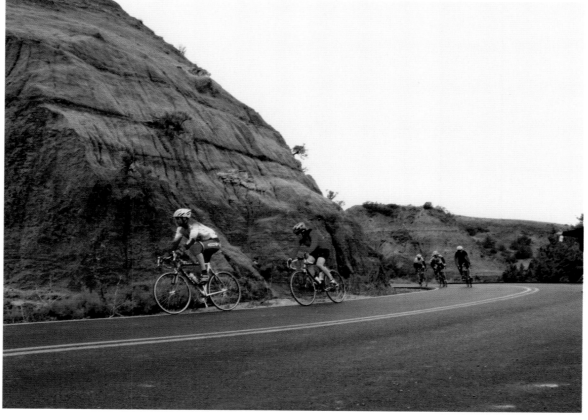

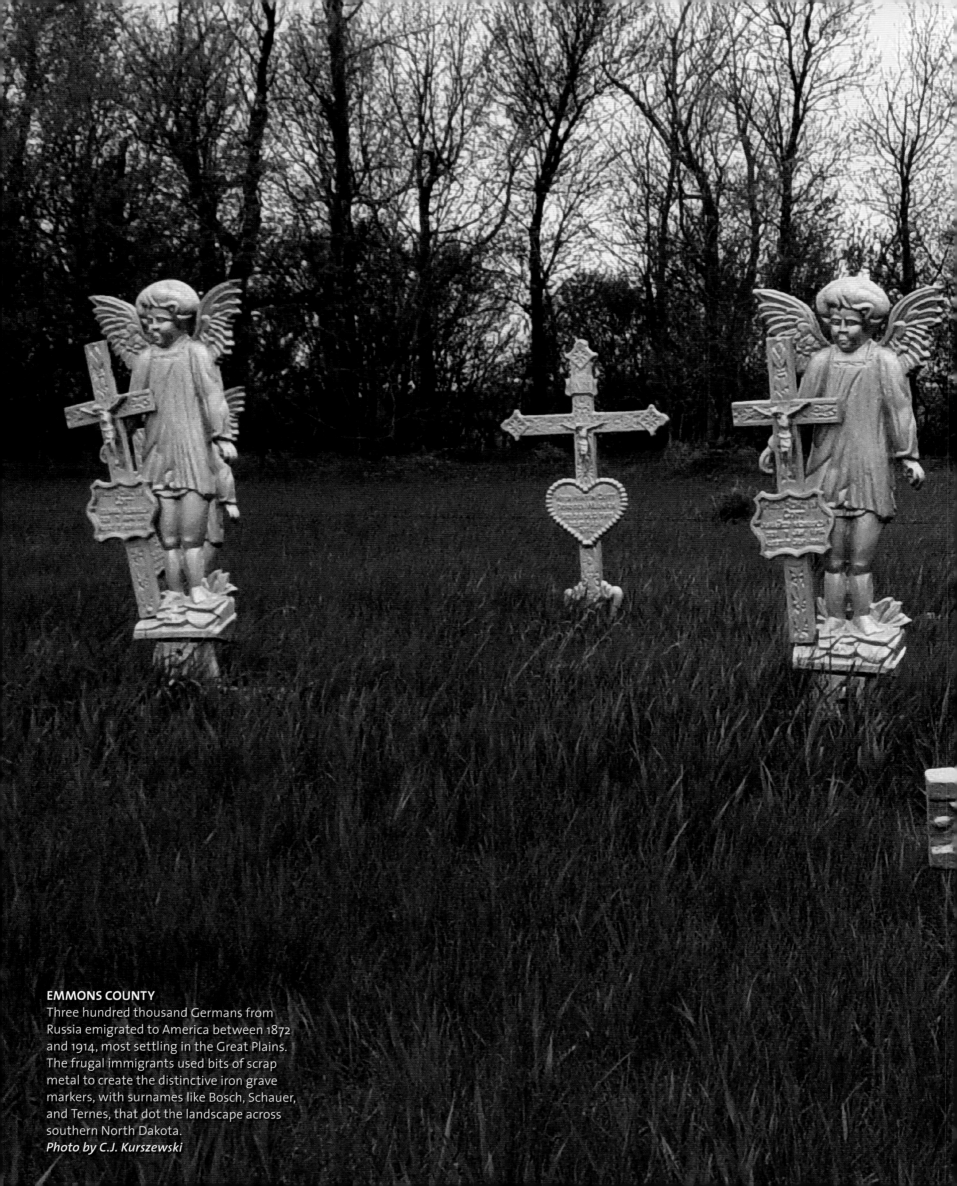

EMMONS COUNTY
Three hundred thousand Germans from Russia emigrated to America between 1872 and 1914, most settling in the Great Plains. The frugal immigrants used bits of scrap metal to create the distinctive iron grave markers, with surnames like Bosch, Schauer, and Ternes, that dot the landscape across southern North Dakota.
Photo by C.J. Kurszewski

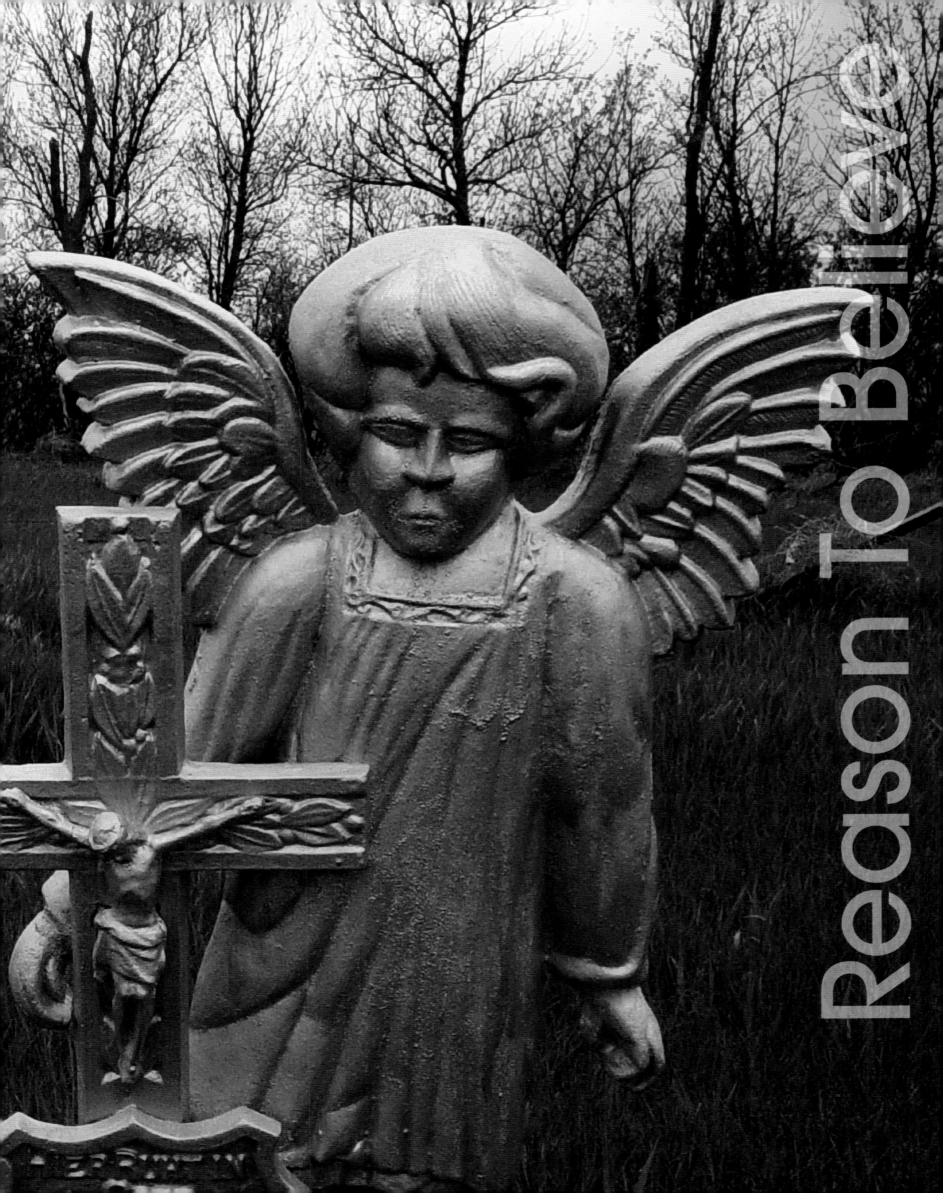

Reason To Believe

GRAND FORKS

It's 5:40 a.m., and Sister Konradine, 93, cleans and replaces the votive candles in a small chapel at St. Anne's Guest Home. Sister Konradine, who was born in Bavaria, entered a convent when she was 14. She arrived at the Guest Home, a retirement facility, in 1968 after 22 years at St. Anne's Mother House in Hankinson.
Photo by Jackie Lorentz

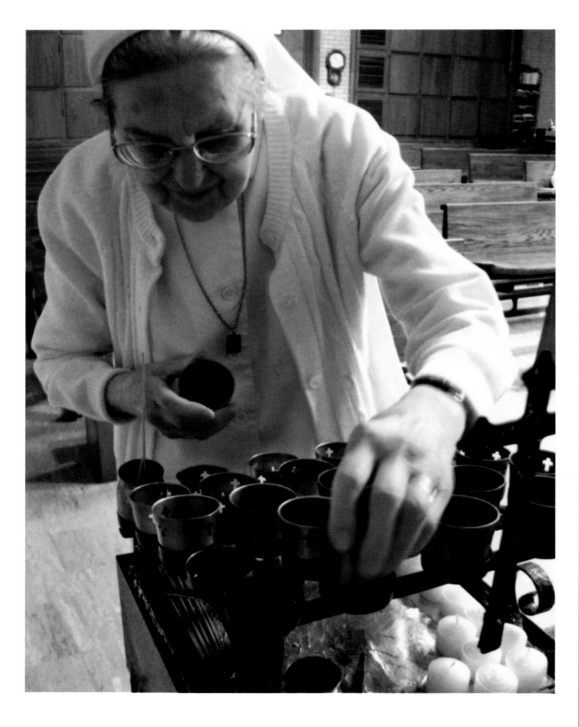

MENOKEN

All in the family: At St. Hildegard's Church, Father David Richter performs the baptism of his nephew James Joseph, held by dad Patrick Richter. Surrounding them are the newborn's aunt Lisa (left) and two uncles, Andy and Thomas. That's mom Denise on the right.

Photo by Tom Stromme

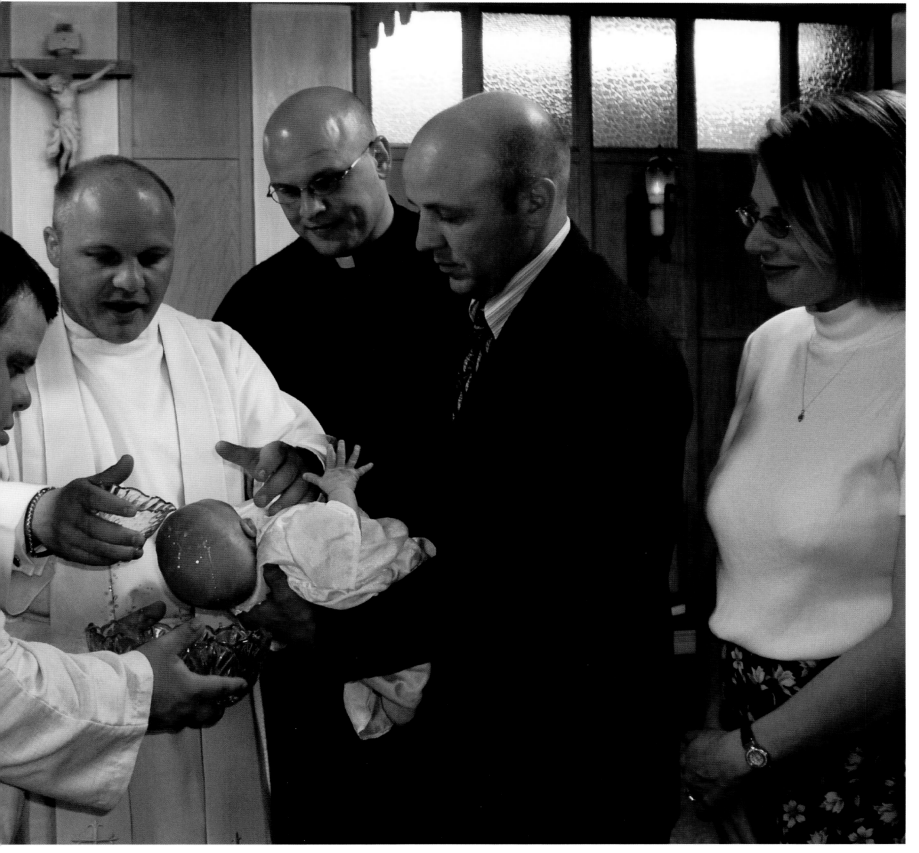

In St. Mary's Church at Assumption Abbey, Father Valerian bows for morning prayers. The 35 monks who live at the 100-year-old Benedictine abbey pray four times each day—when they're not at work in the monastery garden, the wine cellar, the infirmary, or the gift shop.
Photos by Jerry Anderson

RICHARDTON

Viewed through the arches of the cloister, a statue of Our Lady of the Immaculate Conception graces the Assumption Abbey courtyard.

RICHARDTON

Brother Llewellyn Kouba manages the Assumption Abbey pottery studio. A potter who has lived in the abbey since 1976, Brother Llewellyn makes both hand-built and wheel-thrown stoneware and porcelain pieces that are sold in the abbey gift shop. Behind him is the Benedictine medal rendered in oil.

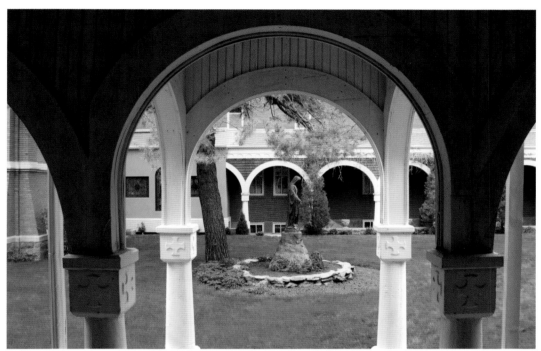

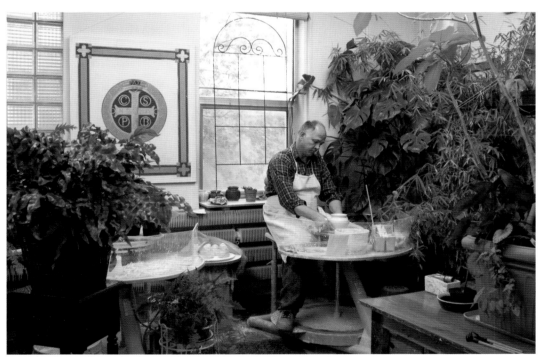

STANDING ROCK INDIAN RESERVATION

At Fort Yates, a wooden cross marks a grave on the reservation cemetery. The fort was built in the 19th century so soldiers could watch over the Native people who lived there. Today, the reservation is home to Yanktonai, Hunkpapa, and Blackfoot Sioux.

Photo by Suzy Q Bee

STANDING ROCK INDIAN RESERVATION

At the cemetery at Fort Yates, a headstone remembers an Indian scout who worked with the U.S. Army during the Indian Wars. Despite a major victory at the Battle of Little Bighorn in 1876, Indian resistance in the Northern Plains formally ended with the surrender of Sioux Chief Sitting Bull in 1881.

Photo by Suzy Q Bee

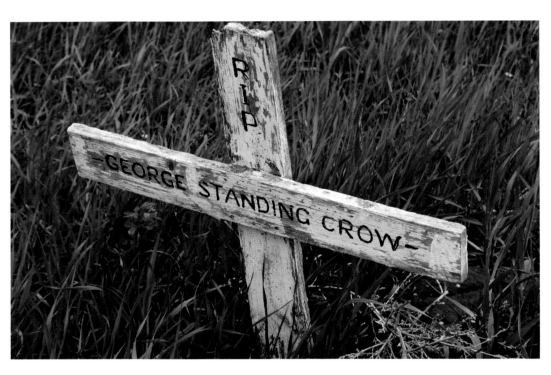

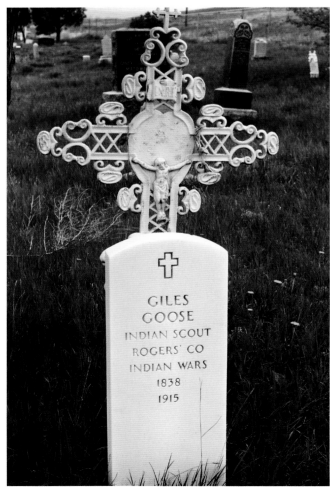

BOWDON

Arne Thomas Fortney homesteaded in Wells County in 1904 and donated 12 acres to Bowdon for a cemetery. In 1980, his grandson, James Fortney, realized that 20 of the graves were unmarked. He raised $6,000, researched old records, and had tombstones erected. "Even though our town is small—just 139 residents—it is important to honor folks who lived here," he says.

Photo by Lewis Ableidinger

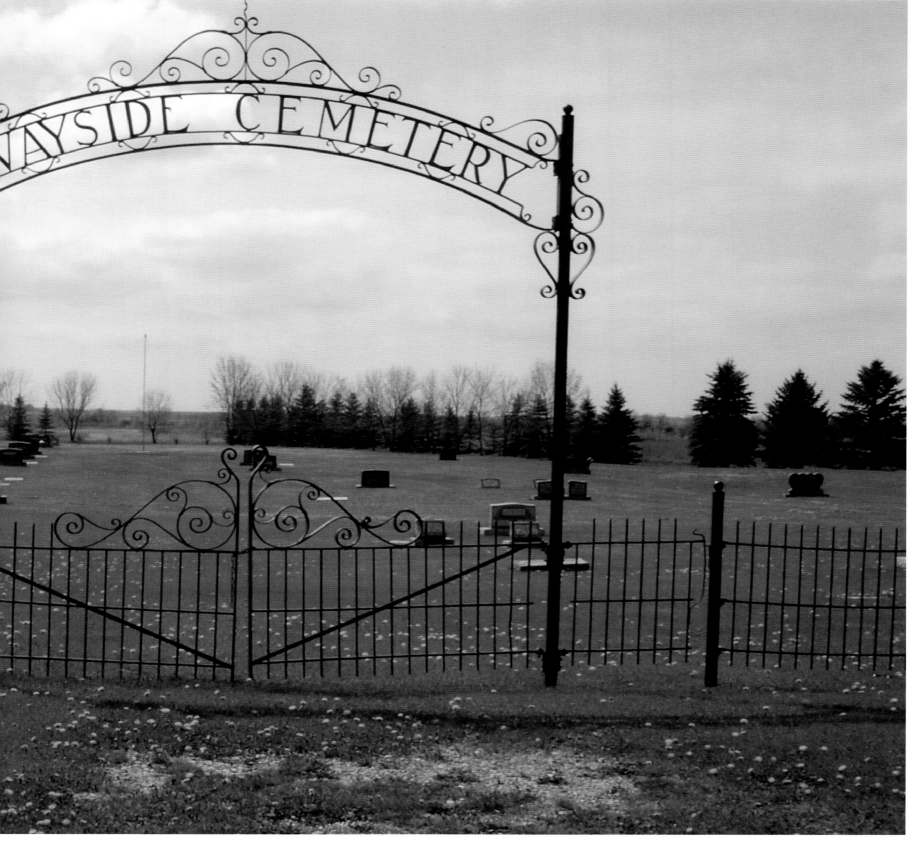

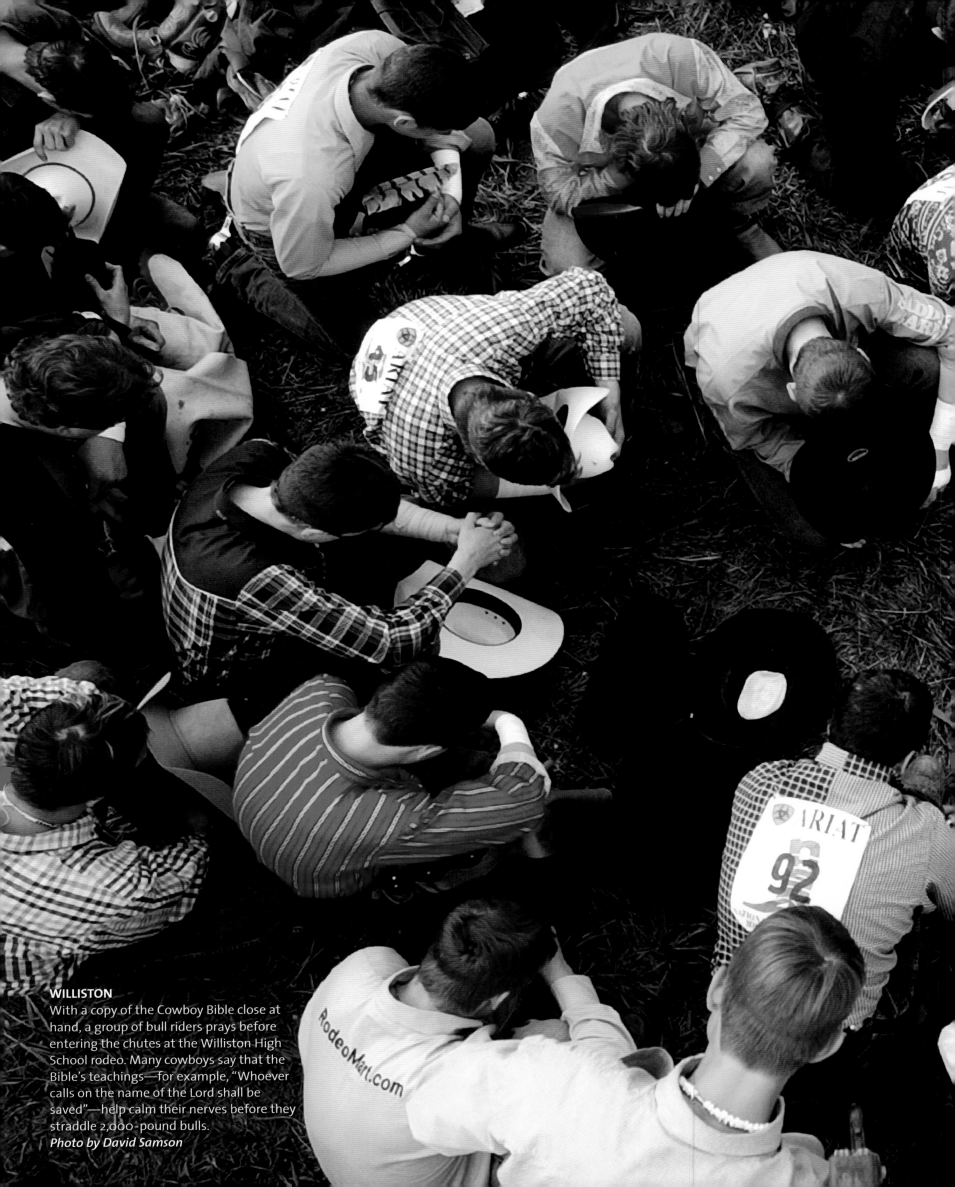

WILLISTON

With a copy of the Cowboy Bible close at hand, a group of bull riders prays before entering the chutes at the Williston High School rodeo. Many cowboys say that the Bible's teachings—for example, "Whoever calls on the name of the Lord shall be saved"—help calm their nerves before they straddle 2,000-pound bulls.
Photo by David Samson

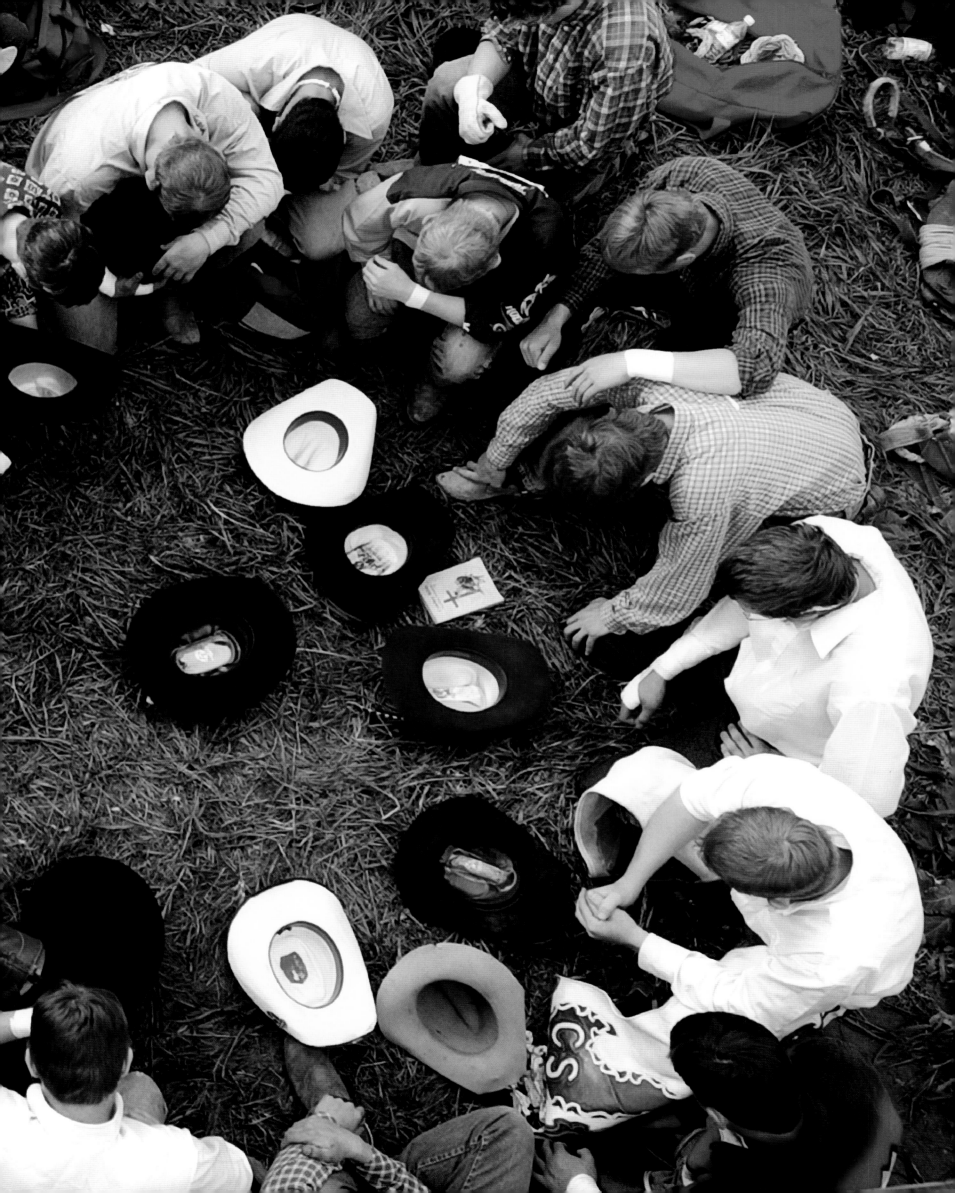

SIBLEY

As migration out of rural North Dakota has increased over the past decade, many prairie churches have been abandoned and fallen into disrepair. Built in 1900, Ladbury Church was near collapse when a nonprofit group called Preservation North Dakota offered to help the community restore it. In 2002, the church reopened with a wedding.
Photo by Meg Luther Lindholm

MOORETON

Settlers built the St. Paul's Lutheran Church in 1888. When the congregation disbanded in 1952, it fell into a state of disrepair and was torn down. Today, Wayne Egenes, president of the St. Paul's Cemetery Association, maintains a miniature replica.
Photo by Dave Arntson

CARRINGTON

Built in 1919 and closed in 1969, the James River Lutheran Church now serves only as a landmark for drivers on Highway 200.
Photo by Jason Lindsey, JasonLindsey.com

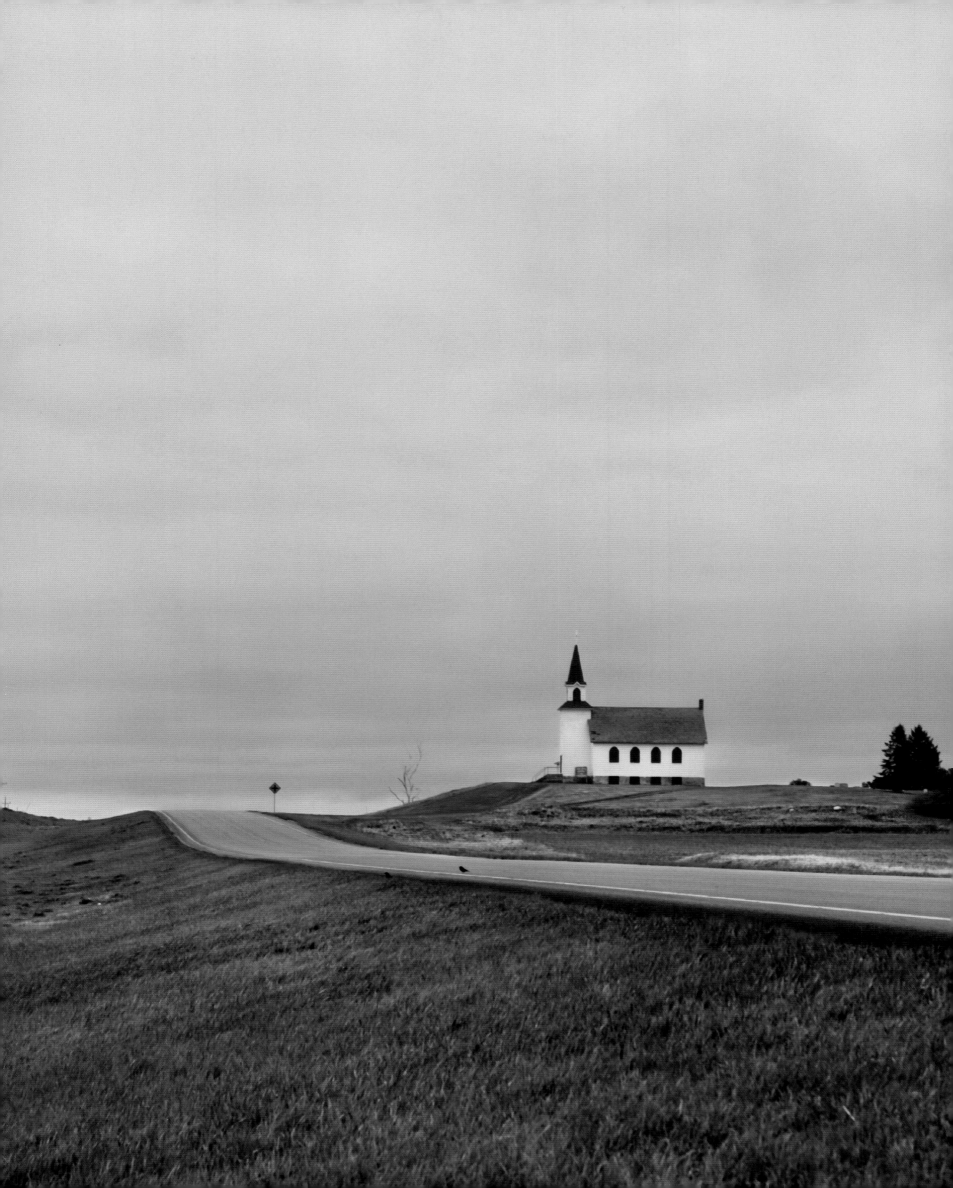

FARGO

Interior designer Dawn Morgan runs the Spirit Room, a nonprofit community art center, hosting poetry readings, CD release parties, and classes in meditation, yoga, and belly dancing. Morgan never knows what to expect from her hometown's spiritual community. "The other day I got a call from a guy who wants me to feng shui his farmhouse," she says.

Photo by Meg Luther Lindholm

FARGO

Father Jack Davis celebrates mass at St. Mary's Cathedral. A native of Devils Lake, Davis was ordained a Catholic priest. In the mid-70s, he requested an assignment in Chimbote, Peru, where he has been ever since. He returned to Fargo with his parish youth choir to raise funds for his mission work.

Photo by Colburn Hvidston III, The Forum, Fargo

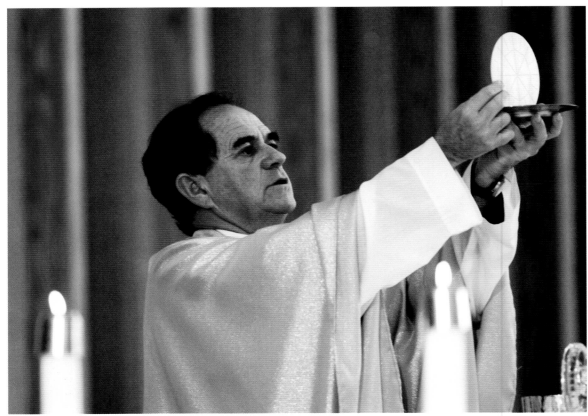

FARGO

The Peruvian youth choir traveling with Father Davis sings the morning mass at St. Mary's Cathedral. Later that day, they performed a concert of songs and dances at St. Anthony's Church in south Fargo.

Photo by Colburn Hvidston III, The Forum, Fargo

FARGO

Every Monday night, Mary Handberry has dinner with Brad Gray at his home. After eating, they prepare for that evening's catechesis class, which they teach together at St. Mary's Cathedral.

Photo by Ed Vizenor, Wisdom Productions

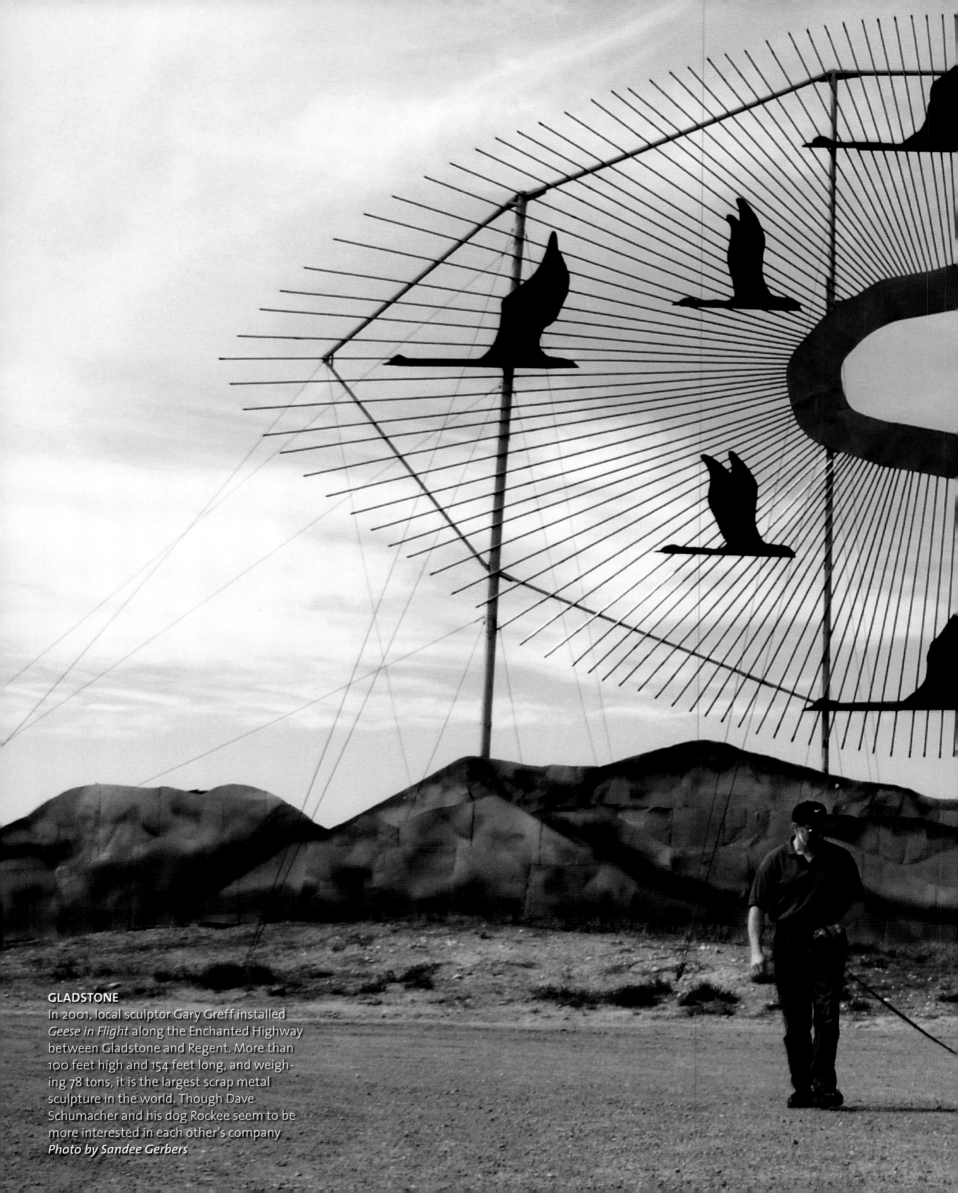

GLADSTONE
In 2001, local sculptor Gary Greff installed *Geese in Flight* along the Enchanted Highway between Gladstone and Regent. More than 100 feet high and 154 feet long, and weighing 78 tons, it is the largest scrap metal sculpture in the world. Though Dave Schumacher and his dog Rockee seem to be more interested in each other's company
Photo by Sandee Gerbers

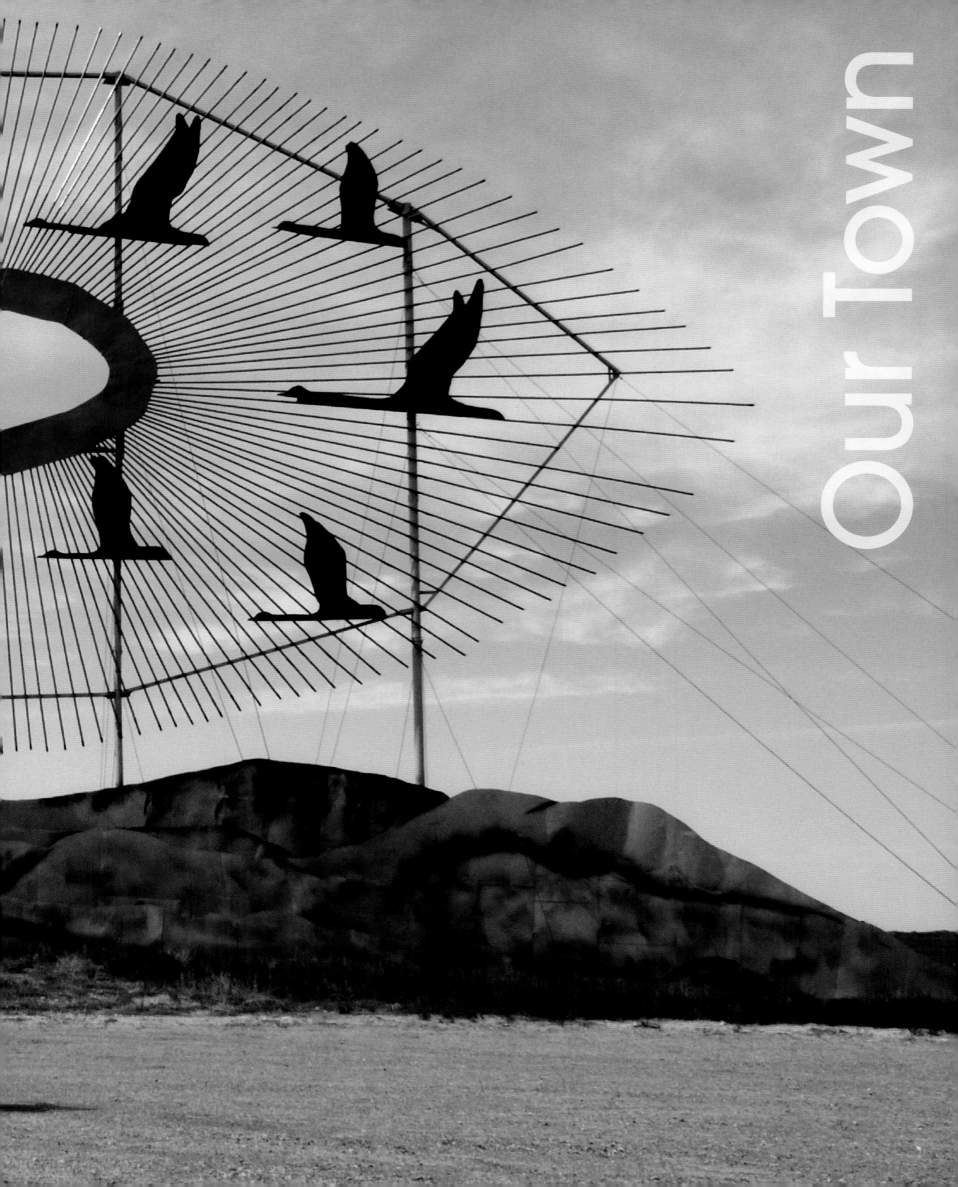

Our Town

FARGO

The blank marquee of the Fargo Theatre obscures the 1926 movie house's fascinating history. In its early days, it staged vaudeville acts and musical revues, screened silent films, and featured appearances by Lillian Gish, Tom Mix, and Babe Ruth. A $2.6 million restoration, completed in 1999, has readied it for another 75 years of films and live performances.
Photo by Darren Gibbins

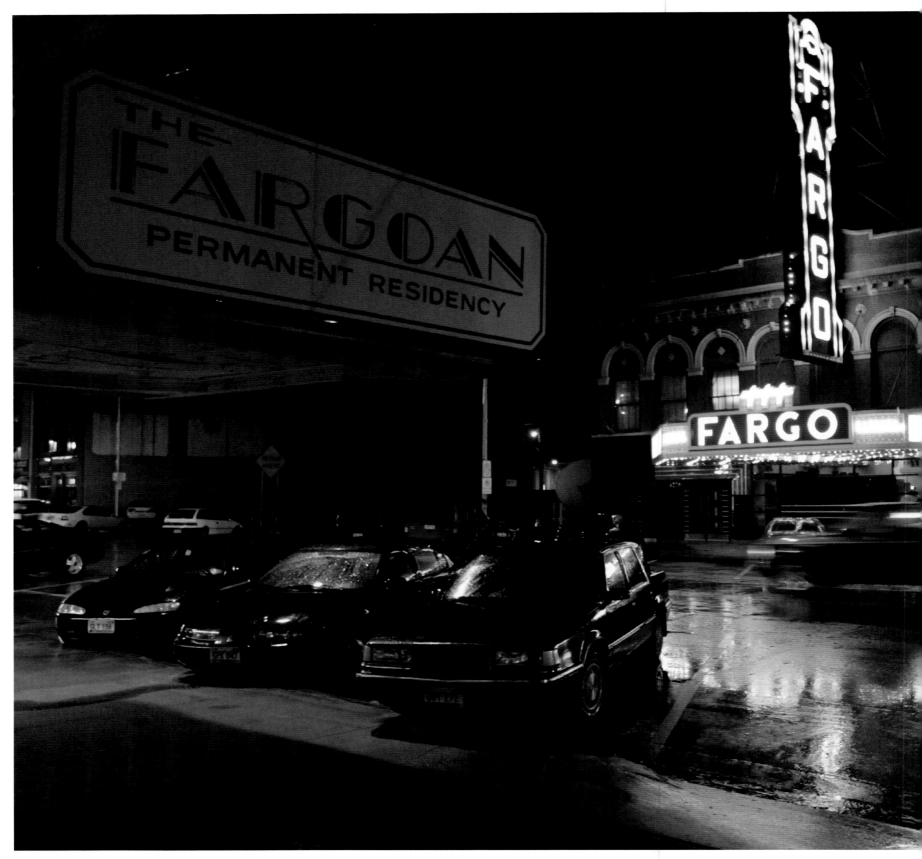

FARGO

Recycling takes center stage in Fargo. The YMCA took over this former cattle barn, built the silo-shaped wing, and started holding classes in 1997. The facility has expanded several times, and now offers an indoor climbing wall and skatepark.
Photo by Ludvik Herrera

FARGO

The Northern Pacific Depot has been a Fargo nexus since it opened in 1898. To help pay for a major renovation in 1981, 9,000 bricks were sold at $20 each, engraved with contributors' names, and used to pave the courtyard. Businesses donated furnishings, including the pedestal clock, globe lights, and wrought-iron tables and chairs.
Photo by David Samson

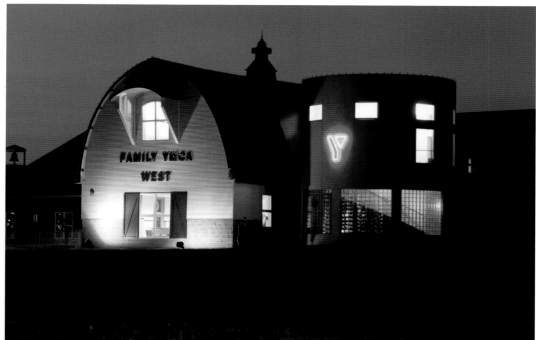

VALLEY CITY
President's House Preservation Society members Janice Stowman and Kara Kramin sweep the front steps. The five-bedroom house was built in 1901 for local doctor Ludvig Platou. From 1929 to 1993, the Valley City State University presidents lived here. In 1995, the 102-year-old Victorian opened its doors to the public.
Photo by Meg Luther Lindholm

EDINBURG
The Edinburg branch of the American Legion has 83 members who either fought in World War II, Korea, or Vietnam. The post provides four college scholarships each year for high school seniors and conducts honor guard services for veterans' funerals.
Photo by Wayne Gudmundson

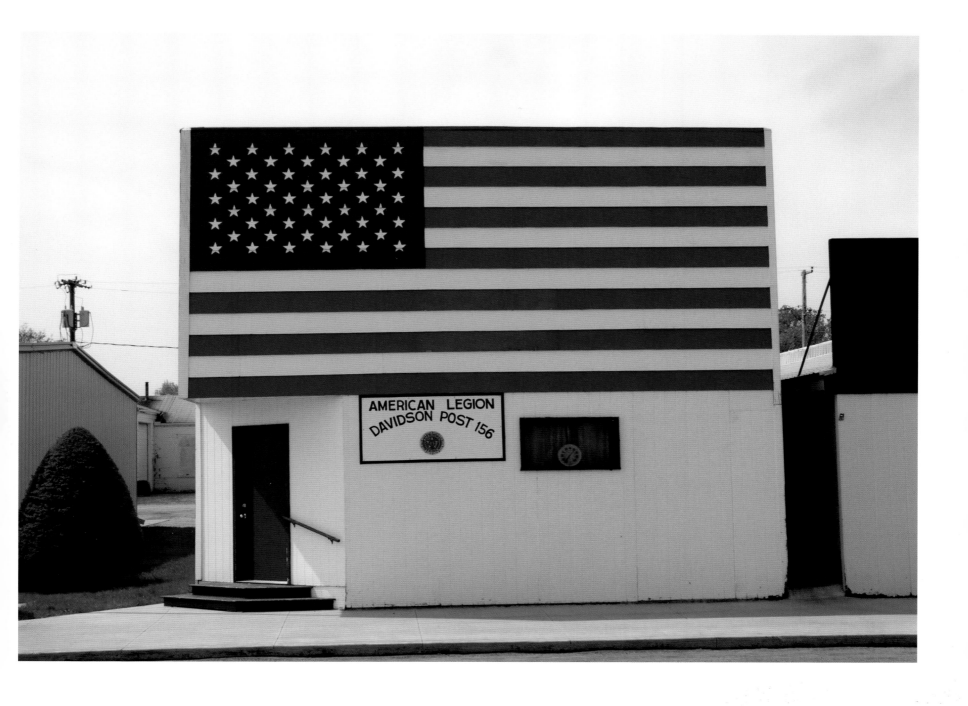

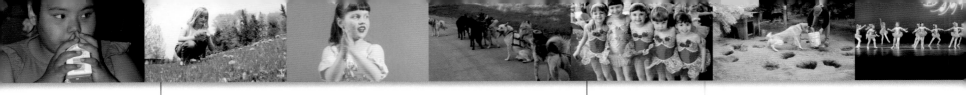

FARGO

Stop to smell the dandelions: Brittany Llewellyn rarely has time for such quiet moments. The 10-year-old is in the Fargo-Moorhead community choir, plays oboe and piano, and performs as a clown with her two sisters at birthday parties and fairs. Her father, who put himself through college on clown earnings, taught the girls the tricks of the trade.

Photo by Sandee Gerbers

GRAND FORKS

Shannon Lee, Erin Hylden, Hannah Modeen, Hannah Phelps, and Aly Corbid line up backstage at the Chester Fritz Auditorium. They're about to perform in "Miracles Happen," the Nancy Pasley Ballet School's ballet, tap, and jazz recital.

Photo by Jackie Lorentz

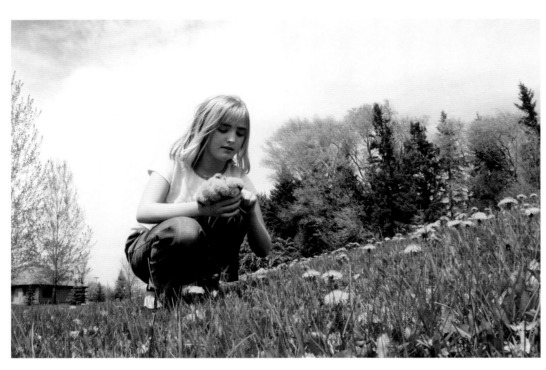

DEVILS LAKE
Prairie View Elementary School fifth-graders
Tracy Schlieve, Kole Jenson, Daniel Wahl, Haley
Prozinski, Kaitlin Kavli, and Brittni Baker form a
Frisbee huddle during gym class.
Photo by Arika Viktoria Johnson

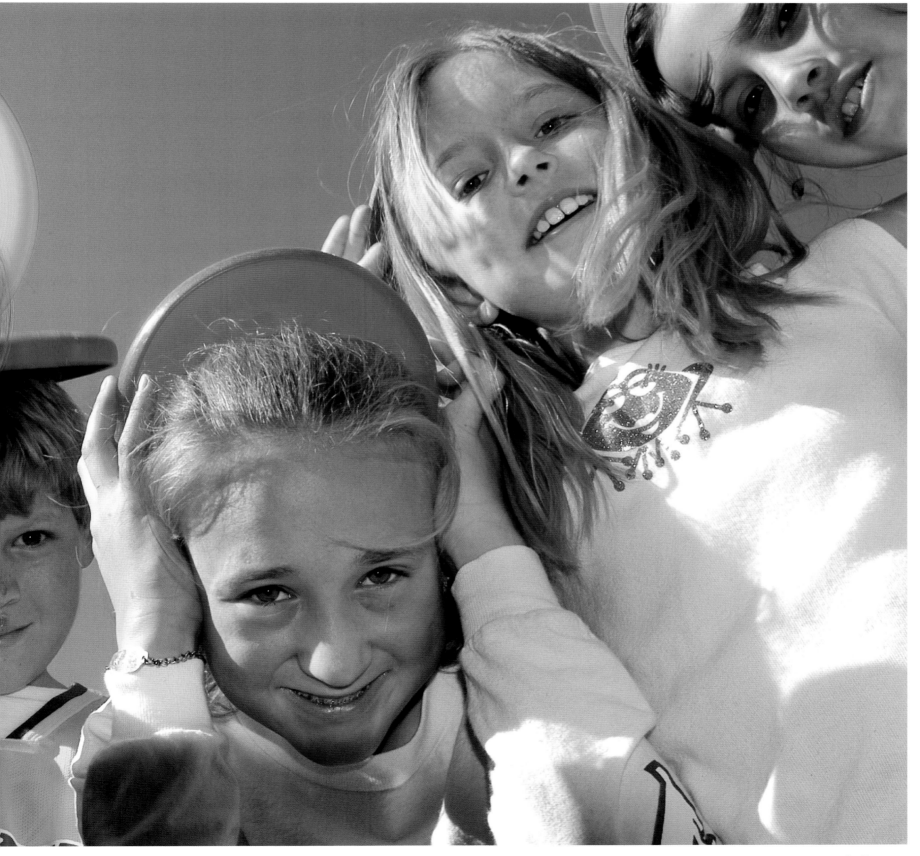

Cathedral of the Holy Spirit School kindergartners
Jordan Smith, Tate Barnhardt, Travis Famias,
Andrew Eckroth, and Michael Fletcher put away
their supplies before leaving music class. The K-8
Catholic school opened in 1946 and it has since
graduated 2,000 students.
Photo by Tom Stromme

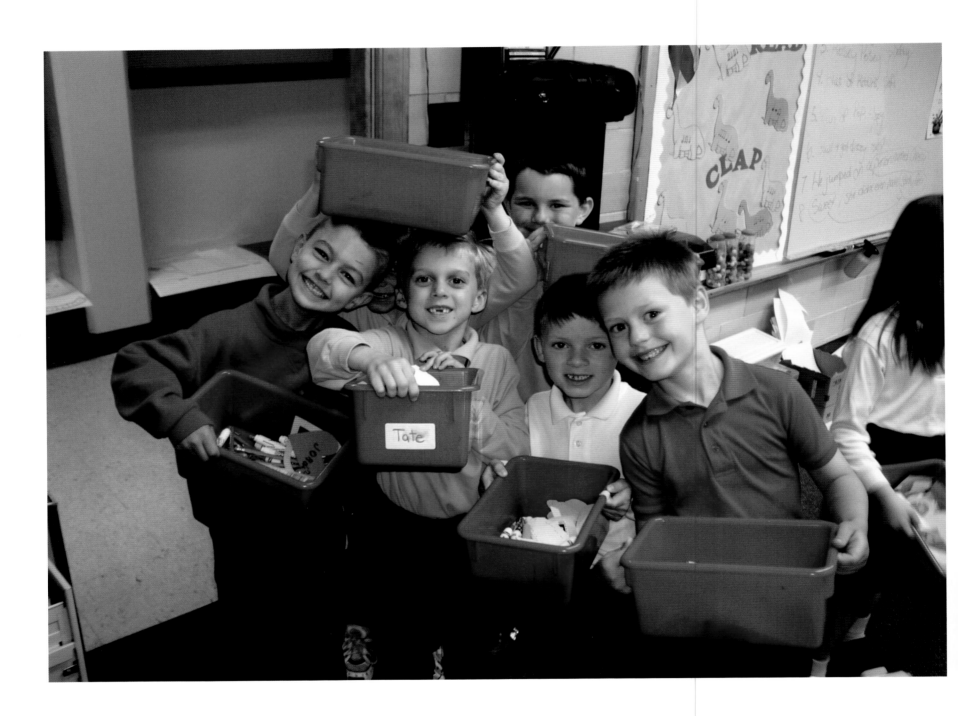

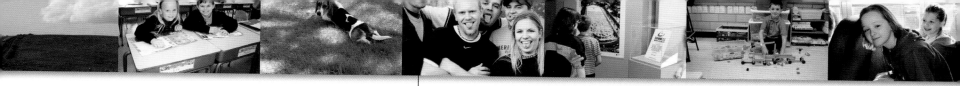

BISMARCK

North Dakota twenty-somethings are just like twenty-somethings anywhere else: They like to hang out, date, and have their tongues and lips pierced—like these five friends who mug for the camera in Sertoma Park along the Missouri River.
Photo by Suzy Q Bee

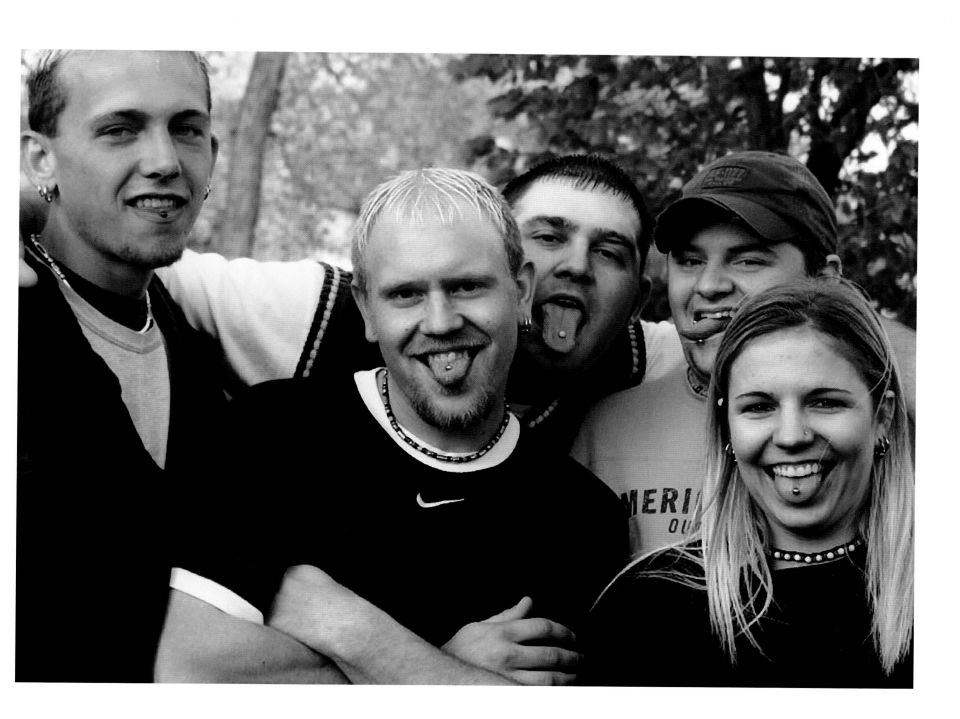

FORDVILLE

Elizabeth Maendel, 87, works in the greenhouse at the Forest River Community. All the flowers are used by the 95 Hutterite residents, while half of the vegetables go up for sale.

Photo by Jackie Lorentz

FARGO

Outdoorswoman Bernice Ihlenfeld, 90, who spent her youth fishing, hunting, and playing tennis, hasn't let the years slow her down. "Once the knees go, you play golf instead of tennis," says Ihlenfeld. "When that is no longer possible, you swim and garden."

Photo by Meg Luther Lindholm

MARMARTH

Linda Ferrell gets her hair done at Roxy's Foxy Locks Shop. To her right is the door to a tanning booth with a sign touting "new bulbs." Roxy's is one of the few businesses in Marmarth, pop. 135.

Photo by Dan Koeck

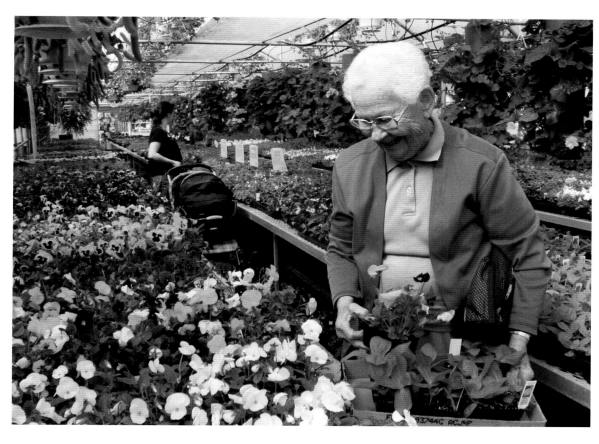

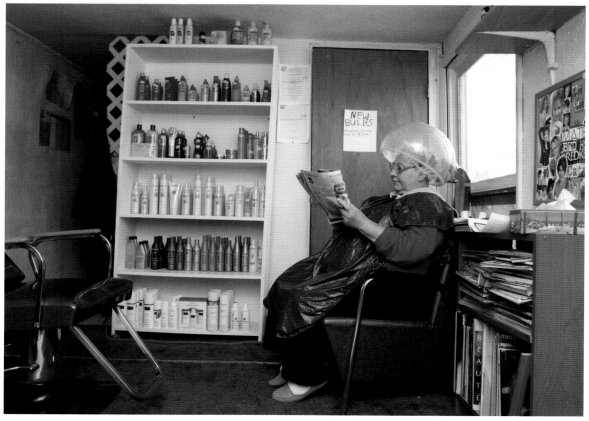

AYR

Antiquarian Keith Johnson, 82, drives his 1903 Oldsmobile down 3rd Avenue past the Ayr Store Company, one of five early 1900s buildings he's restored over the past 20 years. Johnson undertook the self-funded civics project in memory of his son Lonnie, who loved his tiny, 50-person hometown.

Photo by Meg Luther Lindholm

WASHBURN

At the Lewis & Clark Fort Mandan Foundation, reenactors Mike Scholl and Gary Anderson hew out a giant cottonwood log to make a canoe like those used during the expedition.

Photo by Tom Stromme

MANDAN

Mark Kenneweg, interpretive director of Fort Abraham Lincoln State Park, cooks pitchfork fondue with bison steaks. This day he was commemorating the 127th anniversary of when General Custer and the men of the Seventh Calvary left for the Little Big Horn.

Photo by Tom Stromme

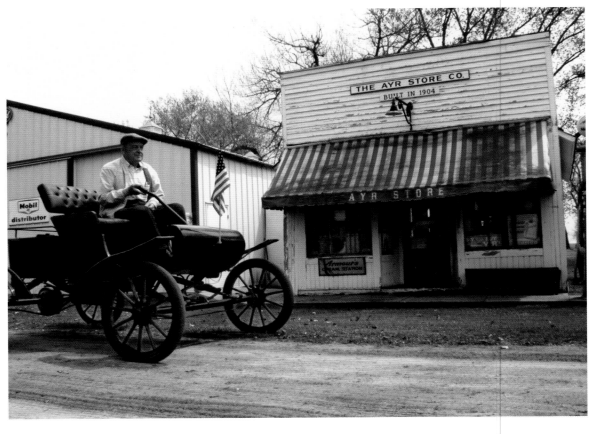

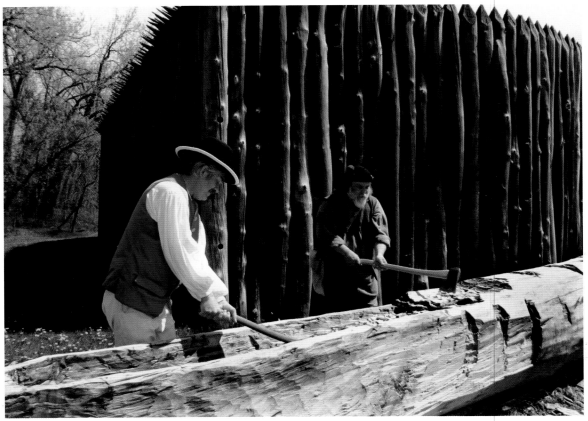

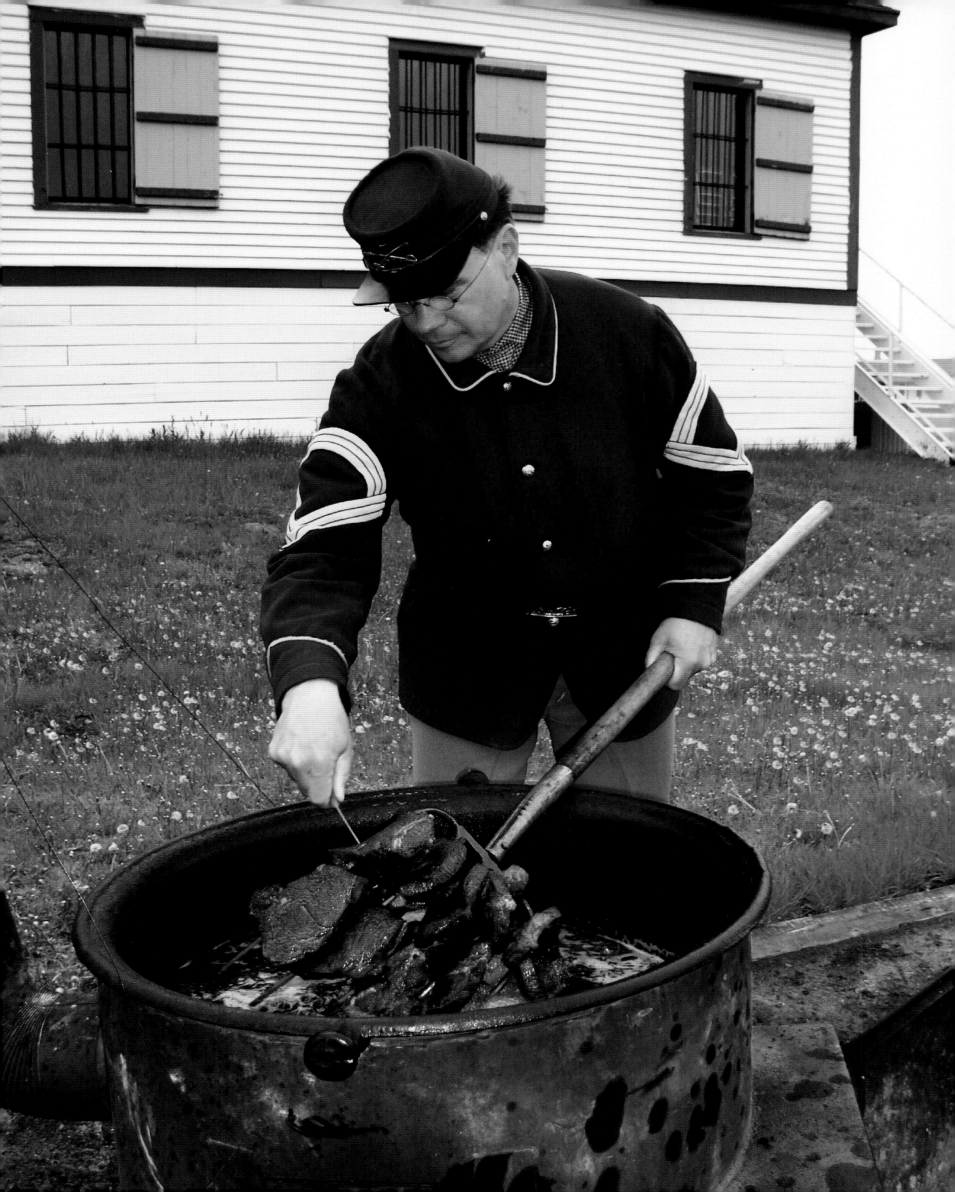

FORT BERTHOLD INDIAN RESERVATION
Adult-education graduates Madison McDonald, Virginia Young Bird, Clifton Whitman, Jr., and Murphy Bell prepare for their commencement ceremony at Fort Berthold Community College. The college offers a variety of certificate and continuing education programs in tribal studies, agriculture, business, and liberal arts.
Photo by Jason Lindsey, JasonLindsey.com

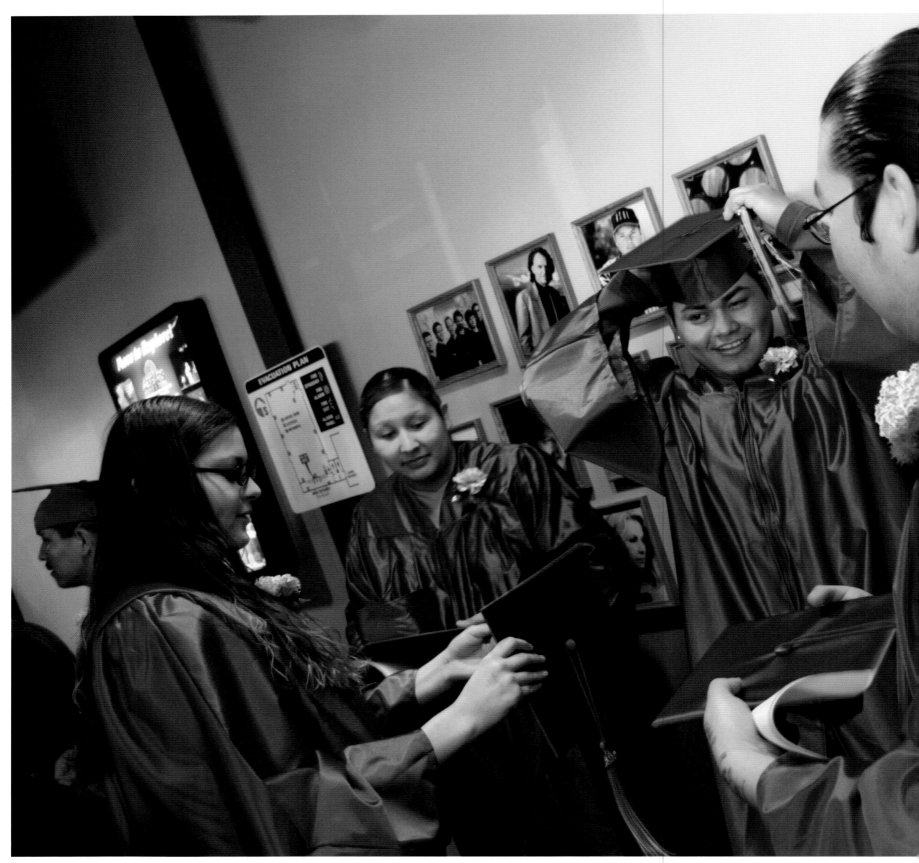

CALVIN

Katie Thomas and Steve Wold are the salutatorian and valedictorian, respectively, of Border Central School. They're also the only students in the 2003 graduating class. A K–12 school, Border Central has a total of 28 students and serves the towns of Calvin and Sarles.

Photo by Eric Hylden, Grand Forks Herald

FORT BERTHOLD INDIAN RESERVATION

Instead of "Pomp and Circumstance," graduates of Fort Berthold Community College walk down the aisle to Mandan, Hidasta, and Arikira songs performed by The Little Shell Singers.

Photo by Jason Lindsey, JasonLindsey.com

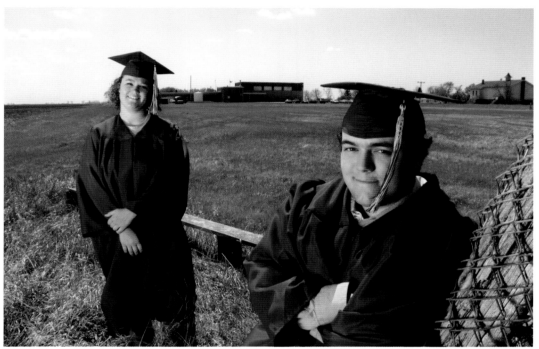

FARGO

After his parents were killed in Sudan's civil war, Elijah Maluk became one of the "Lost Boys," and spent 13 years in African refugee camps. The Lutheran Social Services agency resettled him in Fargo in 2001. Admitted to Oak Grove High School, the 17-year-old joined the track team and ran the half-mile in 1:59, placing third in the state.
Photo by Darren Gibbins

FARGO

International Islamic Girl Scouts Naima Abdinasir, Sadia Abdinasir, Farhiyo Abdulkarim, and Huda Bashir call their group by its acronym, IIGS. They are making a quilt for a Bosnian refugee family in Fargo. Founded in 2002, North Dakota's only Muslim Girl Scout troop has 45 girls from the state's 2,000 Muslims.

Photo by Dave Arntson

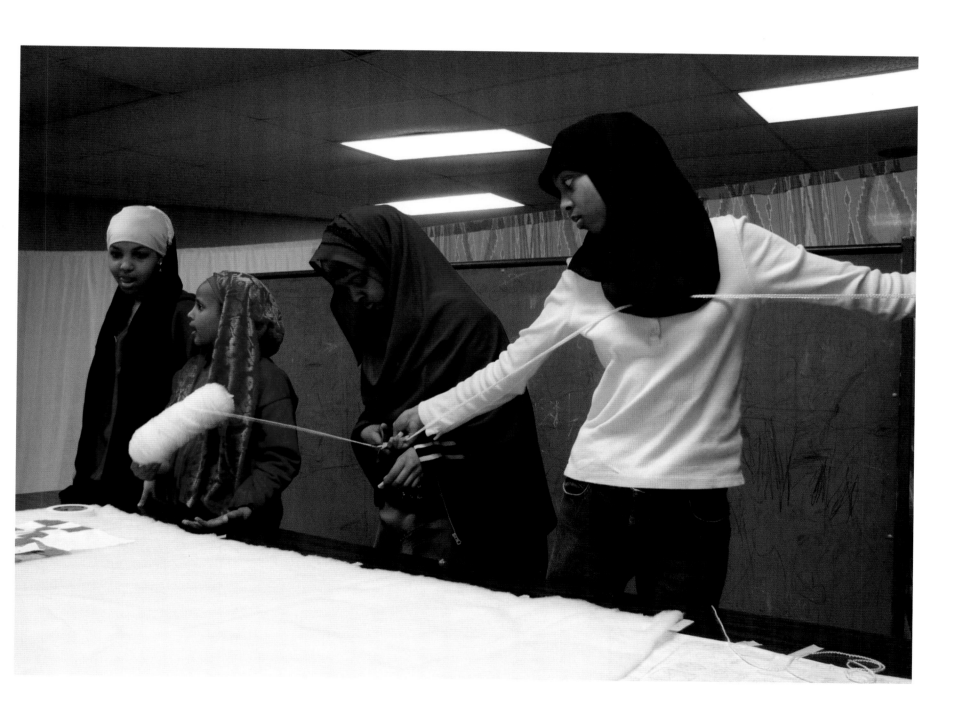

DEVILS LAKE

While most students at Devils Lake High School don prom dresses and suits for "Dress Your Best Day," sophomore Pac Konzak chose a Canadian military school uniform and senior Carol Whitson selected a medieval gown to be different. Ballerina Paige Johnson joins the duo outside The Liquid Bean cafe.

Photo by Arika Viktoria Johnson

FARGO

Dustin Buchanan and Aanaleah Shaw, sophomores at Minnesota State University at Moorhead, hang out in the parking lot of the West Acres Cinema. A group of 12 friends is spending two nights here waiting for tickets to go on sale for *The Matrix Reloaded*. To pass the time, they brought food, video games, DVDs, skateboards, and homework.

Photo by Ludvik Herrera

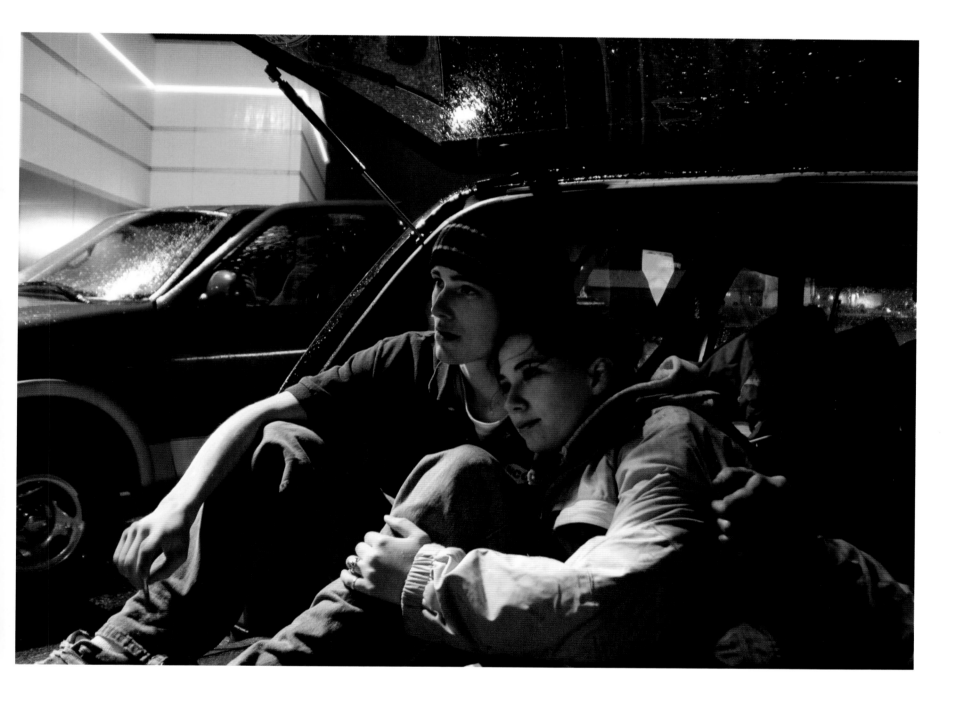

JAMESTOWN

General education teacher Sue Judd helps
Michael Gunderson create his page in the birth-
day book at the Anne Carlsen Center for Children,
where he is one of 51 residents. Born with
myelomalacia (a softening of the spinal cord),
Michael, 8, has little motor control, so therapists
outfitted him with a laser head pointer to help
him communicate.
Photo by Sandee Gerbers

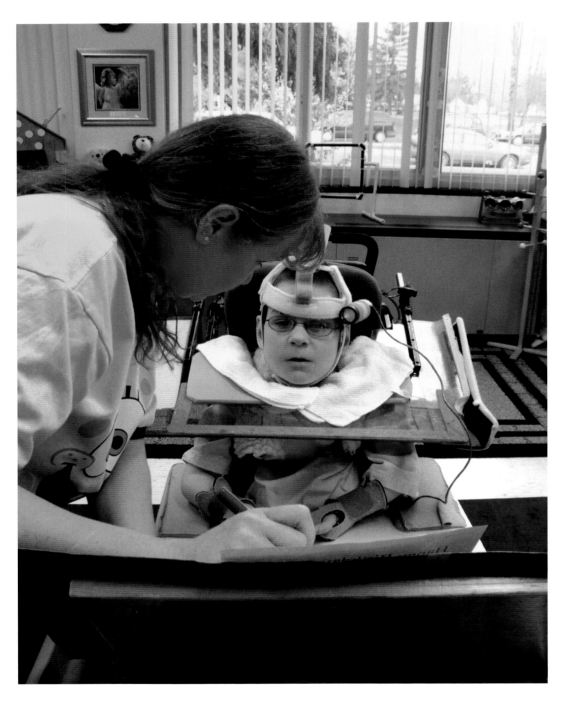

MORTON COUNTY

Say ahhh! At the one-room Sweet Briar School, seventh-graders Justin Schwab and Jed Luther test out an otoscope provided by a visiting doctor who spoke about the medical profession. Twelve students, kindergarten through eighth grade, attend the rural school.
Photo by Will Kincaid

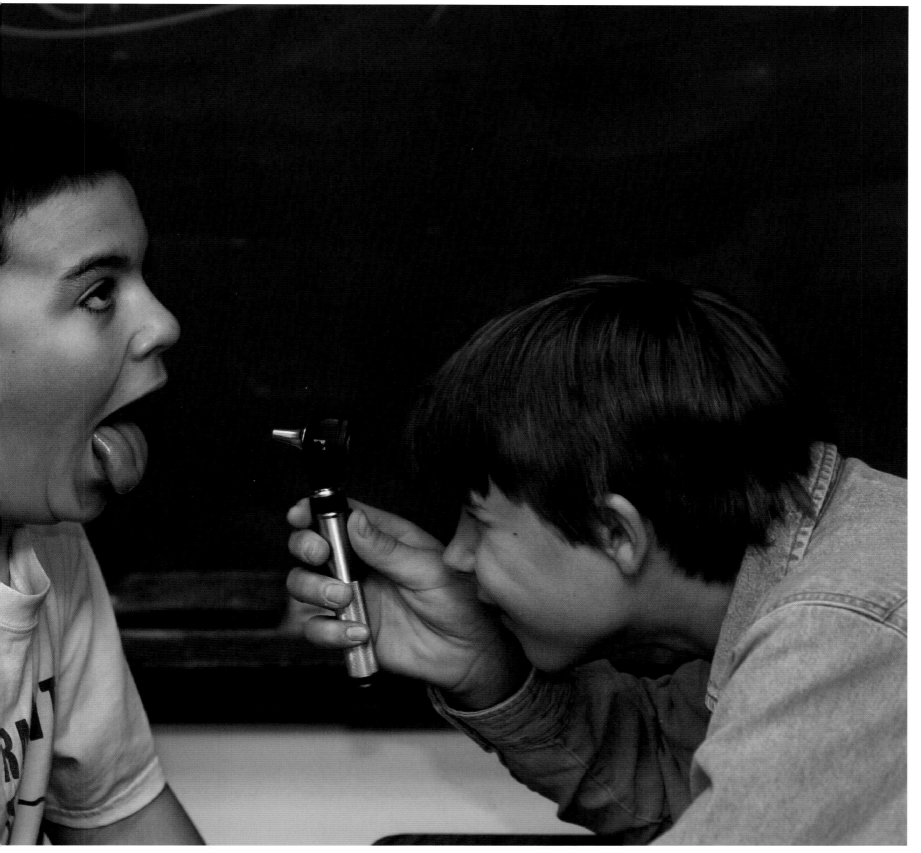

MEDORA

Wild horses roam the acres of Theodore Roosevelt National Park. Horses became extinct in North America 10,000 years ago but were reintroduced by the Spanish in the 16th century. Steeds clever enough to elude humans were called mustangs, from an old Spanish word, *mesteño*, meaning wild.
Photo by Amy Taborsky,
Bismarck Tribune

FARGO

For his wife Andrea's birthday, Scott Seibel crafted this sign for the entrance to their place on County Road 20. The beams are cast-off telephone poles; the horse design was hand-torched out of quarter-inch steel.
Photo by David Samson

MORTON COUNTY

Neigh-sayer: On a country road south of Mandan, a horse expresses itself.
Photo by Suzy Q Bee

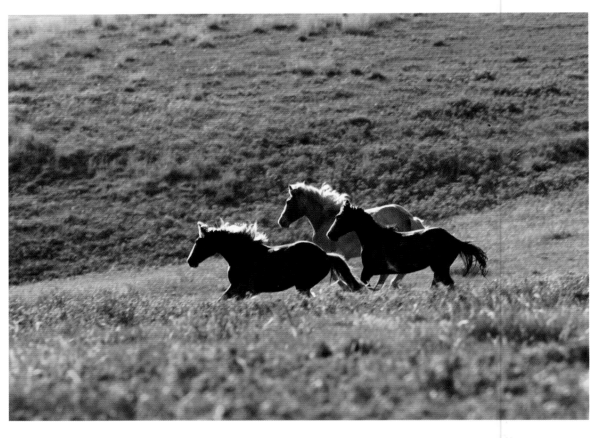

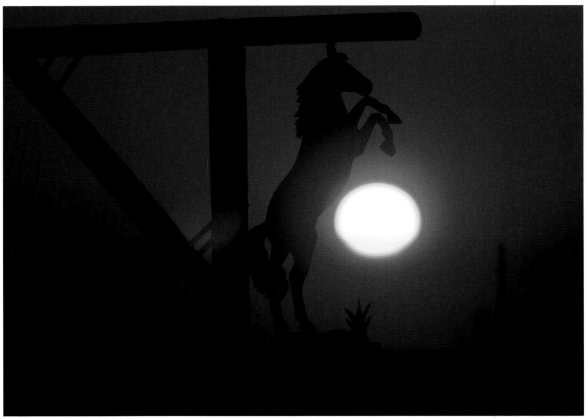

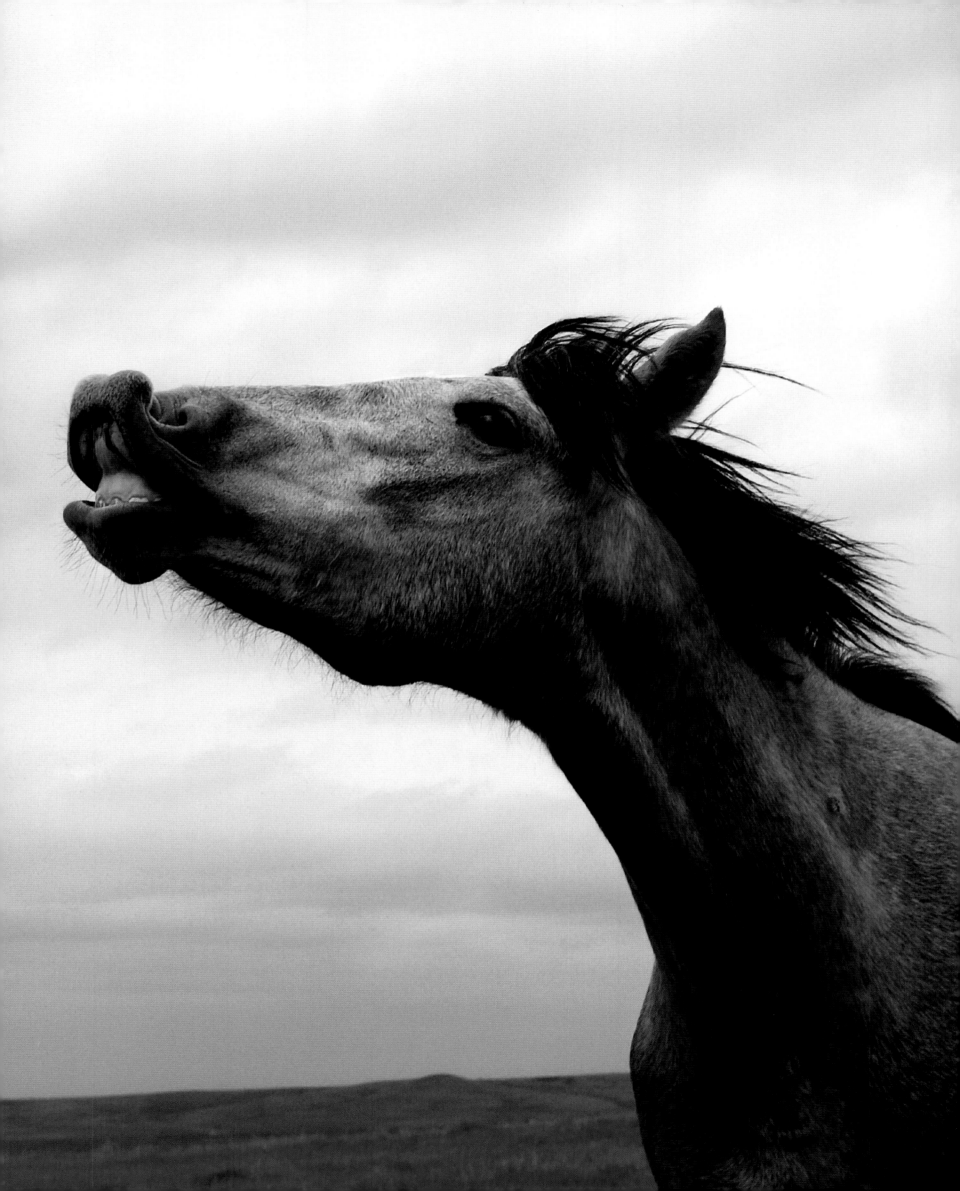

FORT BERTHOLD INDIAN RESERVATION
An American bison eyes photographer Jason Lindsey. They can weigh up to 2,400 pounds and stand as tall as 6.5 feet. Near extinction in the late 1800s, bison now number 400,000, and 1,100 live on this reservation.
Photo by Jason Lindsey, JasonLindsey.com

FORT BERTHOLD INDIAN RESERVATION

Ted Siers, assistant manager of the Three Affiliated Tribes Buffalo Project, drives through a 32,000-acre pasture to deliver feed to his dependents. Since 1982, Theodore Roosevelt National Park has given its excess stock to the reservation, which invites the public in for hunts, charging up to $2,000 for a trophy kill.

Photo by Jason Lindsey, JasonLindsey.com

WATFORD CITY

American bison were reintroduced to the Theodore Roosevelt National Park in 1963 after an absence of about 100 years. The 600-head herd roams the Sage Creek wilderness area of the park.

Photo by Dan Koeck

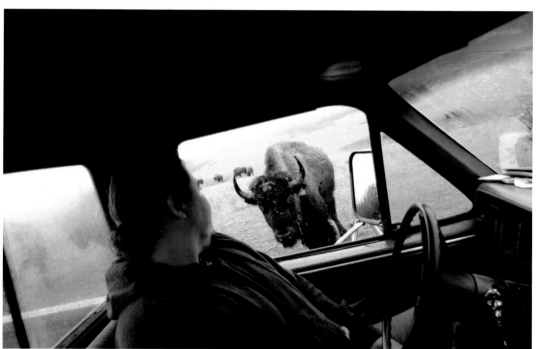

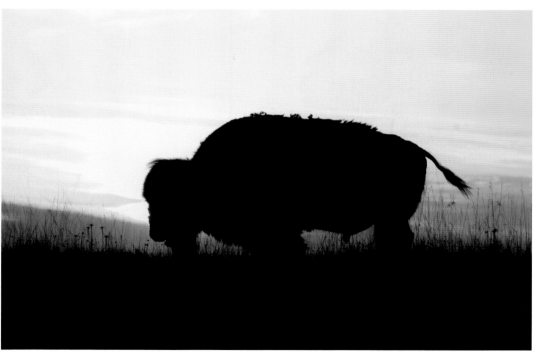

PARK RIVER
The Park River Community Development Corporation bought the rundown Lyric Theater in 1997. Five years later, they hooked up with the Park River Public School District and, with grant money, refurbished the early 1900s movie house. It reopened in February 2003 as a nonprofit and is staffed by student volunteers.
Photo by Eric Hylden, Grand Forks Herald

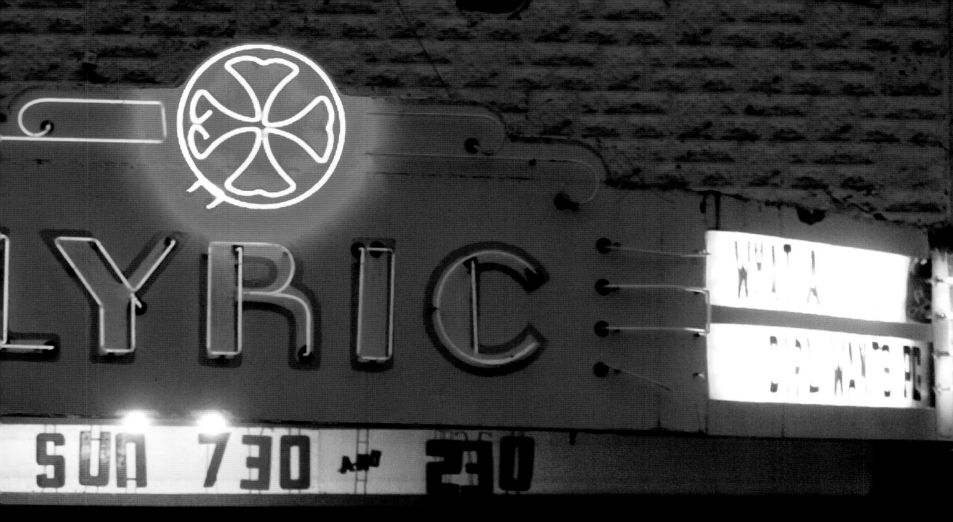

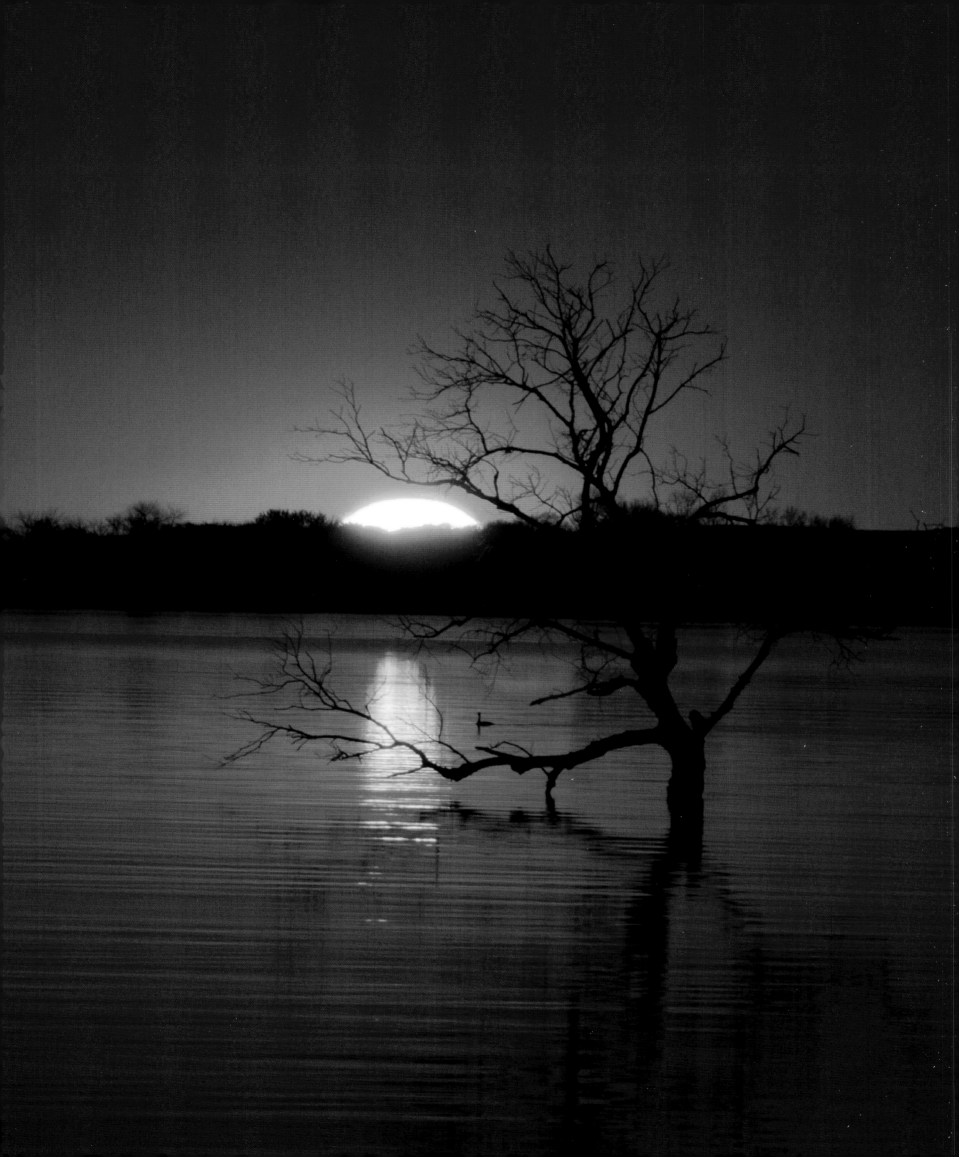

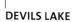

DEVILS LAKE

Due to a decade-long wet cycle in North Dakota's northern prairies, Devils Lake has more than doubled in size since 1993. The flood submerges trees and threatens water quality as the lake's accumulated chlorides and sulfates seep into the surrounding communities' water supplies.

Photo by Arika Viktoria Johnson

GRAND FORKS

Amtrak's Empire Builder runs between Chicago and Seattle/Portland and stops in Grand Forks twice a day. The eastbound trip departs at 12:54 a.m.; the westbound leaves at 5:04 a.m. Amtrak ridership statewide totaled 82,900 in fiscal year 2003, up 22 percent from 2002.

Photo by Kory Wallen

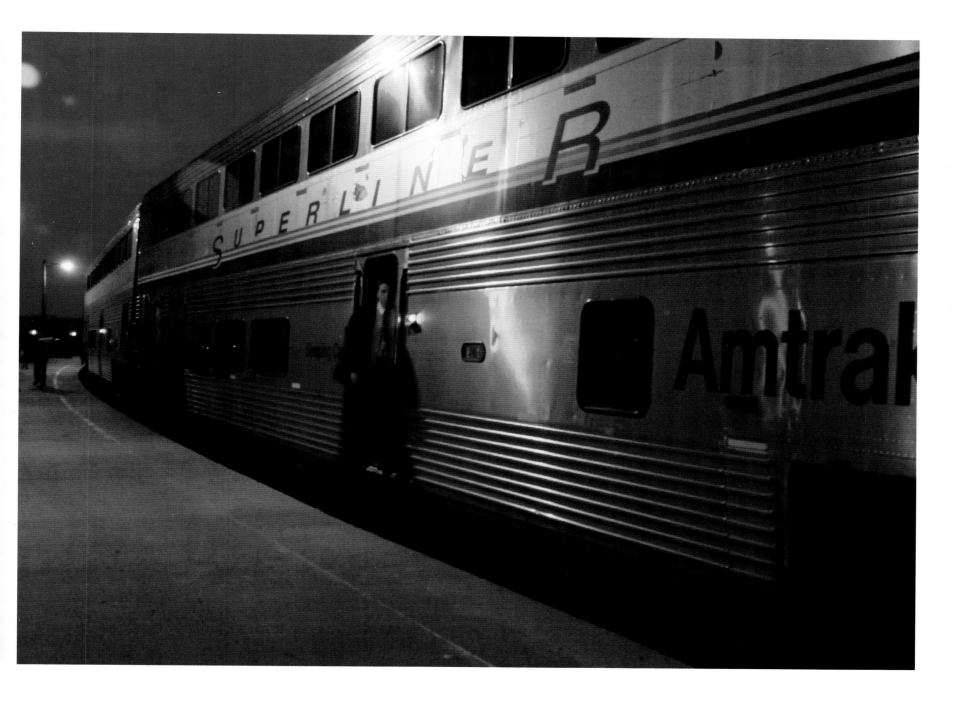

How It Worked

The week of May 12-18, 2003, more than 25,000 professional and amateur photographers spread out across the nation to shoot over a million digital photographs with the goal of capturing the essence of daily life in America.

The professional photographers were equipped with Adobe Photoshop and Adobe Album software, Olympus C-5050 digital cameras, and Lexar Media's high-speed compact flash cards.

The 1,000 professional contract photographers plus another 5,000 stringers and students sent their images via FTP (file transfer protocol) directly to the *America 24/7* website. Meanwhile, thousands of amateur photographers uploaded their images to Snapfish's servers.

At *America 24/7*'s Mission Control headquarters, located at CNET in San Francisco, dozens of picture editors from the nation's most prestigious publications culled the images down to 25,000 of the very best, using Photo Mechanic by Camera Bits. These photos were transferred into Webware's ActiveMedia Digital Asset Management (DAM) system, which served as a central image library and enabled the designers to track, search, distribute, and reformat the images for the creation of the 51 books, foreign language editions, web and magazine syndication, posters, and exhibitions.

Once in the DAM, images were optimized (and in some cases resampled to increase image resolution) using Adobe Photoshop. Adobe InDesign and Adobe InCopy were used to design and produce the 51 books, which were edited and reviewed in multiple locations around the world in the form of Adobe Acrobat PDFs. Epson Stylus printers were used for photo proofing and to produce large-format images for exhibitions. The companies providing support for the *America 24/7* project offer many of the essential components for anyone building a digital darkroom. We encourage you to read more on the following pages about their respective roles in making *America 24/7* possible.

SHOOT

7 images maximum uploaded to online Snapfish accounts

Snapfish servers

10s of 1,000s of amateurs

Photographers use **Adobe Photoshop** to convert RAW images to JPEG, and Photo Mechanic tagging software to add data

1,000 professionals with **Olympus** C-5050 cameras and **Lexar Media** compact flash cards

1,000s of stringers & students

Toolkit, registration info & password via email to photographers laptops

Printer

InDesign layouts output via **Acrobat** to PDF format

5 graphic design and production teams

51 books: one national, 50 states

Produced by 24/7 Media, published by DK Publishing

50 state posters designed by 50 AIGA member firms

24/7

DESIGN & PUBLISH

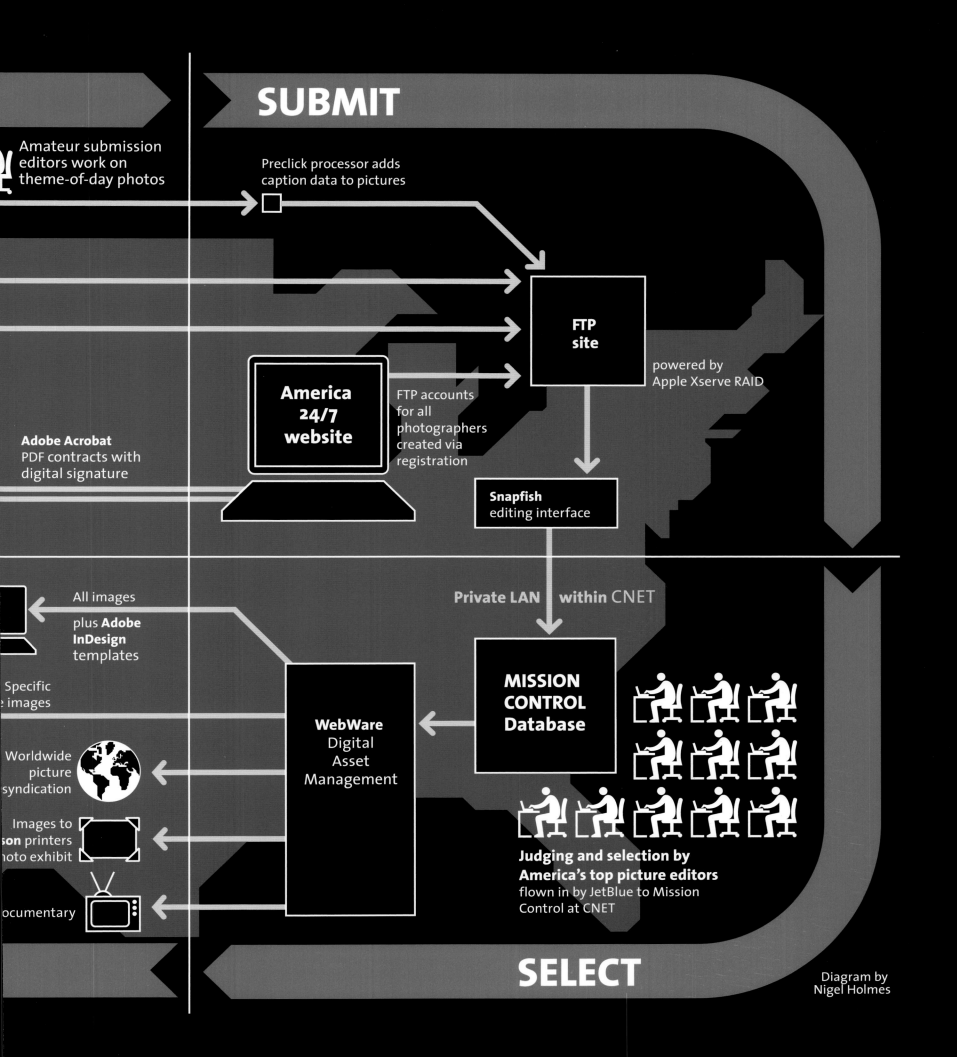

SUBMIT

Amateur submission editors work on theme-of-day photos

Preclick processor adds caption data to pictures

Adobe Acrobat
PDF contracts with digital signature

America 24/7 website

FTP site

powered by Apple Xserve RAID

FTP accounts for all photographers created via registration

Snapfish editing interface

All images

plus **Adobe InDesign** templates

Specific images

Worldwide picture syndication

Images to son printers oto exhibit

ocumentary

Private LAN **within** CNET

WebWare Digital Asset Management

MISSION CONTROL Database

Judging and selection by America's top picture editors flown in by JetBlue to Mission Control at CNET

SELECT

Diagram by Nigel Holmes

About Our Sponsors

America 24/7 gave digital photographers of all levels the opportunity to share their visions of what it means to live in the United States. This project was made possible by a digital photography revolution that is dramatically changing and improving picture-taking for professionals and amateurs alike. And an Adobe product, Photoshop®, has been at the center of this sea change.

Adobe's products reflect our customers' passion for the creative process, be it the photographer, graphic designer, layout artist, or printer. Adobe is the Publishing and Imaging Software Partner for *America 24/7* and products such as Adobe InDesign®, Photoshop, Acrobat®, and Illustrator® were used to produce this stunning book in a matter of weeks. We hope that our software has helped do justice to the mythic images, contributed by well-known photographers and the inspired hobbyist.

Adobe is proud to be a lead sponsor of *America 24/7*, a project that celebrates the vibrancy of the American spirit: the same spirit that helped found Adobe and inspires our employees and customers to deliver the very best.

Bruce Chizen
President and CEO
Adobe Systems Incorporated

Olympus, a global technology leader in designing precision healthcare solutions and innovative consumer electronics, is proud to be the official digital camera sponsor of *America 24/7*. The opportunity to introduce Americans from coast to coast to the thrill, excitement, and possibility of digital photography makes the vision behind this book a perfect fit for Olympus, a leader in digital cameras since 1996.

For most people, the essence of digital photography is best grasped through firsthand experience with the technology, which is precisely what *America 24/7* is about. We understand that direct experience is the pathway to inspiration, and welcome opportunities like this sponsorship to bring the power of the digital experience into the lives of people everywhere. To Olympus, *America 24/7* offers a platform to help realize a core mission: to deliver and make accessible the power of the digital experience to millions of American photographers, amateurs, and professionals alike.

The 1,000 professional photographers contracted to shoot on the America 24/7 project were all equipped with Olympus C-5050 digital cameras. Like all Olympus products, the C-5050 is offered by a company well known for designing, manufacturing, and servicing products used by professionals to perform their work, every day. Olympus is a customer-centric company committed to working one-to-one with a diverse group of professionals. From biomedical researchers who use our clinical microscopes, to doctors who perform life-saving procedures with our endoscopes, to professional photographers who use cameras in their daily work, Olympus is a trusted brand.

The digital imaging technology involved with *America 24/7* has enabled the soul of America to be visually conveyed, not just by professional observers, but by the American public who participated in this project—the very people who collectively breath life into this country's existence each day.

We are proud to be enabling so many photographers to capture the pictures on these pages that tell the story of who we are as a nation. From sea to shining sea, digital imagery allows us to connect to one another in ways we never dreamed possible.

At Olympus, our ideas have proliferated as rapidly as technology has evolved. We have channeled these visions into breakthrough products and solutions to meet the demands of our changing world-products like microscopes, endoscopes, and digital voice recorders, supported by the highly regarded training, educational, and consulting services we offer our customers.

Today, 83 years after we introduced our first microscope, we remain as young, as curious, and as committed as ever.

Lexar Media has grown from the digital photography revolution, which is why we are proud to have supplied the digital memory cards used in the America 24/7 project. Lexar Media's high-performance memory cards utilize our unique and patented controller coupled with high-speed flash memory from Samsung, the world's largest flash memory supplier. This powerful combination brings out the ultimate performance of any digital camera.

Photographers who demand the most from their equipment choose our products for their advanced features like write speeds up to 40X, Write Acceleration technology for enabled cameras, and Image Rescue, which recovers previously deleted or lost images. Leading camera manufacturers bundle Lexar Media digital memory cards with their cameras because they value its performance and reliability.

Lexar Media is at the forefront of digital photography as it transforms picture-taking worldwide, and we will continue to be a leader with new and innovative solutions for professionals and amateurs alike.

Snapfish, which developed the technology behind the *America 24/7* amateur photo event, is a leading online photo service, with more than 5 million members and 100 million photos posted online. Snapfish enables both film and digital camera owners to share, print, and store their most important photo memories, at prices that cannot be equaled. Digital camera users upload photos into a password-protected online album for free. Users can also order film-quality prints on professional photographic paper for as low as 25¢. Film camera users get a full set of prints, plus online sharing and storage, for just $2.99 per roll.

Founded in 1995, eBay created a powerful platform for the sale of goods and services by a passionate community of individuals and businesses. On any given day, there are millions of items across thousands of categories for sale on eBay. eBay enables trade on a local, national and international basis with customized sites in markets around the world.

Through an array of services, such as its payment solution provider PayPal, eBay is enabling global e-commerce for an ever-growing online community.

JetBlue Airways is proud to be *America 24/7's* preferred carrier, flying photographers, photo editors, and organizers across the United States.

Winner of Condé Nast Traveler's Readers' Choice Awards for Best Domestic Airline 2002, JetBlue provides friendly service and low fares for travelers in 22 cities in nine states across America.

On behalf of JetBlue's 5,000 crew members, we're excited to be involved in this remarkable project, and for the opportunity to serve American travelers each and every day, coast to coast, 24/7.

DIGITAL POND™

Digital Pond has been a leading creator of large graphic displays for museums, corporations, trade shows, retail environments and fine art since 1992.

We were proud to bring together our creative, print and display capabilities to produce signage and displays for mission control, critical retouching for numerous key images for the book, and art galleries for the New York Public Library and Bryant Park.

The Pond's team and SplashPic® Online service enabled us to nimbly design, produce and install over 200 large graphic panels in two NYC locations within the truly "24/7" production schedule of less than ten days.

WEBWARE™

WebWare Corporation is pleased to be a major sponsor of the America 24/7 project. We take pride in being part of a groundbreaking adventure that is stretching the boundaries—and the imagination—in digital photography, digital asset management, publishing, news, and global events.

Our ActiveMedia Enterprise™ digital asset management software is the "nerve center" of *America 24/7*, the central repository for managing, sharing, and collaborating on the project's photographs. From photo editors and book publishers to 24/7's media relations and marketing personnel, ActiveMedia provides the application support that links all facets of the project team to the content worldwide.

WebWare helps Global 2000 firms securely manage, reuse, and distribute media assets locally or globally. Its suite of ActiveMedia software products provide powerful media services platforms for integrating rich media into content management systems marketing and communication portals; web publishing systems; and e-commerce portals.

Google's mission is to organize the world's information and make it universally accessible and useful.

With our focus on plucking just the right answer from an ocean of data, we were naturally drawn to the America 24/7 project. The book you hold is a compendium of images of American life distilled from thousands of photographs and infinite possibilities. Are you looking for emotion? Narrative? Shadows? Light? It's all here, thanks to a multitude of photographers and writers creating links between you, the reader, and a sea of wonderful stories. We celebrate the connections that constitute the human experience and are pleased to help engender them. And we're pleased to have been a small part of this project, which captures the results of that interaction so vividly, so dynamically, and so dramatically.

Special thanks to additional contributors: FileMaker, Apple, Camera Bits, LaCie, Now Software, Preclick, Outpost Digital, Xerox, Microsoft, WoodWing Software, net-linx Publishing Solutions, and Radical Media. The Savoy Hotel, San Francisco; The Pan Pacific, San Francisco; Four Seasons Hotel, San Francisco; and The Queen Anne Hotel. Photography editing facilities were generously hosted by CNET Networks, Inc.

Participating Photographers

Coordinator: Colburn Hvidston III, *The Forum*, Fargo

Lewis Ableidinger
Bill Alkofer
Jerry Anderson
Dave Arntson
Susan Beehler
Meredith Ehli
Anna Frissell
Darren Gibbins
Wayne Gudmundson
Ludvik Herrera
Colburn Hvidston III, *The Forum*, Fargo
Eric Hylden, *Grand Forks Herald*
Arika Viktoria Johnson
Chuck Kimmerle
Will Kincaid
Dan Koeck

C.J. Kurszewski
Jason Lindsey, JasonLindsey.com
Jackie Lorentz
Meg Luther Lindholm
Mason Mannie
Mike McCleary
David Samson
Sandee Gerbers
John Stennes
Tom Stromme
Amy Taborsky, *Bismarck Tribune*
Ed Vizenor, Wisdom Productions
Kory Wallen
Heidi Weiss, *Minot Daily News*
Tammy Wheelock

Thumbnail Picture Credits

Credits for thumbnail photographs are listed by the page number and are in order from left to right.

20 Ludvik Herrera
Ludvik Herrera
Heidi Weiss, *Minot Daily News*
Ludvik Herrera
Mike McCleary
Ludvik Herrera
Ed Vizenor, Wisdom Productions

21 Heidi Weiss, *Minot Daily News*
Ludvik Herrera
Heidi Weiss, *Minot Daily News*
Mike McCleary
Ludvik Herrera
Ludvik Herrera
Suzy Q Bee

23 Suzy Q Bee
Jackie Lorentz
Jason Lindsey, JasonLindsey.com
Jackie Lorentz
Jason Lindsey, JasonLindsey.com
C.J. Kurszewski
Jackie Lorentz

24 Colburn Hvidston III, *The Forum*, Fargo
Darren Gibbins
Suzy Q Bee
Dan Koeck
Jackie Lorentz
Heidi Weiss, *Minot Daily News*
Meg Luther Lindholm

25 Ludvik Herrera
Suzy Q Bee
Tom Stromme
Suzy Q Bee
Tom Stromme
Suzy Q Bee
Tom Stromme

30 Suzy Q Bee
Jason Lindsey, JasonLindsey.com
Jason Lindsey, JasonLindsey.com
Jason Lindsey, JasonLindsey.com
Suzy Q Bee
Suzy Q Bee
C.J. Kurszewski

31 Suzy Q Bee
Suzy Q Bee
Suzy Q Bee
Suzy Q Bee

Jason Lindsey, JasonLindsey.com
Suzy Q Bee
Suzy Q Bee

32 Dan Koeck
C.J. Kurszewski
C.J. Kurszewski
Dan Koeck
C.J. Kurszewski
Mike McCleary
Dan Koeck

33 Dan Koeck
Lewis Ableidinger
Lewis Ableidinger
Dan Koeck
Wayne Gudmundson
Sandee Gerbers
Dan Koeck

34 Heidi Weiss, *Minot Daily News*
Eric Hylden, *Grand Forks Herald*
Heidi Weiss, *Minot Daily News*
Wayne Gudmundson
Sandee Gerbers
Wayne Gudmundson
Darren Gibbins

36 Suzy Q Bee
Dave Arntson
Dave Arntson
C.J. Kurszewski
David Samson
C.J. Kurszewski
Dave Arntson

37 Sandee Gerbers
Dan Koeck
Darren Gibbins
Dave Arntson
Dave Arntson
Dave Arntson
Dan Koeck

39 Jerry Anderson
Dan Koeck
Jackie Lorentz
Dan Koeck
Tom Stromme
Dan Koeck
Darren Gibbins

40 Ann Arbor Miller
Suzy Q Bee
Ann Arbor Miller
Ed Vizenor, Wisdom Productions
Jerry Anderson
Suzy Q Bee
Amy Taborsky, *Bismarck Tribune*

41 Dave Arntson
Darren Gibbins
Suzy Q Bee
Suzy Q Bee
Ed Vizenor, Wisdom Productions
Suzy Q Bee
Suzy Q Bee

48 Jason Lindsey, JasonLindsey.com
Jason Lindsey, JasonLindsey.com
Jason Lindsey, JasonLindsey.com
Jason Lindsey, JasonLindsey.com
C.J. Kurszewski
Jason Lindsey, JasonLindsey.com
Lewis Ableidinger

49 Jason Lindsey, JasonLindsey.com
Jason Lindsey, JasonLindsey.com
Jason Lindsey, JasonLindsey.com
Jason Lindsey, JasonLindsey.com
Jason Lindsey, JasonLindsey.com
Jason Lindsey, JasonLindsey.com
Jason Lindsey, JasonLindsey.com

50 Jason Lindsey, JasonLindsey.com
Jason Lindsey, JasonLindsey.com
Amy Taborsky, *Bismarck Tribune*
Arika Viktoria Johnson
Jason Lindsey, JasonLindsey.com
Dave Arntson
Arika Viktoria Johnson

51 Amy Taborsky, *Bismarck Tribune*
Jason Lindsey, JasonLindsey.com
Arika Viktoria Johnson
Jason Lindsey, JasonLindsey.com
Jason Lindsey, JasonLindsey.com
Lewis Ableidinger
Jason Lindsey, JasonLindsey.com

52 Mike McCleary
Mike McCleary
Mike McCleary
Mike McCleary
Mike McCleary
Mike McCleary
Jerry Anderson

53 Jerry Anderson
Mike McCleary
C.J. Kurszewski
Jerry Anderson
Mike McCleary
Wayne Gudmundson
Mike McCleary

54 Meg Luther Lindholm
Colburn Hvidston III, *The Forum*, Fargo
Will Kincaid
Meg Luther Lindholm
Sandee Gerbers
Will Kincaid
Will Kincaid

55 C.J. Kurszewski
Jerry Anderson
Chuck Kimmerle
Will Kincaid
Jerry Anderson
C.J. Kurszewski
Will Kincaid

58 Heidi Weiss, *Minot Daily News*
Eric Hylden, *Grand Forks Herald*
Colburn Hvidston III, *The Forum*, Fargo
Colburn Hvidston III, *The Forum*, Fargo
C.J. Kurszewski
Colburn Hvidston III, *The Forum*, Fargo
C.J. Kurszewski

59 Meg Luther Lindholm
Eric Hylden, *Grand Forks Herald*
C.J. Kurszewski
Eric Hylden, *Grand Forks Herald*
Suzy Q Bee
Tom Stromme
Suzy Q Bee

60 Amy Taborsky, *Bismarck Tribune*
Arika Viktoria Johnson
David Samson
Eric Hylden, *Grand Forks Herald*
David Samson
Eric Hylden, *Grand Forks Herald*
Colburn Hvidston III, *The Forum*, Fargo

61 Eric Hylden, *Grand Forks Herald*
Eric Hylden, *Grand Forks Herald*
Dan Koeck
Jerry Anderson
David Samson
Ludvik Herrera
Meg Luther Lindholm

63 Sandee Gerbers
Chuck Kimmerle
Bill Alkofer
Chuck Kimmerle
Chuck Kimmerle
Bill Alkofer
Bill Alkofer

64 Amy Taborsky, *Bismarck Tribune*
C.J. Kurszewski
Amy Taborsky, *Bismarck Tribune*
C.J. Kurszewski
Darren Gibbins
Amy Taborsky, *Bismarck Tribune*
C.J. Kurszewski

65 C.J. Kurszewski
Amy Taborsky, *Bismarck Tribune*
Amy Taborsky, *Bismarck Tribune*
Dan Koeck
David Samson
Kory Wallen
Amy Taborsky, *Bismarck Tribune*

66 Arika Viktoria Johnson
Meg Luther Lindholm
Sandee Gerbers
Jackie Lorentz
Arika Viktoria Johnson
Sandee Gerbers
Meg Luther Lindholm

68 Dan Koeck
Suzy Q Bee
Sandee Gerbers
Suzy Q Bee
Dan Koeck
Suzy Q Bee
Dan Koeck

69 Sandee Gerbers
Suzy Q Bee
Suzy Q Bee
Suzy Q Bee
Sandee Gerbers
Suzy Q Bee
Suzy Q Bee

72 David Samson
David Samson
David Samson
David Samson
David Samson
David Samson
David Samson

75 David Samson
David Samson
David Samson
David Samson
Jason Lindsey, JasonLindsey.com
David Samson
David Samson

76 David Samson
David Samson
David Samson
David Samson
David Samson
David Samson

78 Dan Koeck
Dan Koeck
Ed Vizenor, Wisdom Productions
Ed Vizenor, Wisdom Productions
Ludvik Herrera
Ed Vizenor, Wisdom Productions
Ed Vizenor, Wisdom Productions

79 Jerry Anderson
Meg Luther Lindholm
Eric Hylden, *Grand Forks Herald*
Sandee Gerbers
Sandee Gerbers
Ludvik Herrera
Suzy Q Bee

80 Dan Koeck
Amy Taborsky, *Bismarck Tribune*
Tom Stromme
Darren Gibbins
Colburn Hvidston III, *The Forum*, Fargo
Wayne Gudmundson
David Samson

81 Suzy Q Bee
Colburn Hvidston III, *The Forum*, Fargo
Colburn Hvidston III, *The Forum*, Fargo
Meg Luther Lindholm
David Samson
Sandee Gerbers
David Samson

82 Colburn Hvidston III, *The Forum*, Fargo
Colburn Hvidston III, *The Forum*, Fargo
Colburn Hvidston III, *The Forum*, Fargo
Colburn Hvidston III, *The Forum*, Fargo
Colburn Hvidston III, *The Forum*, Fargo
Colburn Hvidston III, *The Forum*, Fargo
Colburn Hvidston III, *The Forum*, Fargo

83 Tom Stromme
Lewis Ableidinger
Colburn Hvidston III, *The Forum*, Fargo
Tom Stromme
Colburn Hvidston III, *The Forum*, Fargo
Kory Wallen
Tom Stromme

86 Dave Arntson
David Samson
David Samson
David Samson
David Samson
Dave Arntson
David Samson

87 David Samson
Lewis Ableidinger
David Samson
David Samson
David Samson
Suzy Q Bee
David Samson

90 Suzy Q Bee
Dan Koeck
Ludvik Herrera
Jason Lindsey, JasonLindsey.com
Ludvik Herrera
Chuck Kimmerle
Dave Arntson

91 Jerry Anderson
Suzy Q Bee
Jerry Anderson
Sandee Gerbers
Eric Hylden, *Grand Forks Herald*
Suzy Q Bee
Tom Stromme

92 Heidi Weiss, *Minot Daily News*
Chuck Kimmerle
Ludvik Herrera
Ludvik Herrera
Suzy Q Bee
Ludvik Herrera
Ludvik Herrera

93 Sandee Gerbers
Ludvik Herrera
Ludvik Herrera
Suzy Q Bee
Sandee Gerbers
Suzy Q Bee
Tom Stromme

96 Amy Taborsky, *Bismarck Tribune*
Jackie Lorentz
Chuck Kimmerle
Jackie Lorentz
Jackie Lorentz
Amy Taborsky, *Bismarck Tribune*
Meg Luther Lindholm

97 Jackie Lorentz
Amy Taborsky, *Bismarck Tribune*
Tom Stromme
Jackie Lorentz
Tom Stromme
Suzy Q Bee
Tom Stromme

98 Jerry Anderson
Jerry Anderson
Jerry Anderson
Jerry Anderson
Jerry Anderson
Jerry Anderson
Jerry Anderson

99 Jerry Anderson
Jerry Anderson
Jerry Anderson
Jerry Anderson
Jerry Anderson
Jerry Anderson
Jerry Anderson

100 Darren Gibbins
Suzy Q Bee
Darren Gibbins
Suzy Q Bee
Suzy Q Bee
Suzy Q Bee
Suzy Q Bee

101 Suzy Q Bee
Suzy Q Bee
Suzy Q Bee
Lewis Ableidinger
Suzy Q Bee
Wayne Gudmundson
Suzy Q Bee

104 C.J. Kurszewski
Meg Luther Lindholm
Dave Arntson
Dave Arntson
Heidi Weiss, *Minot Daily News*
Jason Lindsey, JasonLindsey.com
Dave Arntson

106 Amy Taborsky, *Bismarck Tribune*
Meg Luther Lindholm
Darren Gibbins
Colburn Hvidston III, *The Forum*, Fargo
Colburn Hvidston III, *The Forum*, Fargo
Lewis Ableidinger
Jerry Anderson

107 Darren Gibbins
Colburn Hvidston III, *The Forum*, Fargo
Colburn Hvidston III, *The Forum*, Fargo
Suzy Q Bee
Ed Vizenor, Wisdom Productions
Suzy Q Bee
Sandee Gerbers

110 Ed Vizenor, Wisdom Productions
Darren Gibbins
Suzy Q Bee
Chuck Kimmerle
Andrew J Severin
Lewis Ableidinger
Jerry Anderson

111 Sandee Gerbers
Ludvik Herrera
Colburn Hvidston III, *The Forum*, Fargo
Jerry Anderson
David Samson
Suzy Q Bee
Suzy Q Bee

113 Lewis Ableidinger
Meg Luther Lindholm
Lewis Ableidinger
Darren Gibbins
Wayne Gudmundson
Darren Gibbins
Suzy Q Bee

114 Arika Viktoria Johnson
Sandee Gerbers
Jackie Lorentz
Arika Viktoria Johnson
Jackie Lorentz
Arika Viktoria Johnson
Jackie Lorentz

115 Will Kincaid
Ludvik Herrera
Wayne Gudmundson
Arika Viktoria Johnson
Arika Viktoria Johnson
Suzy Q Bee
Will Kincaid

116 Suzy Q Bee
Dave Arntson
Tom Stromme
Suzy Q Bee
Tom Stromme
Suzy Q Bee
Sandee Gerbers

117 Dan Koeck
Tom Stromme
Heidi Weiss, *Minot Daily News*
Suzy Q Bee
Suzy Q Bee
Tom Stromme
Suzy Q Bee

119 Dan Koeck
Jackie Lorentz
Dan Koeck
Meg Luther Lindholm
Suzy Q Bee
Dan Koeck
Dan Koeck

120 Tom Stromme
Meg Luther Lindholm
Tom Stromme
Tom Stromme
Meg Luther Lindholm
Tom Stromme
Meg Luther Lindholm

122 Jason Lindsey, JasonLindsey.com
David Samson
Suzy Q Bee
Jason Lindsey, JasonLindsey.com
C.J. Kurszewski
Jason Lindsey, JasonLindsey.com
Jerry Anderson

123 Jason Lindsey, JasonLindsey.com
Eric Hylden, *Grand Forks Herald*
Tom Stromme
C.J. Kurszewski
Jason Lindsey, JasonLindsey.com
Suzy Q Bee
Jason Lindsey, JasonLindsey.com

124 Will Kincaid
Darren Gibbins
Dave Arntson
Jerry Anderson
Dave Arntson
Darren Gibbins
Ed Vizenor, Wisdom Productions

125 Dave Arntson
Darren Gibbins
Dave Arntson
Lewis Ableidinger
Jerry Anderson
Wayne Gudmundson
Dave Arntson

127 Arika Viktoria Johnson
Arika Viktoria Johnson
Darren Gibbins
Ludvik Herrera
Ludvik Herrera
Will Kincaid
Ludvik Herrera

128 Will Kincaid
Sandee Gerbers
Will Kincaid
Will Kincaid
Will Kincaid
Will Kincaid
Jerry Anderson

129 Will Kincaid
Will Kincaid
Will Kincaid
Lewis Ableidinger
Will Kincaid
Wayne Gudmundson
Will Kincaid

130 Suzy Q Bee
Amy Taborsky, *Bismarck Tribune*
Suzy Q Bee
David Samson
Amy Taborsky, *Bismarck Tribune*
Suzy Q Bee
Amy Taborsky, *Bismarck Tribune*

132 Amy Taborsky, *Bismarck Tribune*
Arika Viktoria Johnson
Dan Koeck
Jason Lindsey, JasonLindsey.com
Jason Lindsey, JasonLindsey.com
Jason Lindsey, JasonLindsey.com
Suzy Q Bee

133 Sandee Gerbers
Jason Lindsey, JasonLindsey.com
Jason Lindsey, JasonLindsey.com
Suzy Q Bee
Dan Koeck
Will Kincaid
Jason Lindsey, JasonLindsey.com

137 John Stennes
Arika Viktoria Johnson
Kory Wallen
Darren Gibbins
Kory Wallen
Darren Gibbins
Andrew J Severin

Staff

The *America 24/7* series was imagined years ago by our friend Oscar Dystel, a publishing legend whose vision and enthusiasm have been a source of great inspiration.

We also wish to express our gratitude to our truly visionary publisher, DK.

Rick Smolan, Project Director
David Elliot Cohen, Project Director

Administrative
Katya Able, Operations Director
Gina Privitere, Communications Director
Chuck Gathard, Technology Director
Kim Shannon, Photographer Relations Director
Erin O'Connor, Photographer Relations Intern
Leslie Hunter, Partnership Director
Annie Polk, Publicity Manager
John McAlester, Website Manager
Alex Notides, Office Manager
C. Thomas Hardin, State Photography Coordinator

Design
Brad Zucroff, Creative Director
Karen Mullarkey, Photography Director
Judy Zimola, Production Manager
David Simoni, Production Designer
Mary Dias, Production Designer
Heidi Madison, Associate Picture Editor
Don McCartney, Production Designer
Diane Dempsey Murray, Production Designer
Jan Rogers, Associate Picture Editor
Bill Shore, Production Designer and Image Artist
Larry Nighswander, Senior Picture Editor
Bill Marr, Sarah Leen, Senior Picture Editors
Peter Truskier, Workflow Consultant
Jim Birkenseer, Workflow Consultant

Editorial
Maggie Canon, Managing Editor
Curt Sanburn, Senior Editor
Teresa L. Trego, Production Editor
Lea Aschkenas, Writer
Olivia Boler, Writer
Korey Capozza, Writer
Beverly Hanly, Writer
Bridgett Novak, Writer
Alison Owings, Writer
Fred Raker, Writer
Joe Wolff, Writer
Elise O'Keefe, Copy Chief
Daisy Hernández, Copy Editor
Jennifer Wolfe, Copy Editor

Infographic Design
Nigel Holmes

Literary Agent
Carol Mann, The Carol Mann Agency

Legal Counsel
Barry Reder, Coblentz, Patch, Duffy & Bass, LLP
Phil Feldman, Coblentz, Patch, Duffy & Bass, LLP
Gabe Perle, Ohlandt, Greeley, Ruggiero & Perle, LLP
Jon Hart, Dow, Lohnes & Albertson, PLLC
Mike Hays, Dow, Lohnes & Albertson, PLLC
Stephen Pollen, Warshaw Burstein, Cohen, Schlesinger & Kuh, LLP
Rick Pappas

Accounting and Finance
Rita Dulebohn, Accountant
Robert Powers, Calegari, Morris & Co. Accountants
Eugene Blumberg, Blumberg & Associates
Arthur Langhaus, KLS Professional Advisors Group, Inc.

Picture Editors
J. David Ake, Associated Press
Caren Alpert, formerly *Health* magazine
Simon Barnett, *Newsweek*
Caroline Couig, *San Jose Mercury News*
Mike Davis, formerly *National Geographic*
Michel duCille, *Washington Post*
Deborah Dragon, *Rolling Stone*
Victor Fisher, formerly Associated Press
Frank Folwell, *USA Today*
MaryAnne Golon, *Time*
Liz Grady, formerly *National Geographic*
Randall Greenwell, *San Francisco Chronicle*
C. Thomas Hardin, formerly *Louisville Courier-Journal*
Kathleen Hennessy, *San Francisco Chronicle*
Scot Jahn, *U.S. News & World Report*
Steve Jessmore, *Flint Journal*
John Kaplan, University of Florida
Kim Komenich, *San Francisco Chronicle*
Eliane Laffont, *Hachette Filipacchi Media*
Jean-Pierre Laffont, *Hachette Filipacchi Media*
Andrew Locke, MSNBC
Jose Lopez, *The New York Times*
Maria Mann, formerly AFP
Bill Marr, formerly *National Geographic*
Michele McNally, *Fortune*
James Merithew, *San Francisco Chronicle*
Eric Meskauskas, *New York Daily News*
Maddy Miller, *People* magazine
Michelle Molloy, *Newsweek*
Dolores Morrison, *New York Daily News*
Karen Mullarkey, formerly *Newsweek, Rolling Stone, Sports Illustrated*
Larry Nighswander, Ohio University School of Visual Communication
Jim Preston, *Baltimore Sun*
Sarah Rozen, formerly *Entertainment Weekly*
Mike Smith, *The New York Times*
Neal Ulevich, formerly Associated Press

Website and Digital Systems
Jeff Burchell, Applications Engineer

Television Documentary
Sandy Smolan, Producer/Director
Rick King, Producer/Director
Bill Medsker, Producer

Video News Release
Mike Cerre, Producer/Director

Digital Pond
Peter Hogg
Kris Knight
Roger Graham
Philip Bond
Frank De Pace
Lisa Li

Senior Advisors
Jennifer Erwitt, Strategic Advisor
Tom Walker, Creative Advisor
Megan Smith, Technology Advisor
Jon Kamen, Media and Partnership Advisor
Mark Greenberg, Partnership Advisor
Patti Richards, Publicity Advisor
Cotton Coulson, Mission Control Advisor

Executive Advisors
Sonia Land
George Craig
Carole Bidnick

Advisors
Chris Anderson
Samir Arora
Russell Brown
Craig Cline
Gayle Cline
Harlan Felt
George Fisher
Phillip Moffitt
Clement Mok
Laureen Seeger
Richard Saul Wurman

DK Publishing
Bill Barry
Joanna Bull
Therese Burke
Sarah Coltman
Christopher Davis
Todd Fries
Dick Heffernan
Jay Henry
Stuart Jackman
Stephanie Jackson
Chuck Lang
Sharon Lucas
Cathy Melnicki
Nicola Munro
Eunice Paterson
Andrew Welham

Colourscan
Jimmy Tsao
Eddie Chia
Richard Law
Josephine Yam
Paul Koh
Chee Cheng Yeong
Dan Kang

Chief Morale Officer
Goose, the dog